CLARK CO. LIB

D0577259

LAS VEGAS-CLARK COUNTY LIBRARY DISTRICT

3 1133 01341 6211

JUN 1990

KF 353 .V969 1989
Voss, Frederick
Portraits of the American
 law

Las Vegas-Clark County
Library District
Las Vegas, Nevada 89119

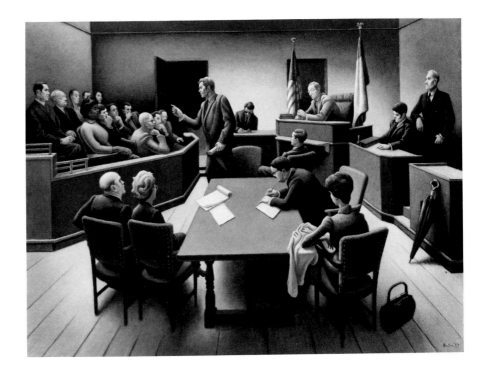

"I will not say . . . that 'The Law will admit of no rival'. . . but I will say that it is a jealous mistress, and requires a long and constant courtship. It is not to be won by trifling favors, but by lavish homage."

JOSEPH STORY

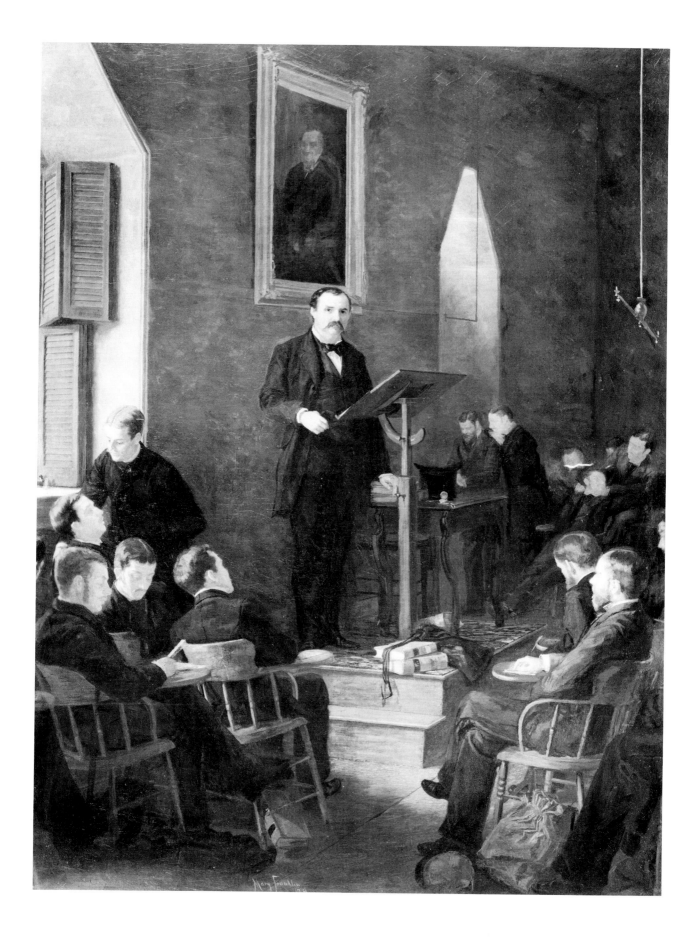

Portraits of
the American Law

FREDERICK S. VOSS

KF 353 .V969 1989
Voss, Frederick
Portraits of the American
 law

Published by the

NATIONAL PORTRAIT GALLERY

SMITHSONIAN INSTITUTION, WASHINGTON, D.C.

in association with the

UNIVERSITY OF WASHINGTON PRESS

SEATTLE AND LONDON

1989

This catalogue and exhibition have been made possible by the law firms of Morgan, Lewis & Bockius, Vinson & Elkins, and Kirkland & Ellis.

An exhibition at the National Portrait Gallery
October 13, 1989, to January 15, 1990

© 1989 by Smithsonian Institution. All rights reserved.
Library of Congress Catalog Card Number: 89-62257
ISBN: 0-295-96909-1

Cover illustration:
Lemuel Shaw, oil on canvas by William Morris Hunt (1824–1879), 1859.
Essex County Bar Association

Back cover illustration:
Felix Frankfurter, oil on canvas by Gardner Cox (1906–1988), 1960. Harvard Law Art Collection

Half-title page:
Trial by Jury, oil on canvas by Thomas Hart Benton (1889–1975), 1964. The Nelson-Atkins Museum of Art; bequest of the artist

Frontispiece:
A Class at the University of Pennsylvania Law School, oil on canvas by Mary Franklin (active 1876–1912), 1879. The Honorable Morris Sheppard Arnold

Contents

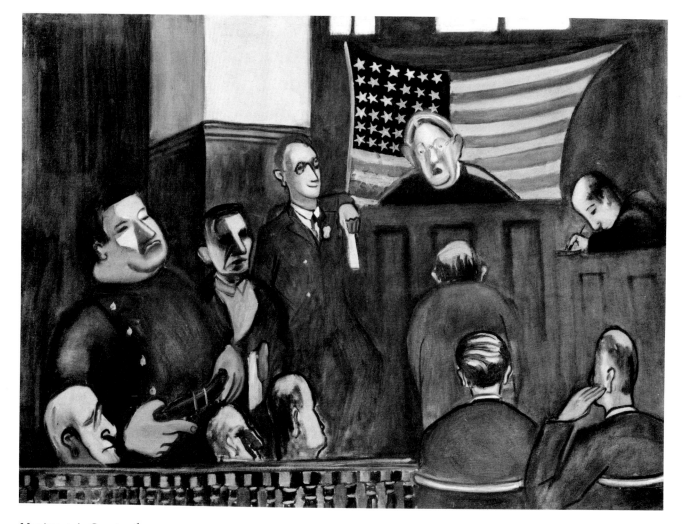

Magistrate's Court, oil on canvas
by Alice Neel (1900–1984), 76.2
x 106.7 cm. (30 x 42 in.), 1936.
Courtesy, Robert Miller Gallery,
New York

Foreword

INSCRIPTIONS CARVED ON BUILDING AFTER BUILDING in Washington proclaim the fundamental importance of the law in the American political system. The complaint that the King of England had denied the colonists his assent to just laws and had failed to provide an independent judiciary was a central issue in the Declaration of Independence. John Adams's advocacy of "a government of laws, and not of men" found its way into the 1780 Massachusetts Constitution six years after he published the idea in *The Boston Gazette*. The Constitution of the United States proclaimed itself, and the laws enacted under its provisions, to be "the supreme law of the land." On September 24, 1789, the first Congress enacted the federal judiciary act, and for the two centuries since then a continuous series of court decisions has defined, tested, and amended the laws enacted by the federal government and by the governments of states and localities across the land. The process continues today and will continue as long as the Constitution is in effect.

Therefore, it is not surprising that lawyers and judges have played such prominent roles in American life. Recent census statistics indicate that more than 700,000 Americans engage in the active practice of law. Twenty American Presidents have been lawyers; one President also became a Chief Justice of the United States. What is surprising is that the National Portrait Gallery should have existed for as long as it has without exploring this significant and influential profession. The bicentennial commemoration of the establishment of the federal judiciary provides the proper occasion to set this right.

This book and the exhibition to which it relates are not about the laws of the land, but about the individuals who have used them, challenged them, and given them life. Our legal system has been in a constant state of change from its very beginnings. The importance of the Supreme Court—today the capstone of a federal judiciary that is manifestly equal in significance to the executive and legislative branches of the government—apparently was scarcely foreseen by the Founding Fathers. The power and independence of the federal judiciary is directly the result of the vision and personality of John Jay, John Marshall, and the other early justices who saw their role more clearly than the drafters of the Constitution may have done.

Cases argued before the Supreme Court by such powerful advocates as Daniel Webster and Joseph Choate helped clarify the limitations on the power of states and communities.

In our history books we read about the fugitive slave laws and the Missouri Compromise as instruments of the division that led the nation into the Civil War, and we recall the great debates about them in the Congress, but we do not often pay attention to those who argued cases under these laws, or who worked for their repeal or amendment in the courts. These are the people celebrated in this volume, and given new life in the lively essays provided by Frederick Voss, who served as the curator and author in this undertaking.

Mr. Voss has selected from the giants of American legal history a group of lawyers and judges distinguished for their accomplishments, their personalities, and—since this is a portrait gallery—for the portraits that have been made of them. Doubtless there are many other lawyers who deserve a place in this group, but the object here is not to be encyclopedic; rather it is to present a sampling of the varied array of individuals who have shaped our legal institutions. Mr. Voss has written as much about the personalities of these attorneys and judges as about their specific impact on American law, and perhaps this is indicative of how our system works. A good idea or a necessary reform requires powerful arguments and compelling advocates if it is to prevail in the adversarial forum of the courtroom; pallid lawyers or colorless presentations are rarely found on the winning side, and successful litigators, naturally enough, have tended to have personalities equal to their profession. These brilliant lawyers were often determined to find artists who would do justice to their personal attainments. They—or those who commissioned their portraits—turned to the leading painters and sculptors of their day, and left behind images evoking uncommon strength of character and intellect.

Of course, not everyone included here excelled in the theatrics of litigation. Some, like Henry Wheaton, owed their distinction to their scholarly writings on the law. Others preferred the classroom to the courtroom, and among these are such towering pioneers of American legal education as Christopher Langdell. The artists who portrayed these introspective personalities have movingly revealed the reflective side of their sitters, in contrast to the stage presence of the notable litigators.

The portraits gathered here come from a variety of

collections, but the largest single source is the Harvard Law School. Harvard's collection dates from the 1830s and 1840s, when admiring students subscribed to commission portraits of James Kent, John Marshall, and Simon Greenleaf, among others, and its growth accelerated when Roscoe Pound became Dean in 1916. Harvard has been exceedingly generous in allowing us to use so many of the remarkable portraits it has gathered over the years, which are now seen here in a new context. We are grateful as well to the many other institutions and individuals who have made portraits, courtroom scenes, documents, and objects available for this celebration of the law in America.

Last, but not least, our deepest gratitude must go to three law firms of national standing that have joined together in an unprecedented gesture of support to their profession. Morgan, Lewis & Bockius, Vinson & Elkins, and Kirkland & Ellis have generously sponsored this exhibition and this book. They understood well the truth of Joseph Story's observation that the law ". . . is a jealous mistress, and requires a long and constant courtship. It is not to be won by trifling favors, but by lavish homage." I leave it to our readers and our viewers to judge whether our homage is "lavish," but I hope that all will agree that the National Portrait Gallery's bicentennial tribute to America's judges and lawyers is anything but "trifling."

ALAN FERN
Director
National Portrait Gallery

Let Me Refresh Your Recollection, lithograph by William Sharp (1900–1961), 23.5 x 35.5 cm. (9 $\frac{1}{4}$ x 14 in.), circa 1937. Harvard Law Art Collection

With Your Honor's Permission, lithograph by William Sharp (1900–1961), 24.1 x 35.5 cm. (9 $\frac{1}{2}$ x 14 in.), circa 1937. Harvard Law Art Collection

Acknowledgments

THE REALIZATION OF THIS BOOK AND THE EXHIBITION of which it is part would never have materialized without substantial help and cooperation from a variety of quarters. In many instances, in fact, the foregoing words of thanks cannot, I fear, reflect the full extent of felt gratitude to the host of people and institutions that facilitated this enterprise.

One of the things readers might note in perusing this volume is the fact that so many of the portraits and illustrations found in it come from the Harvard Law School. What they may not appreciate, however, is that the number of pieces reproduced here from that institution is large enough to suggest that neither book nor exhibition would have been possible without its willingness to share some of the treasures of its art, manuscript, and rare book collections with the National Portrait Gallery. I am therefore thankful indeed to have had the law school as an ally in this venture. More particularly, I am grateful to the individuals at the law school who were the chief implementers of Harvard's collaboration with the National Portrait Gallery— Curator of Art Bernice Loss, Assistant Librarian for Special Collections David Warrington, and Manuscripts Associate Judith Mellins.

Expressions of appreciation are also owing to several individuals who, when consulted on various aspects of this chronicle on noted American jurists, gave freely and generously of their time and knowledge. Among them is Maeva Marcus, editor of the United States Supreme Court documentary history project, whose assistance in determining some of the figures to be included here proved invaluable. In the course of investigating the origins of the portraits featured in this publication, I also had the pleasure of encountering the late Gardner Cox, who painted several of those likenesses, and I shall always consider the opportunity to discuss those pictures with him as one of the more rewarding bonuses that came with working on this project. Equally memorable is a morning spent with the daughter and son-in-law of artist Charles Hopkinson, Joan and William Shurcliff, discussing the three Hopkinson portraits found in these pages.

As for staff at the National Portrait Gallery, the list of

people instrumental in making book and exhibition a reality is a long one. To Director Alan Fern and Assistant Directors Carolyn Carr and Marc Pachter I am especially grateful both for the latitude they allowed me in this enterprise and for their invariably warm moral support. To Curator of Exhibitions Beverly Cox and Assistant Curator Claire Kelly, I can only say that no vote of thanks—however lengthy or eloquent—can adequately repay them for their efficient administration of the many details of this undertaking. A similar sentiment applies to editors Frances Stevenson and Dru Dowdy, whose expertise in preparing this manuscript for publication simply reinforced the conviction that they are two of the Gallery's most indispensable assets. The museum's registrar Sue Jenkins and her staff and its designers Nello Marconi and Al Elkins have also played central parts in this venture, and in thanking them, I feel compelled to note as well what a pleasure it has been to work with them.

Finally, it is no exaggeration to say that both book and exhibition would have suffered greatly without the able assistance of Susan Davis whose virtues as both a researcher and discerning critic are far too numerous to list.

Also crucial to this enterprise has been the willingness of three law firms—Morgan, Lewis & Bockius, Vinson & Elkins, and Kirkland & Ellis—to provide the bulk of the funding needed for it. To Director Alan Fern's thanks for this generosity, I add my own.

FREDERICK S. VOSS

Lenders to the Exhibition

Mrs. Fritzie Abadi

Julia Davis Adams

The Honorable Morris Sheppard Arnold

The Association for the Preservation of Virginia Antiquities, Richmond

The Association of the Bar of the City of New York, New York

The Boston Athenaeum, Massachusetts

The Bostonian Society, Boston, Massachusetts

The Carnegie Museum of Art, Pittsburgh, Pennsylvania

Richard Henry Dana

Mrs. Mary Hand Darrell

Dialectic and Philanthropic Societies Foundation, Inc., Chapel Hill, North Carolina

Mr. Edward I. Elicofon

Grenville T. Emmet, Jr.

Essex County Bar Association, Salem, Massachusetts

The Fine Arts Museums of San Francisco, California

Hamilton College Collection, Emerson Gallery, Clinton, New York

Harvard Club of New York, New York

Harvard Law School Library, Cambridge, Massachusetts

Jenkins Memorial Law Library, Philadelphia, Pennsylvania

Department of Justice, Washington, D.C.

Library of Congress, Washington, D.C.

Langston Hughes Memorial Library, Lincoln University, Lincoln, Pennsylvania

The Maryland Historical Society, Baltimore

Pictured in this portrayal of the
Supreme Court, done in about 1960,
are Chief Justice Earl Warren
flanked by (left to right): Charles
Whittaker, John Harlan, William
Douglas, Hugo Black, Felix
Frankfurter, Tom Clark, William
Brennan, and Potter Stewart.

Lithograph by William Sharp
(1900–1961), 48.6 x 67.5 cm.
(19¹/₈ x 26⁹/₁₆ in.), circa 1960.
National Portrait Gallery,
Smithsonian Institution

Massachusetts Historical Society, Boston

Robert Miller Gallery, New York, New York

National Archives, Washington, D.C.

National Gallery of Art, Washington, D.C.

*National Portrait Gallery, Smithsonian Institution,
 Washington, D.C.*

The Nelson-Atkins Museum of Art, Kansas City, Missouri

The New York Law Institute, New York

The New York Public Library, New York

New York State Historical Association, Cooperstown

New York University School of Law, New York

Joseph Rauh

The Rhode Island Historical Society, Providence

*Museum of Art, Rhode Island School of Design,
 Providence*

*Proprietors of the Social Law Library, Boston,
 Massachusetts*

State Historical Society of Wisconsin, Madison

*The Supreme Court of the United States,
 Washington, D.C.*

The Union League Club, New York, New York

The University of Michigan Law School, Ann Arbor

Mrs. John Hay Whitney

*Earl Gregg Swem Library, The College of William
 and Mary in Virginia, Williamsburg*

Yale University Art Gallery, New Haven, Connecticut

Introduction

IT HAS BEEN OBSERVED MANY TIMES THAT AMERICANS are some of the most legalistically minded people on earth and that among the chief forces directing the course of this country's history has been a firmly entrenched habit of viewing legal process and principle as a main and indispensable check on the abuses of power. To substantiate those claims, one has only to examine the forces leading to the American Revolution. For although it would be a mistake to minimize the purely practical factors behind that event, such as economic self-interest, central to the thirteen colonies' quest for nationhood was a set of notions regarding the proper relationship between government and the governed that was firmly rooted in legal theory. Thus, in reviewing the landmark events that impelled the colonies toward their final break with Great Britain, one finds that among the most significant—from the earliest cries of "no taxation without representation" to the Declaration of Independence—were those occasions when Americans set forth what they regarded as their inalienable rights under the law. Nor is it particularly startling to discover that one of the occupations most heavily represented among the Revolution's leadership was the legal profession; of the fifty-six men who gathered at Philadelphia in 1776 to sign the Declaration of Independence, fully twenty-five of them were members of the colonial bar.

But despite the legal profession's prominent part in the making of American nationhood, the years immediately following the Revolution witnessed in many quarters a marked disenchantment with lawyers. Inspired largely by the new republic's depressed economic state, this animosity toward the bar originated primarily because, in the wake of worsening business conditions, property foreclosures and debt collections became the chief order of business for attorneys and judges. In the process, the perception arose that the nation's jurists had become little better than overfed parasites, grown fat and prosperous on the misfortunes and travails of their fellow citizens. Echoing this outlook in the late 1780s, one observer complained that it was now possible for lawyers to "amass more wealth without labor, than the most opulent farmer, with all his toils." "What a pity," he added, "that our forefathers, who happily extinguished so many fatal customs did not also prevent the introduction of a set of men so dangerous." At about the same time, yet another spokesman for America's growing anti-lawyer contingency

Courtroom Scene—Trial of Don Pasquale, gouache, pencil, and ink on paper by Hank Virgona (born 1929), 66 x 50.8 cm. (26 x 20 in.), 1968. Mrs. Fritzie Abadi

declared that "among the multiplicity of evils which we at present suffer, there are none more justly complained of than those we labour under by the many pernicious practices in the profession of law." As for the solution to this intolerable situation, he suggested that since the "'order'" of human species—commonly known as lawyers—had grown "not only USELESS, but . . . DANGEROUS," it should be forever "abolished," and that filling the vacuum left by the demise of professional attorneys and judges should be a system of arbitration consisting mainly of responsible laymen.

This hostility toward bench and bar continued into the first several decades of the nineteenth century and, in fact, has never entirely died. Nevertheless, the legal profession not only survived the sporadic questionings of its utility within the new American republic; it prospered and waxed ever stronger in its influence. When the celebrated French chronicler of America's democratic mores and institutions, Alexis de Tocqueville, arrived here in the early 1830s, he soon concluded that of all the classes and types peopling its communities, the group most deserving of deference and respect was its lawyers. Of this phenomenon, he wrote in *Democracy in America*, the subsequent narrative of his travels: *In America there are neither nobles nor men of letters, and the people distrust the wealthy. Therefore the lawyers form the political upper class and the most intellectual section of society. . . . If you ask me where the American aristocracy is found, I have no hesitation in answering that it is not among the rich, who have no common link uniting them. It is at the bar or the bench that the American aristocracy is found.*

Had Tocqueville observed the wheels of due process as they turned in the remoter regions of America's wilderness, he might not have made this statement with such absolute certainty. In the backwoods, the system of justice was often as rough-hewn and woolly as the sparsely settled communities that it served. For starters, the structures that housed what passed for courts there could be crude beyond belief and between sessions sometimes even served as shelters for livestock. There was, for example, the case of the Tennessee judge who defended himself against charges of failing to hold court in timely fashion by citing the vermin infesting his so-called courthouse due to its recent use as a pigpen. But when a genre painter of the day depicted a lawyer trying to weave his spell over judge and jury in a farmer's barn and another portrayed a court proceeding in a humble cobbler's shop, they underscored only some of the more superficial dimensions of the primitiveness prevailing in early

Congressional bill to establish the federal judiciary, September 24, 1789. Rare Books Division, Library of Congress

frontier law. For, while these visual records put in lively relief a sense of the improvised venues that often served as tribunals of justice in the backwoods, they did not convey the rather appalling want of professional learning that frequently characterized the practitioners of wilderness jurisprudence. One wonders whether Tocqueville would have been quite so confident in his high estimation of the legal profession's place in American life had he witnessed the courtroom rejoinder that one Indiana lawyer made when his opponent repeatedly tried to build his case with citations from "the great English common law." "If we are to be guided by English law at all," the attorney declared in the perfect certainty that he was striking a deadly blow to the opposition, "we want their best law, not their common law. We want as good a law as Queen Victoria herself makes use of; for, gentlemen, we are sovereigns here." Then, too, one cannot help but ponder how Tocqueville would have revised his judgment, had he known of one Simon Suggs, who began his rise at the Arkansas bar by winning his license to practice law at a card game, or had he seen the Kentucky magistrate's warrant that ran in part: "T'is warrnt othorizes the hi constable to tak [Henderson Harris] whar he ain't as wel as whar he is and bring him to be delt with accordin' to the laws of Jett's Creek." Doubtless more shocking yet to the aristocratically bred Frenchman would have been the frequency with which unlettered frontier counsels expressed their courtroom differences by resorting to fisticuffs.

Nevertheless, Tocqueville's inclination to see young America's legal establishment as a powerful and unusually capable elite was not without good and ample grounds. The United States at the time of his visit was well into what in retrospect has come to be known as its "golden age" of law. Some of the more memorable figures of this epoch, such as William Pinkney and Thomas Addis Emmet, either of whom could overwhelm juries by the sheer weight of their erudition, had been dead for some years and were already passing into legend. But a good many others still remained. While the era's most glittering ornament, Chief Justice John Marshall, continued to enlist his intuitive brilliance in forging Supreme Court decisions that were to shape America's institutional makeup for years to come, other jurists, such as James Kent, Joseph Story, and Henry Wheaton, were creating a body of literature on Anglo-American and international law that ultimately inspired reverential encomiums on both sides of the Atlantic. At the same time, it seemed that America had more than its fair share of talented courtroom advocates. While news of Daniel Webster's appearance before the Supreme Court invariably brought crowds

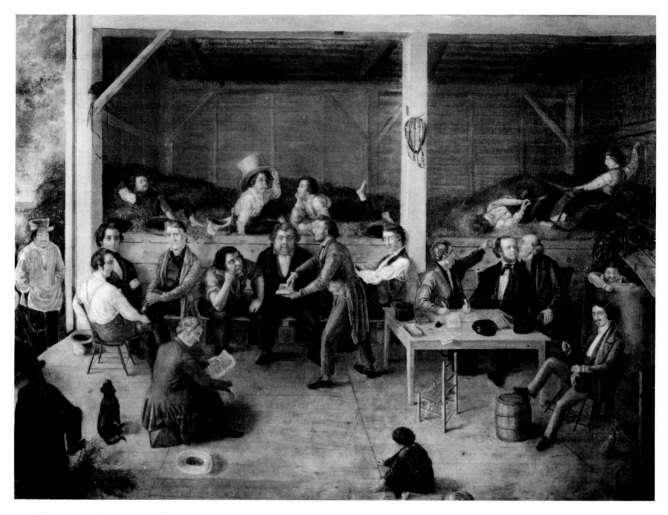

Trial by Jury, oil on canvas by A.
Wighe (active late 1840s), 88.3 x
121.3 cm. (34 $^3/_4$ x 47 $^3/_4$ in.), not
dated. Museum of Art, Rhode Island
School of Design

flocking to experience a sample of his Olympian logic, his good friend Rufus Choate was building a reputation for winning even the most hopeless of cases, and Horace Binney was approaching the end of his career as a widely revered expert in commercial and maritime law. Meanwhile, Lemuel Shaw was beginning his tenure as chief justice of the Massachusetts Supreme Court, which would be noted for a body of decisions destined to play a substantial role in determining the workings of this country's emerging industrial corporate order.

The curtain finally came down on American law's golden age at about the time of the Civil War, but its end did not necessarily mean that the pivotal influence that Tocqueville had ascribed to the law profession had ended as well. To the contrary, the legal world has continued to exercise significant impact on the directions of American life to the modern day, and at times its power to foster or hinder change has even seemed to be not merely noteworthy but all-encompassing.

In the years following the Civil War, for example, as America changed from essentially an agricultural society to an industrial one, the bench and bar often provided the rationales for retarding early legislative attempts to alleviate abuses in the new corporate order. Moreover, when the drive to curb the excesses of private enterprise culminated in Franklin Roosevelt's New Deal of the 1930s, some of those same legal rationalizations not only undid crucial aspects of Roosevelt's program; they also seemed for a time to preclude the possibility of achieving any new governmental control over the private sector, regardless of a widely recognized need for it.

The legal establishment's power to affect the paths of American development, however, has not been limited to blocking change. From time to time, it has proven as well to be a catalyst for rather drastic reformations in the status quo. Thus, in tracing the story of this country's move toward racial equality in the twentieth century, it is no exaggeration to say that one of the first causes of this trend was a host of courtroom proceedings mandating the elimination of discrimination on the basis of race. Nor would it be unfair to identify the exertions of the legal profession as a chief force in broadening this country's tolerance for free and open dissent from mainstream thinking.

It is possible to talk about the history of American law in terms of constitutional principles, precedents, and landmark court decisions and to only rarely allude to the individuals involved in that history. And indeed in many a chronicle of our

legal past, the element of human biography is sometimes barely present. This volume, however, approaches the story of American law in terms of some of the noteworthy individuals who have shaped it.

If Horace Binney, one of the figures included in this book, is to be believed, taking that avenue poses definite hazards to writer and reader alike. "If a lawyer confines himself to the profession," Binney once observed, it *makes sad work for his biography. You might almost as well undertake to write the biography of a mill-horse. It is at best a succession of concentric circles, widening a little perhaps from year to year, but never, when most enlarged, getting away from the original centre. He always has before him the same things, the same places, the same men, and the same end. . . . The more a man is a lawyer, then, the less he has to say for himself. . . . The biography of lawyers, however eminent, qua lawyers, is nothing.* To some extent, Binney had a point: The story of how this lawyer or that judge handled the succession of cases that became his lot in the course of his career is hardly the stuff of swashbuckling romance.

Yet it would be a mistake to characterize the lives of jurists as invariably and unremittingly dull. As much as any part of the human race, they too have their moments of drama, and the texture of personality to be found within the legal profession is perhaps as rich and variegated as any occupational group can offer. Thus, among the selection of American legal notables treated in the following pages are such figures as William Pinkney, whose prima-donna behavior in the courtroom sometimes rivaled that of the most temperamental and self-centered actor. Then there is Rufus Choate, whose ability to enrapture juries with his inexhaustible fund of poetic metaphor made him a legend even in his own time. Included as well is the self-righteous Supreme Court Justice John Marshall Harlan, who, outraged over one of the Court's decisions, did not hesitate to violate the normally self-controlled decorum of the nation's highest tribunal by publicly and roundly chastising his brethren for their wrongheadedness. And there is also Horace Binney himself who, contrary to his claim that a lawyer's accomplishments made for dull reading, inspired during one of his appearances before the Supreme Court a flood of newspaper copy that sometimes reads like a battlefield report.

It is also worth noting that the lives of America's great jurists have contained their share of amusing and sometimes epoch-making ironies. When, for example, a young Joseph Story began studying the writings of Sir Edward Coke, he dissolved

into tears over his inability to comprehend the sentences before him; yet, by the time of his death many years later, his own accomplishments in the law had made him the Coke of his day. Then there is the case of Earl Warren, who on becoming United States Chief Justice was thought to be a bland and thoroughly safe moderate but who ended up leading the Supreme Court toward some of the most jolting decisions in its history.

But while this book might afford glimpses in some of its brief biographical narratives into a number of the more colorful human aspects of our legal history, it is also meant to call attention to the distinguished body of portraiture that records the outward features of some of this country's greatest jurists. Painted and sculpted likenesses often fail to disclose to us as much about a subject's character as some of their creators claim they do. Nevertheless, in the selection reproduced here, there are a goodly number that go considerably beyond capturing physical traits to suggest less tangible things about their subjects.

The portrait of Daniel Webster that Francis Alexander painted to commemorate Webster's defense of Dartmouth College in *Dartmouth v. Woodward* is admittedly a highly romanticized interpretation of its subject. Yet in its romanticization, it offers a kind of visual metaphor of the oracular dignity that often made Webster seem in his courtroom appearances to be on a level well above his fellow lawyers. Similarly, the full-length portrait of Lemuel Shaw by William Morris Hunt brings to mind in its monumental simplicity the reverence with which so many of Shaw's professional contemporaries regarded his accomplishments on the bench. Finally, closer to the modern day, the restless spontaneity found in Gardner Cox's likeness of Supreme Court Justice Felix Frankfurter is a reminder of the boundless energy that characterized Frankfurter both on and off the bench.

This publication and the exhibition that inspired it are not intended to be an encyclopedic compendium of all the outstanding legal minds this country has produced. In perusing its pages, many may consequently wonder why this or that figure is excluded. Part of the answer to such queries lies in the fact that the numbers of individuals who have made significant contributions to American law have been too great for a book of this kind to accommodate them all. But although some distinguished jurists are neglected here, it is hoped that those featured will convey a sense of the varied array of personalities, accomplishments, and points of view that make up our legal history.

The Portraits

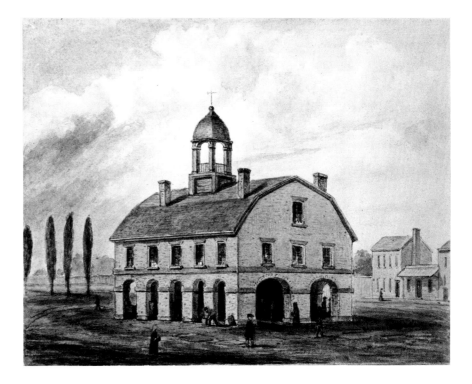

New York City's first Merchants
Exchange, which served as the site
for the first sessions of the United
States Supreme Court.

Watercolor on paper by unidentified
artist, 11.5 x 15 cm. (4 $\frac{1}{2}$ x 5 $\frac{7}{8}$ in.),
not dated. Emmet Collection, Print
Collection, Miriam & Ira D.
Wallach Division of Art, Prints and
Photographs, The New York Public
Library; Astor, Lenox and Tilden
Foundations

JOHN JAY
1745–1829

GILBERT STUART

1755–1828

Oil on canvas

130.9 x 101.9 cm.

(51$\frac{1}{2}$ x 40$\frac{1}{8}$ in.)

1794

National Gallery of Art;

lent by Peter Jay

Not in exhibition

In late 1782, with the treaty officially ending the American Revolution now in its final stages, John Adams, one of the four Americans charged with negotiating that momentous agreement, noted that the French had taken to calling him "Le Washington de la Negotiation." More properly, Adams admitted, that title belonged to his fellow American peace commissioner, John Jay. In recalling later how Jay's adroit defense of American interests at the Paris peace table had contributed so heavily to a favorable treaty, Adams reiterated the compliment, observing that "a man and his office were never better united than Mr. Jay and the commission for peace."

But Jay's service to his country did not end with this diplomatic triumph, and in the years following 1782, few worked more assiduously toward forging the newborn United States into a viable political entity. Under the Articles of Confederation, he had served as secretary of foreign affairs, and upon discovering that the weak central authority established under the Articles placed America in a perilously vulnerable position in relation to other powers, he had argued strenuously for a new and considerably stronger federal government. When the Constitutional Convention of 1787 produced a document promising to create such a structure, he had joined with Alexander Hamilton and James Madison in coauthoring the famous *Federalist Papers* urging the Constitution's ratification.

If Jay's public career had ended there, his admission to the ranks of the Founding Fathers would have been unassailably secure. But destiny had fated him for yet one more distinction qualifying him for that hallowed circle. On September 24, 1789, within hours of congressional passage of a law establishing the federal judiciary, President George Washington was writing to his old friend Jay asking him to accept the position as first Chief Justice of the United States Supreme Court. "In nominating you for the important station which you now fill," Washington told Jay, "I not only acted in conformity to my best judgment, but I trust I did a grateful thing to the good citizens of the United States."

Generally, students of our legal past have not placed such great store in Jay's chief justiceship, and in a polling of recent years, experts ranked his performance on the Supreme Court as no better than average. To a large extent, this mediocre rating rests on the fact that when Jay took his seat on the Court at its maiden session on February 1,

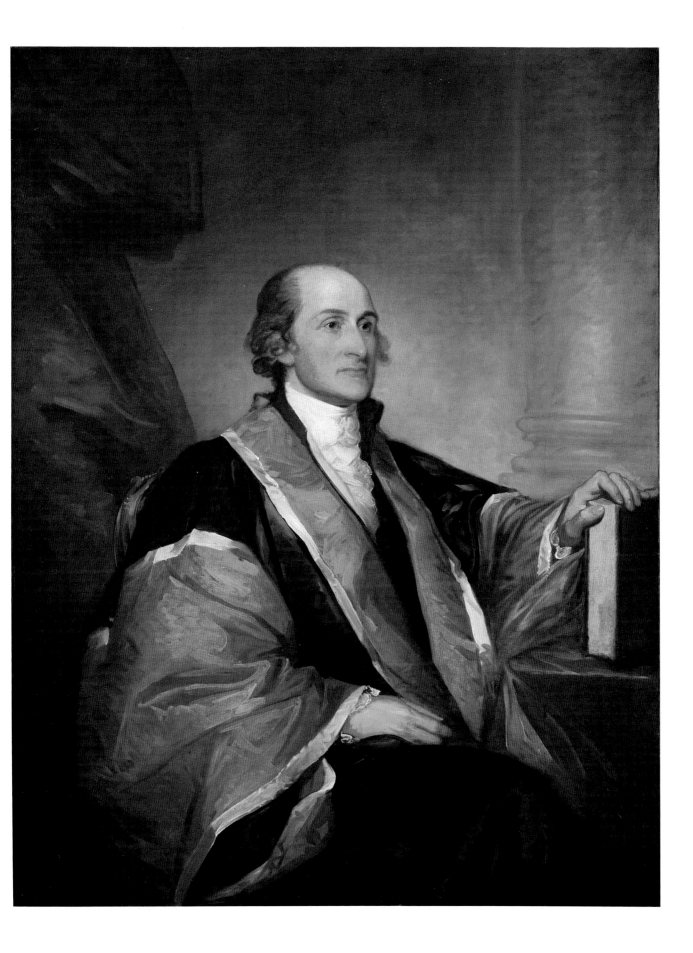

1790, its docket of cases was empty, and until its sixth session in 1792 its business remained virtually nil. Nevertheless, just as Jay left a strong imprint on the Treaty of Paris, so also did he shape the character and scope of the nation's newly formed federal judiciary. Thus, although history would give later justices the lion's share of the credit for molding the Supreme Court and the lesser federal tribunals into a dynamic element of the nation's constitutional system of checks and balances, the Supreme Court under Jay's guidance paved the way for that development. Among the small body of decisions reached by Jay and his fellow justices—both on the Court itself and in the circuit courts where they were also required to preside—lay precedents for asserting the federal judiciary's power to review the constitutional validity of both state and federal laws. Also found in these early rulings were interpretations of international law that would become the legal foundation for safeguarding American sovereignty against foreign encroachment.

Equally important, when Washington applied to the Jay Court in 1793 to assist in determining policies related to the current Anglo-French hostilities in Europe, Jay quickly replied that neither he nor any other member of his Court could advise the administration in this or any other matter. In doing so, he established firmly a principle—adhered to ever since—that the judicial branch must not involve itself in the actions of either the legislative or executive branches, lest it be called upon to judge those actions.

In short, although the brevity of the Constitution's Article III outlining the Supreme Court's functions led many in the 1790s to think that it would play a minor and probably subservient role in the new federal government, Jay brought to his chief justiceship a clear sense that the Court should be neither secondary nor subservient. Instead, if it was to promote the hope for a strong and enlightened federal republic, it must assiduously maintain a disinterested independence while vigorously asserting its right, when necessary, to place checks on the actions and policies of our other branches of government. In significant measure, that twofold objective was achieved during Jay's tenure.

In the spring of 1794, Washington dispatched Jay to London, charging him with resolving a host of commercial and territorial issues that were currently sources of growing animosity between the United States and England. Although he would remain Chief Justice until his official resignation following his return in 1795, Jay never presided over the Court again. Nevertheless, even as he crossed the Atlantic, one aspect of Jay's legacy to Supreme Court history—albeit a minor one—was still in process. For in the months prior to his departure, the nation's first Chief Justice had taken steps to leave posterity with a visual record of his tenure on the Court and, dressed in his judicial robe, had begun to pose for his portrait by Gilbert Stuart.

Soon to win fame as the artist who painted the definitive likeness of Washington, Stuart was notoriously slow in finishing his commissions, and when Jay sailed for England, the portrait was far from done. In August 1794, Jay's wife Sarah was complaining to her husband in London that despite frequent proddings from her, the dilatory Stuart

As this first page of the first volume of Supreme Court minutes indicates, the Court's first session, on February 1, 1790, adjourned quickly because only three of its six justices were present. National Archives

had still not delivered it. Finally, however, after several sessions where one of Jay's nephews posed for Stuart dressed in his uncle's court robe, the portrait moved toward completion. On November 15, 1794, Mrs. Jay could report to her husband that "Just as I had laid aside my pen to take tea, Mr. Stuart arrived with your picture." The final painting had been worth the wait, and several weeks later she was telling Jay that the portrait now hung in the family dining room, adding that "you cannot imagine how much I am gratified in having it."

For a long time, it was commonly believed that in its early years the Supreme Court had no official garb for its justices and that when sitting on the Court Jay had consequently called into service an academic robe that he received when the University of Dublin allegedly presented him with an honorary doctorate in the mid-1780s. For that reason, many have assumed that the flowing outer garment with salmon and white silk facings worn by Jay in Stuart's portrait was his Dublin robe.

There is, however, no record of Jay's ever receiving a Dublin degree. But there are firsthand newspaper accounts indicating that by early 1792 the Court had, in fact, adopted an official robe, scarlet in color and trimmed with ermine in a manner unmistakably patterned on English judicial garb. The new attire pleased some, but others found it pretentious and smacking of an unseemly imitation of a nation that, as one observer put it, "we are lately so fond of disdaining." Apparently this second view ultimately prevailed. Shortly after donning their ermine-trimmed finery, the Court's justices discarded it in favor of "party-colored" robes of black, salmon, and white, and it is this second version of the dress prescribed for all the justices during the Supreme Court's early years that Jay wears in his portrait.

WILLIAM PINKNEY

1764–1822

CHARLES BIRD KING

1785–1862

Oil on canvas

113 x 87.6 cm. (44¹/₂ x 34¹/₂ in.)

Circa 1815

The Maryland Historical Society;

gift of Mrs. Laurence R. Carton

Even William Pinkney's admirers conceded that he was humorless, and they all readily agreed that the splendor of his scrupulously tailored suits—not to mention the corset and facial makeup he used for shielding nature's imperfections—expressed a personal vanity run indecorously rampant. They also knew that if insulting arrogance were ever to replace good works as the means for achieving grace, that blessed state would be Pinkney's for the asking. Yet for all these unpleasing traits, this dandified Marylander was the most universally venerated and highly paid courtroom lawyer of the early American republic, and although his many diplomatic missions through six presidential administrations sharply curtailed the opportunities for practicing his chosen profession, his erudition and eloquence before the bar—once witnessed—were never to be forgotten.

As a result, while few records of Pinkney's case arguments were ever made, the praises heaped upon him by other jurists of his day survive in abundance. In recalling Pinkney many years after his death, Chief Justice Roger Taney remarked: "I have heard almost all the great advocates of the United States, both of the past and present generation, but I have seen none equal to him." Writing in 1812, Supreme Court Justice Joseph Story, who as a law professor at Harvard would later lecture his students on Pinkney's singular genius, declared the Maryland jurist "a man of consummate talents," and two years later he observed that every time he heard Pinkney in court, "he rises higher and higher in my estimation." Even some of those who felt the sting of Pinkney's haughty insults could not deny his skills. Thus his fellow lawyer William Wirt, who once complained that Pinkney cared "as little for his colleagues or adversaries as if they were men of wood," was forced to admit that he was, nevertheless, "the most thoroughly equipped lawyer I have ever met" and that there was never any "disparagement in being foiled by him."

But the most interesting accolade came from Chief Justice John Marshall in rendering the Supreme Court's opinion on the *Nereide* case of 1815, involving the American confiscation of a neutral cargo found on a captured enemy British ship during the War of 1812. Enlisted on this occasion to defend the right of confiscation, Pinkney was at his metaphorical best, declaring at one point that: *The prosopopoeia, to which I invite you is scarcely, indeed, within the power of Fancy . . . when she is . . . most disposed to force incompatibilities*

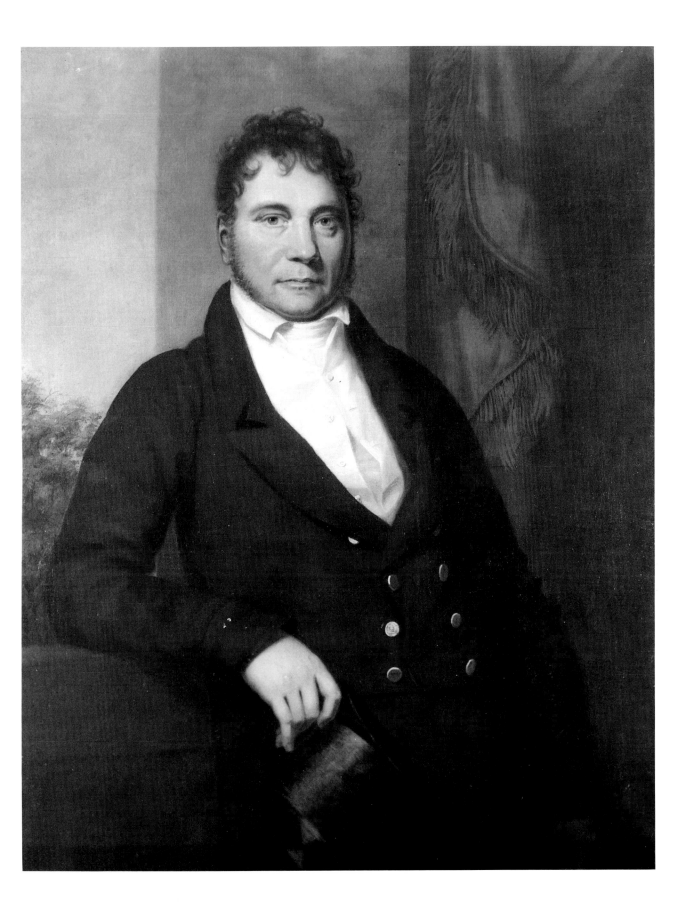

into fleeting and shadowy combination, but if you can accomplish it, it would give you something like the kid and the lion, the lamb and the tiger, portentously incorporated with ferocity and meekness co-existent in the result, and equal as motives of action. It would give you a modern Amazon, more strangely constituted than those with whom ancient fable peopled the borders of Thermidon. Today such imagery would be quickly dismissed as pretentious and overwrought. But in early nineteenth-century America, it was received with awe, and despite the Court's ultimate rejection of Pinkney's view in this instance, Marshall could not forebear in the final decision from paying homage to his extraordinary powers of persuasion. "So exquisite was the skill of the artist," he noted of Pinkney's argument, "so dazzling the garb in which the figure was presented" that the Court had had all it could do "to discover its only imperfection,—its want of resemblance."

Pinkney's several biographers have attributed much of his success to his voracious and lifelong quest for knowledge both of the law itself and of the world in general. When interchanges with others found him wanting in a particular branch of knowledge, they tell us, for example, that he would apply himself to that subject until he was master of it. But the theatrical posturing seen in his portrait by Charles Bird King, painted in about 1816 shortly before the subject left America on missions to Naples and Russia, underscores yet another source of his eminence. For Pinkney was as much an actor as he was a lawyer, and the impact of his courtroom performances rested not only on erudition and a gift for metaphor; it depended as well on an extraordinary ability to make his arguments seem casual and extemporaneous. In reality they were generally neither and were instead the result of long hours of arduous preparation and repeated rehearsal in the privacy of his study. But when he rose in perfect self-confidence to address a court, he created the illusion that his words were mere afterthoughts of the moment. The effect, of course, was overwhelming, and few of his listeners could resist the thought that Pinkney's genius was singular indeed.

Joseph Story once told his Harvard students that Pinkney "never . . . lost sight of the fact that he . . . was speaking for fame." He might have added that at the root of this concern for celebrity was Pinkney's determination that no one should ever eclipse him at the bar. In truth, however, Pinkney was *sui generis*. As Story put it, several years after Pinkney's death, "his place has not yet been occupied, and I think never can be, at least in my day."

THOMAS ADDIS EMMET
1764–1827

In 1815, while appearing before the Supreme Court in a case involving the legality of a ship confiscation during the War of 1812, William Pinkney added substantially to his reputation for insulting his colleagues of the legal profession. On this occasion his opponent was the New York lawyer Thomas Addis Emmet, and after the quietly dignified Emmet had concluded his argument, Pinkney proceeded to suggest to the Court in his most imperious manner that Emmet was an incompetent ignoramus hardly worthy of his own learned attention and that he would soon decimate Emmet on every point. The unseemly incident was remembered for years by many who witnessed it, and few who have written about Pinkney or Emmet have failed to recall it.

Considering Emmet's background and credentials, the story is laden with more than a little irony. For although Pinkney ultimately won this case, his barbs reflected worse on him than on his intended victim. If nothing else, Emmet was a man of deep erudition and superior capabilities. Born in Ireland into a family of considerable note, he originally intended to devote his life to medicine, and after receiving his doctorate in 1784 from the University of Edinburgh, where he distinguished himself as a member and officer of more than a half-dozen learned societies, he had set up practice in Dublin. By his mid-twenties, he was the *ex officio* physician to the royal family, and it was clear that a brilliant career in medicine lay ahead of him. In 1789, however, on the death of his brother Christopher, who had shown equal promise in the legal profession, Emmet's grief-stricken father urged him as a kind of tribute to his sibling to become a lawyer. Emmet honored this parental wish. By the early 1790s, having prepared for his new endeavor at the Temple in London, he was making his way as a member of the Irish bar.

The precipitous career change did not diminish Emmet's fortunes for long, and his gift for oratory and unusual intellectual breadth quickly earned him prominence within the legal profession. Meanwhile, his ardent sympathy for the cause of Irish autonomy in the centuries-old dispute between Ireland and her English rulers was also drawing him ever more deeply into the escalating Anglo-Irish tensions of the 1790s. Here his talents for the bar served him especially well. Before long he was known as one of the most adroit defenders of Irish

Thomas Addis Emmet

Attributed to GILBERT STUART

1755–1828

Oil on canvas

57.1 x 45.7 cm.

(22¹/₂ x 18 in.)

Circa 1785

Grenville T. Emmet, Jr.

political dissidents whose protests against Catholic disenfranchisement and other British wrongs were increasingly bringing them into court on charges of sedition against the Crown. Among Emmet's most superb moments as a chief counselor for the protesters came in 1795, when he defended one of them against charges of treason for administering an oath of loyalty on behalf of the nationalistically oriented Society of United Irishmen. His client was found guilty, but upon delivery of the verdict, Emmet called for an arrest of judgment and thereupon launched into an eloquent oration, which he ended by swearing in open court his own allegiance to the United Irishmen. This bold move made his point as nothing else could: the act of administering or taking the oath of a reformist organization could hardly be interpreted as treason, and his client got off with a light fine.

With that, Emmet became the idol of the Irish nationalist movement, and he was soon a member of the United Irishmen's directory, where his effectiveness was such that at one point the British tried to bribe him out of the organization by offering him the solicitor generalship of Ireland. His distinctions in this group, however, had unhappy personal consequences. Early in 1798, in their haste to squash all Irish dissent, the British placed Emmet—now known as "the mind" of the United Irishmen—under arrest without bringing charges. In 1804, two years after his release from prison on the understanding that he should never return to Ireland again, he was on his way with his wife and family to New York City in the hope of establishing a new life for himself.

But Emmet's travails were not entirely over. Although he found a warm welcome in the city's more liberal quarters, New York's conservative Federalists thought that his recent eminence in Irish protest labeled him a dangerous subversive and an unfit candidate for the practice of law in America. For awhile it seemed as if that view might prevent him from pursuing his profession in this country. In the end, however, he finally won admission to the bar, and he was soon on his way to becoming, in the words of Joseph Story, "the favorite counsellor of New York."

By all accounts, Emmet's gifts of persuasion and breadth of knowledge were every bit a match for Pinkney's. But there the similarity ended. For Emmet lacked Pinkney's flamboyant theatricality and tendency to gild his thoughts with erudite allusions. At the same time, as he himself once put it in Pinkney's presence, by the time he was settled into his New York practice he was no longer inclined "to attempt the dangerous paths of fame." Nevertheless, thanks to the vigor of his courtroom logic, fame came to him anyway. When he suddenly suffered an ultimately fatal stroke while defending a cause in the United States circuit court in 1827, his demise was likened to the collapse in Britain's Parliament of the great Earl of Chatham in 1778, not only because of the similarity in circumstances but because, like Chatham's, Emmet's brilliance had grown into something of a legend.

When Emmet sat for his earliest known likeness (thought by some to be the work of Gilbert Stuart), his features still had the freshness of youth. By his fiftieth year, however, the time spent in an English

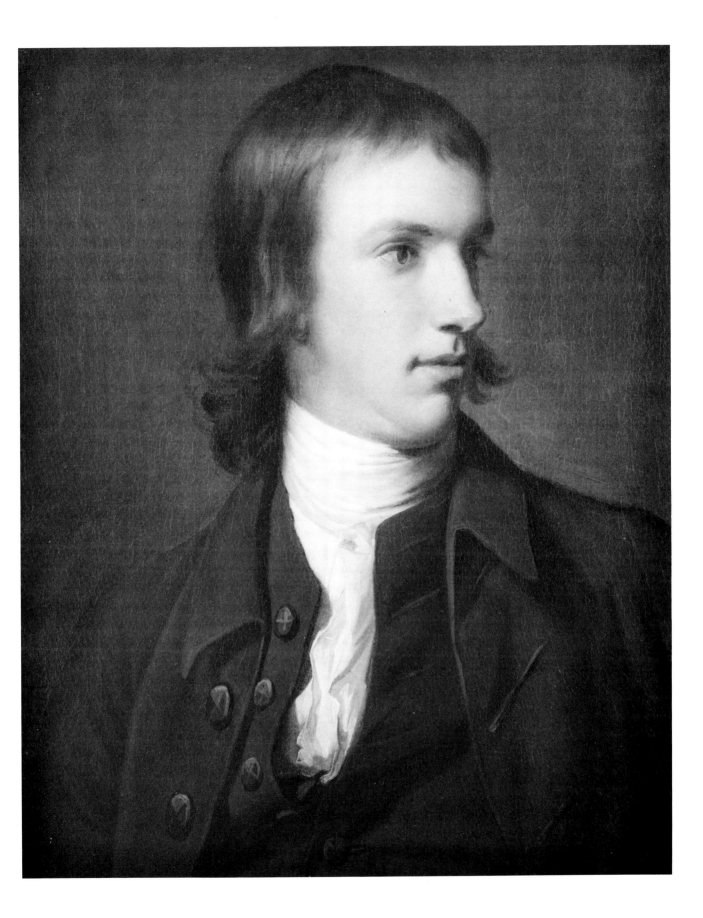

Thomas Addis Emmet as he
appeared in his later years.
Mezzotint by John Rubens Smith
(1775–1849) after Samuel F.B.
Morse, 29.7 x 25.2 cm. (11 $^3/_4$ x 9 $^{15}/_{16}$
in.). National Portrait Gallery,
Smithsonian Institution

prison, the grief of forced exile, and the anxiety of establishing himself anew in a strange land had taken a sharp toll on Emmet, and several of his admirers observed that he seemed perpetually mournful and old beyond his years. "There is," noted George Ticknor in 1815, "an appearance of pre-mature age in his person and of a settled melancholy in his countenance, which may be an index to all that we know of himself and his family." Yet somehow Emmet wore his sad gravity well, and even before he began to speak, said Ticknor, he won his listeners' interest.

WILLIAM WIRT
1772–1834

In the first paragraph of his memoir on the life of William Wirt, John Pendleton Kennedy remarked on the startling resemblance his subject had borne to Johann Goethe, and a comparison of Wirt's portraits with likenesses of that noted German poet, novelist, and playwright indeed gives substance to this observation. But the affinity between Goethe and this Virginia lawyer did not end there. Although Wirt's distinction rested on his career in the law, it was in literature that he wished to leave his mark, and through much of his working life, as he moved from one legal distinction to another, he longed for the day when his accumulation of wealth would free him to, as he once phrased it, "raise by my pen a monument to my name."

Unfortunately that hoped-for time never came. Although Wirt managed to produce a number of modestly notable literary works—including a biography of Patrick Henry—he was forced to end his days practicing a profession that he regarded mainly as an expedient to a more noble end. Still, even Wirt himself would not have considered his life a tragedy. Nor, in all frankness, would he have said that his life in the law had been without significance.

Equipped with a library that consisted of an edition of Blackstone's *Commentaries*, two volumes of *Don Quixote*, and another of *Tristram Shandy*, Wirt began the practice of law in Culpeper, Virginia, in the early 1790s. At the outset, however, it seemed to many of his friends that his gregarious nature and uncommon fondness for late-night revelry boded poorly for success in the law.

But as time passed, so too did the taste for bacchanalian pleasure. Following his second marriage in 1802, this man, who in youth had regarded Henry Fielding's picaresque *Tom Jones* as his spiritual "bread and butter," settled into his profession in sober earnest. Within a few years he was widely regarded as one of the most capable lawyers in Virginia, and largely because of his growing reputation he became in 1807 the lawyer entrusted with conducting the prosecution of Aaron Burr on charges of conspiracy to inspire insurrection in this country's western territories. In this celebrated proceeding, presided over in Richmond by Chief Justice John Marshall, Wirt lost his case in the end. Even so, it had afforded him an opportunity to exhibit his talents in a forum that drew the whole country's attention, and exhibit them he did. For years his masterfully vivid portrayal of Burr as the serpent

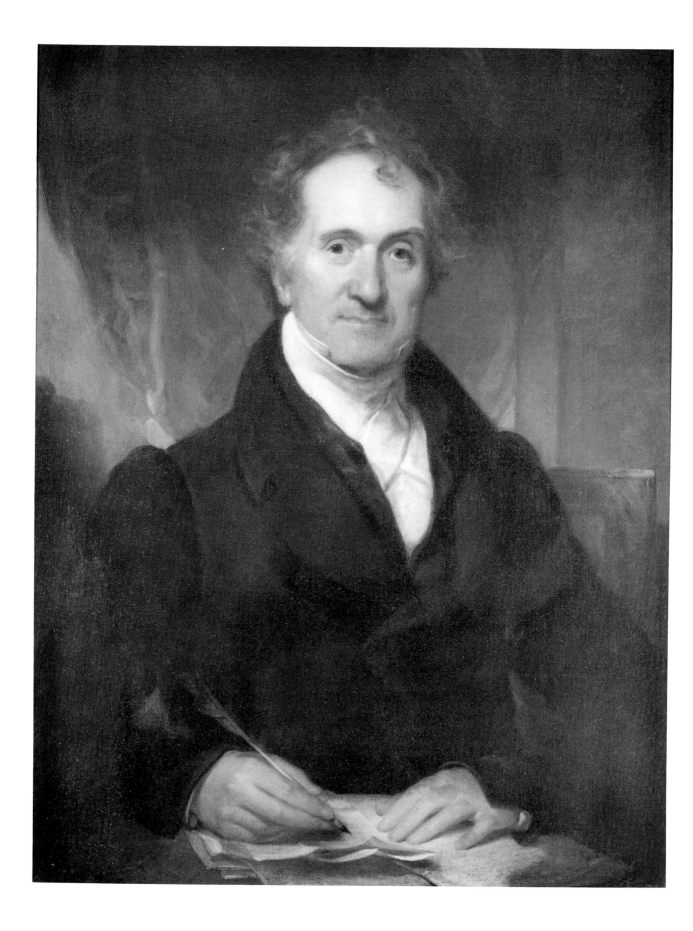

in America's Garden of Eden was held up as a model of courtroom oratory worthy of Cicero, and while Burr eventually went free, Wirt emerged from the trial a figure of national prominence.

Despite this newfound fame, Wirt still yearned periodically for the literary life, but his growing brood of children prevented him more than ever from trading a thriving practice for the financial uncertainties of writing. Continuing disappointment in this cherished ambition might have broken a lesser man. But as long as economic necessity was going to keep Wirt at the bar, he was determined to make the most of it, and considering the often spellbinding quality of his courtroom oratory, it was obvious that he took substantial pride in his work. It was also apparent that he relished ever greater tests of his professional mettle. When, for example, he found in 1816 that he would be arguing his first case before the Supreme Court against the incomparable William Pinkney, he declared to a friend (slightly misquoting Shakespeare's *Henry IV*) that "'The blood more stirs to rouse the lion than to hunt the hare.'"

Despite this bravado, Wirt did not acquit himself particularly well on that occasion. But by then his reputation was such that one mediocre performance could not tarnish it. Shortly thereafter, President James Monroe appointed him attorney general—a post he would hold for the next twelve years.

During his tenure in this office, Wirt reached the height of his distinction, and under his aegis the attorney generalship—hitherto considered only a minor position that could be administered on a part-time basis—began to assume its modern-day stature as the executive department's primary adviser in legal matters. At the same time, this was still the age when it was permissible for an attorney general to pursue his own practice, and although Wirt was often preoccupied with the expanding responsibilities of his office, he nevertheless found time to participate in many of the great precedent-setting Supreme Court cases of the day. In 1819 he served as a counsel in the Dartmouth College case, where Chief Justice John Marshall issued his famous opinion safeguarding the private contracts against state encroachment. That same year, Wirt found himself arguing (in tandem with William Pinkney) in *McCulloch v. Maryland* for the constitutional legitimacy of a national bank and against the right of states to tax it. In 1824 he was a counsel in the case of *Gibbons v. Ogden*, where the issue was the extent of the federal government's power over American commerce.

Once described as "all that anybody could be that was delightful," the affable and well-spoken Wirt probably would have succeeded more than passingly well had he ever chosen to focus his energy on elective office, and there were those—including Thomas Jefferson—who had strongly urged him to do so. But aside from one term in Virginia's House of Delegates, Wirt always eschewed that route to distinction.

In 1832, however, he reluctantly became the presidential nominee of the newly formed Anti-Masonic party and in so doing claimed the honor of being this country's first minority-party candidate for the White House. Ultimately, Wirt tried to withdraw his name from the

William Wirt

HENRY INMAN

1801–1846

Oil on canvas

92.2 x 71.2 cm.

(36¹/₄ x 28 in.)

Circa 1833

The Boston Athenaeum;

gift of John Davis Williams,

1838

contest but failed. Nevertheless, his candidacy seemed doomed practically from the start, and when the certainty of defeat became apparent, he noted that "a culprit pardoned at the gallows could not be more light-hearted."

At about the time Wirt was attempting to extricate himself from presidential candidacy, he was also sitting for his likeness by Henry Inman, a young New York portraitist who in recent years had come to enjoy considerable popularity. Wirt was in his early sixties, and had his life gone as he had so often hoped, the iconographical meaning of the papers situated on the table in this picture would have reminded viewers that they were looking upon one of early America's distinguished literati. But that, of course, could not be. Instead Inman showed his subject penning a statement that recalled Wirt's prosecution of Aaron Burr back in 1807 and that read in part: "I consider [Burr's actions] . . . as treason against Society and a wicked conspiracy against the laws of God and man." The urbane complacency of Wirt's expression as he gazes up from this document hints that he has finally reconciled himself to his lot as a lawyer, and probably that was the case. A few years later this would-be man of letters lay on his deathbed. In the delirium of his final moments, it was not of unfulfilled literary ambitions that he spoke; rather it was of the law and of cases that he had once argued before the Supreme Court.

HENRY WHEATON

1785–1848

WHEATON'S INTERNATIONAL LAW

TRANSLATED INTO CHINESE

BY

W. A. P. MARTIN, D. D.

OF THE

AMERICAN PRESBYTERIAN MISSION;

ASSISTED BY A COMMISSION

APPOINTED BY

PRINCE KUNG.

PUBLISHED AT PEKING
AT THE EXPENSE
OF THE IMPERIAL GOVERNMENT.
1864.

A standard text in the legal profession for many years, Wheaton's *Elements of International Law* went through many editions and, as this 1864 Chinese version indicates, was eventually translated into many languages. Harvard Law School Library

"I doubt," a longtime friend once speculated of Henry Wheaton, "if at any period in his life he could accurately state the difference between a Plea in Abatement and a Special Demurrer." And, indeed, despite a life devoted to the law, it is altogether likely that Wheaton was never very conversant with such terms, which most of his fellow lawyers used daily as a matter of course. As this same acquaintance observed, Wheaton's intellectual keel ran "too deep" for the "narrow rivers and shallow creeks" of his profession's more routine details. Instead, he seemed to gravitate by instinct to the "great ocean" of broad inquiry and thought.

Thus, after graduating from Rhode Island College at sixteen and winning admission to the bar at nineteen, Wheaton set sail in the spring of 1805 for Europe, where for a year he sought to enlarge his knowledge through the study of English and French law. From this point on, Wheaton's course was set. On his return to America the following year, he settled in Providence, Rhode Island, announcing to his fellow townsmen that "H. Wheaton . . . has commenced the practice of his profession as an Attorney and Counsellor at Law. Office over Messrs. Watson & Gladdings Store." But although he maintained this practice for several years and would later argue some cases before the Supreme Court, Wheaton was never deeply interested in day-to-day legal business. By 1816, when he became the official reporter for the United States Supreme Court, his inquiring mind had come to focus its energies for the most part on expounding upon the law's historical evolution, its underlying principles, and the relation of those principles to contemporary jurisprudence.

Such an emphasis would be deemed useful in any period, but in this age when America was just beginning to build its own legal tradition, it proved especially valuable. As the Supreme Court's reporter until 1827, Wheaton provided the nation's lawyers not merely with an annual chronicle of the decisions reached by that body; more importantly, he included in his Reports extensive commentaries of his own that were intended to illuminate the premises and precedents from both American and European law on which the decisions had been based. The result was a set of volumes that one German reviewer described collectively as "the golden book of American law," and that drew admiring plaudits from such legal luminaries as Joseph Story and Daniel Webster.

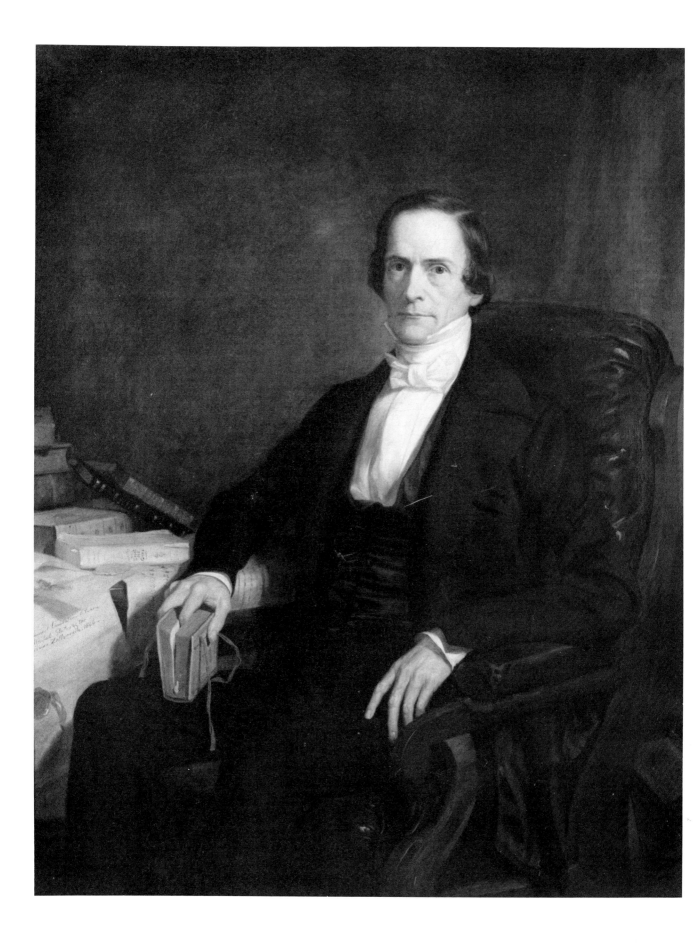

Henry Wheaton

GEORGE P. HEALY

1813–1894

Oil on canvas

125.7 x 100.3 cm.

(49$\frac{1}{4}$ x 39$\frac{1}{2}$ in.)

Circa 1847

The Rhode Island

Historical Society

In 1823 Wheaton's skill as a reporter for the Supreme Court made him a candidate for the vacancy left in that body by the death of Justice Brockholst Livingston. But the appointment never materialized. Instead, in 1827 John Quincy Adams designated him as an emissary to Denmark, where he was entrusted with the task of negotiating a treaty regarding reparations for Danish infringements on American commercial shipping. Wheaton spent seven years on this mission and in the end succeeded in arriving at a settlement substantially more favorable to American interests than had been originally expected. In 1836, his success in this matter won him appointment as *chargé d'affaires* at Berlin, where he was charged with negotiating commercial agreements with the member states of the German Customs Union, known as the Zollverein.

Diplomatic duties, however, could not prevent Wheaton from indulging his passion for studying and discoursing on the law. Rather, he made his European sojourns the occasion for giving that twofold endeavor a new direction, and in 1836 he published his *Elements of International Law*. An examination of the customs and rules that guided the relationships of western nations in both peace and war, *Elements* reflected many years of unremitting study and on its publication elicited high praise on both sides of the Atlantic. In 1855 it became prescribed reading for would-be members in Britain's foreign service, and as late as 1916, a legal journal declared that *Elements* continued to rank "too high for criticism."

Wheaton, however, was apparently never tempted to rest on his laurels. In 1841, while still fulfilling responsibilities at Berlin, he published the first edition of his *History of the Law of Nations in Europe and America*, which, like *Elements* before it, quickly won recognition as one of the most authoritative texts of its kind ever written.

Wheaton was relieved of his diplomatic responsibilities in 1847, and in May of that year he arrived in America after some two decades of living mostly abroad. Given his many years of service in Europe and the international distinction of his legal writings, his homecoming inevitably was marked by some commemorative events. Not least of the honors accorded him was the commissioning of a portrait by the citizens of Providence who, wanting only the best for their city's famous native son, hired for this work George P. A. Healy, then enjoying great prestige largely as a result of the royal patronage he had recently found in France. At about the time this likeness was begun, New Yorkers undertook to honor Wheaton with a banquet, presided over by Thomas Jefferson's now ancient secretary of the treasury, Albert Gallatin. When the decrepit Gallatin—himself a much renowned expert in international law—ushered Wheaton to the table, he paid his honored guest a compliment that in its way may well have represented the ultimate accolade. If the focus of the evening's festivities had been anyone else, Gallatin confided, he would never have consented to officiating.

JOHN MARSHALL
1755–1835

CHESTER HARDING

1792–1866

Oil on canvas

242.1 x 150.2 cm.

(95$^5/_{16}$ x 59$^1/_4$ in.)

1830

Harvard Law Art Collection

By late 1779, the young ladies of Yorktown, Virginia, had heard a great deal about a strapping captain in Washington's Revolutionary army named John Marshall. A veteran of the battles of Brandywine, Monmouth, and Germantown and of the dreadful winter encampment at Valley Forge, this Fauquier County youth was the idol of his family, then residing in Yorktown, and his siblings' many admiring references to him in their conversations with neighbors had conjured up visions among the local belles of a dashing, smartly uniformed gallant. As a result, when news came that the captain was soon to arrive in the town, there was much discussion among the community's unattached females regarding who would receive the first introduction to this most splendid of catches at an upcoming ball. Once their eyes lighted on the rustic-mannered, ungainly, and carelessly dressed Marshall, however, his legion of would-be admirers quickly retreated in disappointment, leaving the field to a fourteen-year-old named Polly Ambler, who would eventually become his wife.

So it was for the remainder of Marshall's life. While so many of his acquaintances venerated him unreservedly, Marshall's simple manners and total indifference to fashion's dictates often left first-time observers with the suspicion that all the wonderful things said about this man were untrue. Several years later, for example, when a stranger, newly arrived in Richmond, Virginia, made inquiry into who the best local lawyer would be to represent him in a case before the court of appeals, he was told that he would be wise to hire Marshall. But once the gentleman had a look at this lank and untidy individual, he was soon searching for another counsel, declaring that he was not about to entrust his fortunes to a rustic simpleton.

If Marshall's exterior was singularly unprepossessing, his abilities as a jurist were decidedly not, and although his formal legal training consisted of no more than a few months of study under George Wythe at the College of William and Mary in 1780, it was clear practically from the outset that his future was bright. Yet when John Adams offered Marshall the chief justiceship of the Supreme Court in January of 1801, it was doubtful that even the most prescient realized fully the fortunate implications of this appointment. For more than three decades Marshall would dominate this body by force of both his intellect and his ingratiating personality, and within those years the Court

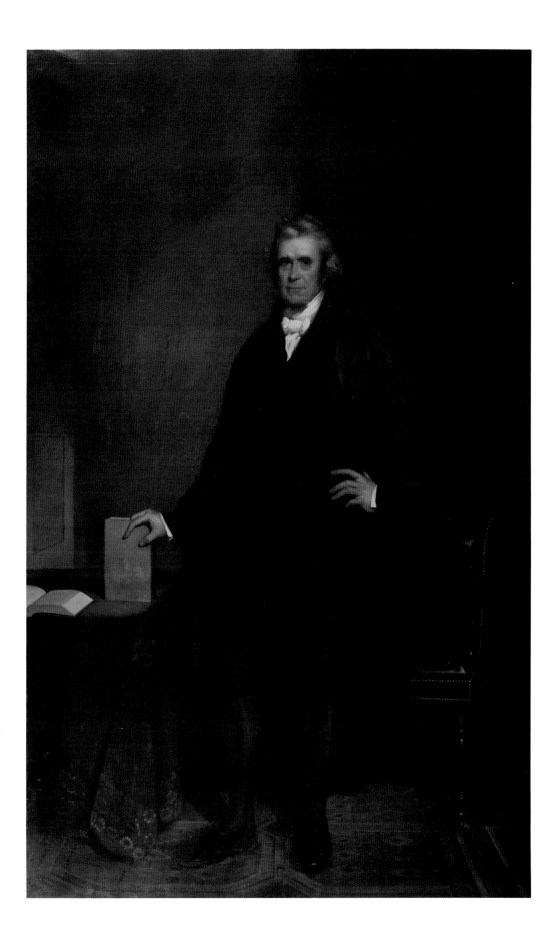

would hand down decisions that were destined to have a double significance. Not only would they serve as crucial precedents in the nation's other courts of law; they would also become some of the psychological underpinnings of America's growing sense of nationhood under the Constitution. Thus, in a succession of cases that began with *Marbury v. Madison* and included *Dartmouth College v. Woodward, McCulloch v. Maryland, Cohens v. Virginia*, and *Gibbons v. Ogden*, the Marshall Court addressed such salient questions—not fully answered in the Constitution—as the Supreme Court's relationship to

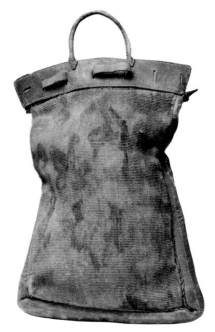

In addition to hearing cases in the Supreme Court, members of that tribunal were required for many years to preside over sessions of the federal circuit courts as well. Pictured here is a saddlebag used by Marshall when riding the circuit assigned to him. The Association for the Preservation of Virginia Antiquities

John Marshall's lap desk. The Association for the Preservation of Virginia Antiquities

the federal government's other two branches; the extent of the federal government's powers over the states; and the right of government to alter or abridge private contracts and charters.

In doing so, Marshall and his fellow justices could have arrived at decisions in these cases that might well have directed this country's political evolution down paths quite different from the one it took. But owing largely to Marshall's own lifelong commitment, on the one hand, to a dynamic federal authority and, on the other, to the protection of private economic interests, his Court opted for a course that firmly asserted the ascendance of the national government and the fostering of private enterprise as a chief mainspring of our prosperity.

Put another way, when Marshall began his tenure as Chief Justice, the final nature of America's governmental makeup was yet largely an ambiguous vision; when he died (still in office) just short of his eightieth birthday in 1835, much of the ambiguity had been eliminated.

Most likely the magnitude of Marshall's achievement was not fully realized in his day, and one historian has suggested that in the eyes of his contemporaries at large he could never claim a stature equal to the Presidents through whose administrations he served. Nevertheless, within the legal profession itself, there was no one more highly honored or loved. "Politics aside," wrote William Wirt in 1827, "there is not a better natured man in the world than the old Chief—and a more powerful mind was scarcely ever sent upon the earth. He ranks in my estimation with Mansfield and Thurlow and Hardwicke, the standards of judicial excellence—the classics of the bench."

But lawyers were not the only ones to think unusually well of Marshall's good nature and intellect. "I have had the gratification," the Boston portraitist Chester Harding reported from Washington in the spring of 1828, *of seeing a good deal of the great of the age, particularly Judge Marshall. I am convinced that I shall feel through life that the opportunity to paint the Chief Justice, and at the same time hear him converse, would be ample compensation for my trouble in accomplishing these objects.* As it turned out, Harding enjoyed that pleasure three times from 1828 through 1830. On the last occasion he produced his most ambitious likeness—a full-length image showing Marshall dressed in his court robe, with one hand casually resting on his hip and the other holding a volume of legal writings. Commissioned by the Boston Athenaeum, whose conservative nationalist membership held Marshall as an idol, the picture later became the basis for the replica reproduced here, which Harding sold in the late 1840s to the Harvard Law School and which was acquired through a subscription raised among faculty and students. Like the original, this second version has an aspect about it that is evocative of what Thomas Jefferson once described as the "lax lounging manner" that so often characterized Marshall in his social intercourse. The picture also bears testimony to Marshall's lifelong inattention to fashion, for in it he wears the knee breeches that by the time of his sitting with Harding in 1830 had been out of style for many years. At the same time, however, the image imbues Marshall with a rather majestic presence, which seems to echo visually Wirt's words ranking the subject among the "classics of the bench."

JAMES GOULD
1770–1838

SAMUEL LOVETT WALDO

1783–1861

Oil on canvas

73.5 x 61.5 cm.

$(28^5/_{16} \times 24^1/_4 \; in.)$

1803

Yale University Art Gallery;

gift of Edward S. Gould

For the most part, legal education in the early years of our history consisted of a kind of apprenticeship system where this country's would-be lawyers learned their future profession by clerking and "reading the law" for a number of years in the offices of an established lawyer. In 1784, however, a new and more formalized alternative for transmitting the art of law to the younger generation came into existence. In that year, having found for some time now the instruction of his clerks to be one of the more congenial aspects of his legal practice, Tapping Reeve opened in Litchfield, Connecticut, the nation's first school of law. The new enterprise proved a success from the start. By the time the Litchfield Law School closed the doors of its white clapboard one-room dwelling for the last time in 1833, more than one thousand students had passed through its fourteen-month curriculum of daily afternoon lectures and weekly moot court sessions.

But the story of this school's success did not lie simply in numbers; it also lay in quality. In proportion to the size of its alumni, there has perhaps never been a professional school in America that produced more graduates of public distinction than Litchfield. Among its roster of pupils were ultimately the names of six cabinet officers, one Vice-President, more than one hundred members of Congress, fourteen state governors, three justices of the United States Supreme Court, and thirty-four members of the highest courts in their respective states. Thus, in describing for its readers in 1822 the impact that the Litchfield School was having on the nation, the *United States Law Journal* was hardly exaggerating when it dubbed Tapping Reeve's nearly thirty-year-old venture "the fertile source of elemental knowledge and the nursery of eminent men."

Although Reeve was Litchfield's founding spirit, he was not its only mainstay, and in fact much of the credit for the school's growing prestige after 1800 belonged to one of his students, James Gould. A graduate of Yale, Gould had studied under Reeve in the late 1790s. On completing the course at Litchfield, however, he found that, thanks largely to the steady proliferation of graduates from Reeve's school, the state of Connecticut, where he intended to settle into practice, was suffering from a severe oversupply of young struggling lawyers. So, given his own natural bent for teaching, Gould rejected the prospect of throwing himself into Connecticut's currently stiff competition for the leavings of more seasoned lawyers. Instead, in 1798 he accepted

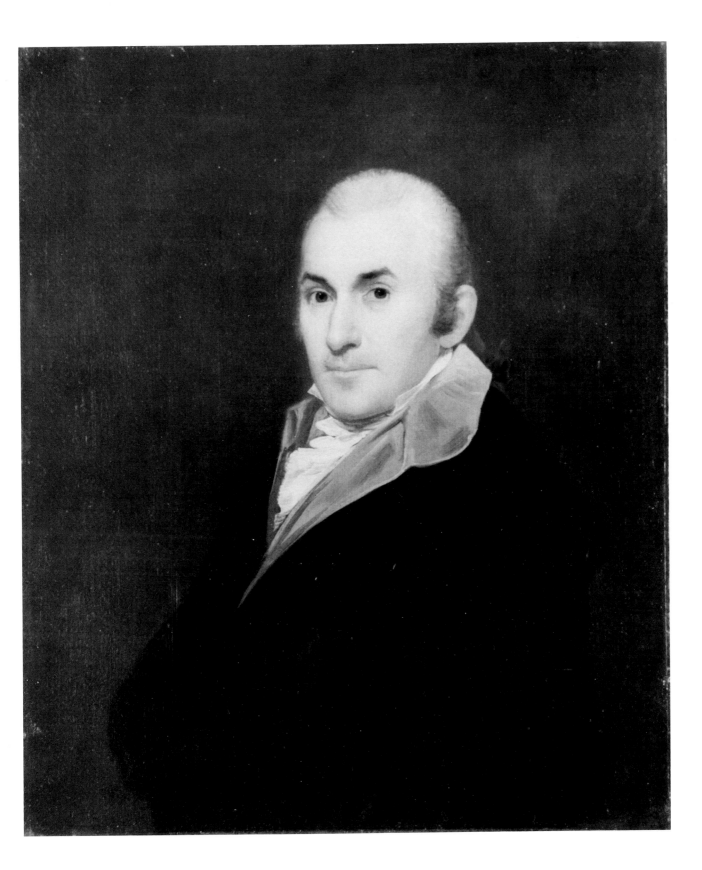

Reeve's invitation to teach at the Litchfield School.

In temperament the two men were quite different. While the sympathetic Reeve inspired affection, the more aloof Gould engendered respect. Where Reeve was spontaneous and off-the-cuff, Gould was meticulously methodical. But the contrasts in personality did not harm the school. To the contrary, it seemed to thrive on them, and it was under Gould's guidance that Litchfield's curriculum assumed the disciplined character that was to usher in the school's heyday as America's most influential dispenser of legal training.

As a teacher, Gould was never particularly imaginative, and his classroom methodology rested mainly on thoroughly prepared lectures, which students in turn were expected to transcribe carefully into their notebooks. But if it was not possible to admire Gould for his imagination, the verbal precision found in his lectures and his insistence on the same from students were a constant source of wonderment. Of his fastidious speech, a pupil noted, "every word was pure English, undefiled, and every sentence fell from his lips perfectly finished, as clear, transparent, and penetrating as light, every rule and principle as exactly defined and limited as the outline of a building

Beginning lawyers in early nineteenth-century America generally did not have ready access to extensive law libraries. Thus, if Caleb Stark, the youth who made these notes on a Gould discourse on pleadings, was a typical product of Litchfield, the chief reference source for guiding him through his first cases were the notes he had taken at Gould's lectures. Harvard Law School Library

The Litchfield Law School as it appears in its restored state today. Courtesy of the Litchfield Historical Society and Museum

against the sky." As for the logic of his thoughts, that, too, was unimpeachable. In Gould's mind, another Litchfield student recalled, "a non sequitur . . . was an offense deserving at the least fine and imprisonment—a repetition of it, transportation for life."

The Litchfield Law School reached its height between the years 1813 and about 1825. In that period student enrollment typically ran between forty-five and fifty-five. But with the growth of the Harvard Law School, which had been founded in 1817, and the establishment of a law school at Yale in 1824, Litchfield began to lose its attraction for students of the law, and by the late 1820s its annual enrollments were declining sharply. At the same time, Gould, who since Reeve's retirement in 1820 had been sole proprietor of the school, was beginning to suffer a decline in health, and in 1833 he, too, retired. So ended America's first full-fledged venture into institutionalized legal education.

As a teacher, Gould had always been a cold and distant individual. In dealings outside of his classroom, however, he could on occasion be surprisingly affable and warm. A case in point was the turn of events that led to the painting of his portrait by the Connecticut artist Samuel Lovett Waldo. In 1803 a young and impecunious Waldo arrived in Litchfield, armed with letters of introduction to two local notables whose favor he hoped would lead to portrait commissions. Unfortunately neither individual proved able to help, and in fact, in his encounter with the second of his hoped-for patrons, the reception to Waldo's overture proved chillingly peremptory. Quite by chance, however, Gould witnessed this unhappy interview, and as the dejected Waldo turned to walk away, Gould followed him. Shortly after providing his new acquaintance with a fine dinner, Gould was leading Waldo to a comfortably furnished bedroom in his own residence, saying, "my house is your home: you may commence painting my wife's portrait as soon as you please, and then my face is at your service."

Tapping Reeve, founder of the Litchfield Law School. Engraving by Peter Maverick (1780–1831) after George Catlin. Courtesy of the Litchfield Historical Society

JEREMIAH MASON
1768–1848

SHOBAL VAIL CLEVENGER

1812–1843

Marble

76.2 cm. (30 in.)

Circa 1841

From an original plaster of 1839

Harvard Law Art Collection

When the Ohio sculptor Shobal Vail Clevenger arrived in Boston in late 1839, his hope was to fashion portraits of some of the city's notables and in the process build his reputation there as an artist worthy of patronage. A community whose art-minded gentry had for some years taken great interest in promoting the fortunes of promising American carvers, the New England metropolis gave Clevenger a warm welcome, and before long he was modeling the likenesses of a number of local luminaries in an improvised studio at the Boston Athenaeum.

Among his subjects was Jeremiah Mason, a prosperous, recently retired lawyer who had spent most of his working life practicing in Portsmouth, New Hampshire, and since the early 1830s had been living in Boston. In Clevenger's finished marble portrait of him, the neoclassical drapery complementing his features made Mason look like a benevolent and wise Roman senator. But the historical simile that seemed to fit Mason better came from yet a more distant past, and for a number of years before his death he was known as the "Anak of the Boston bar."

This sobriquet—alluding to an unusually tall character from the Old Testament—carried a double meaning. Standing six feet six inches in his stocking feet, Mason was indisputably a towering presence of a man, and back in 1795, in the course of a brief interview at Philadelphia, even George Washington—unused to being eclipsed in this department—had betrayed some amazement at Mason's great height. But Mason was a giant in yet another respect. Although he had confined his practice for the most part to his native New England, had handled more than his share of routine business, and had never argued before the United States Supreme Court, his reputation among many of his professional peers was unmatched. In fact, Daniel Webster—himself one of the greatest jurists of early America—once admitted that much of his own distinction was the result of his conscious efforts as a novice at the bar to imitate Mason's courtroom style. As Mason and Webster faced each other over the succeeding years in various courts of law, the latter's respect for Mason only deepened. Toward the end of his life, Webster observed that if asked to name the greatest lawyer of his time, he might be tempted to follow conventional wisdom and say John Marshall. "But if you took me by the throat," he added, "and

In his first days of law practice in rural Vermont, Mason may not have encountered a courtroom setting quite as crude and improvised as the one portrayed here. He did, however, find the state of professional knowledge among his fellow jurists primitive indeed. Of his earliest experiences in arguing cases, he later admitted, "I certainly knew very little law." But that was by no means a liability, since the judges he addressed knew "none at all."

Justice's Court in the Backwoods, oil on canvas by Tomkins Matteson (1813–1884), 80.6 x 111.7 cm. (31³/₄ x 44 in.), 1852. New York State Historical Association

pinned me to the wall and demanded my real opinion, I should be compelled to say it was Jeremiah Mason."

Mason retired from active practice in 1838, and after one and a half centuries, it is difficult to arrive at a clear picture of the courtroom personality that made him the object of so much admiration. Nevertheless, the many anecdotal descriptions of Mason left by his contemporaries afford at least a partial glimpse of this jurist at work. Among other things, it was said that when it came to handling a witness expected to hurt his client's case, Mason invariably proved a master of subtle manipulation. Beginning his questioning with inquiries of a seemingly innocuous nature and ever careful to maintain an unthreatening tone in his voice, Mason soon lulled the witness into unwary complacence. With that accomplished, his probing by imperceptible degrees shifted toward the point he wished to make, and without knowing precisely how it had happened, the witness suddenly found himself ensnared in Mason's seemingly friendly web, volunteering information flatly contradictory to the testimony he had intended to offer.

At the same time, unlike a good many other prominent lawyers of

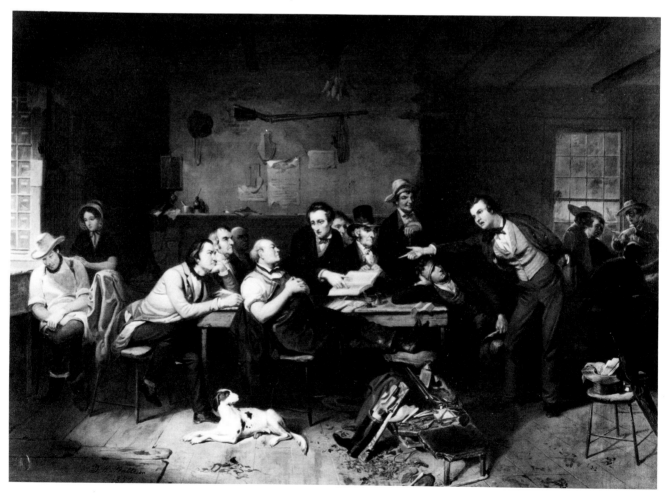

the early nineteenth century, who littered their arguments with literary metaphors and classical allusions, Mason's strength in argument lay in the crisp simplicity of his language and the clarity of his logic, which even the slowest of jury members might follow. On one occasion, when the lawyer opposing him was Rufus Choate—known far and wide for his florid prose—Mason rose, following Choate's richly ornamented summation, and announced to the jury: "I cannot gyrate to ye, Gentlemen, as my brother Choate has done, but I should like to state ye a few pints."

Finally there was Mason's quick sarcastic wit, which often gave him the last word on a subject. Speaking once of a newly appointed judge, Mason predicted that the individual in question would be slow to arrive at his decisions. When asked why, he answered: "He'll have twice as much to do as most other judges. He'll have first to decide what is right, and then to decide whether he'll do it." On another occasion, as Mason stood in court casting doubt on the veracity of an affidavit offered in evidence against his client, the opposing counsel interrupted, saying that he had just heard that the author of this document had died. This gave Mason some pause, but when his opponent confessed that the report might have been untrue, Mason chimed: "Thank God for that! The man who gave that affidavit ought to have time for repentance."

In the course of his long career, which began in 1791 in a small Vermont town and ended nearly fifty years later in Boston, Mason involved himself in a wide variety of cases—from one inquiring into the ownership of two pigs to a celebrated murder trial and the lower court proceedings that culminated in the historic *Dartmouth v. Woodward*. But however mundane or significant the issue, he always seemed amazingly capable, and although extravagant claims of professional virtuosity ought generally to be taken with a grain of salt, it is tempting to believe the statement often made by his acquaintances that no lawyer ever argued more cases and lost fewer than Mason.

DANIEL WEBSTER
1782–1852

FRANCIS ALEXANDER

1800–1880

Oil on canvas

76.2 x 63.5 cm. (30 x 25 in.)

1835

Mrs. John Hay Whitney

Ask an expert on oratory who the most compelling speaker on patriotic public occasions was in pre-Civil War America, and without a pause he would say Daniel Webster. Ask a specialist in party politics who were the three or four most influential Whigs when that coalition emerged as a major party in the 1830s, and he, too, would doubtless mention Webster. Ask a historian of constitutional interpretation who offered the most persuasive defense of the inviolability of American union before the Civil War, and he also would say Daniel Webster. Finally, ask a student of the Civil War who the main figures were in forging the great Compromise of 1850, which delayed armed conflict between North and South for some ten years, and inevitably Webster's name would surface yet again. In short, this United States senator and sometime secretary of state was one of those rare personalities in this country's past who seemed to loom over his age as a kind of dominating beacon. Although the "Godlike" Daniel Webster never realized his perennial ambition to win the presidency, it could be said that in a good many respects the impact of his multiple accomplishments often eclipsed the individuals who occupied that office in his stead.

Yet for all his influence as an orator, party leader, and defender of national unity, there was still another area of endeavor where Webster could claim preeminence. Thus, if one were to ask a legal history expert to list the foremost courtroom lawyers of the early American republic, Webster's name would stand high on that roster as well.

When Jeremiah Mason first witnessed Webster's ability at the bar in New Hampshire in about 1806, Webster was only in his early twenties and had been practicing law for no more than a year or so. Nevertheless, the far more seasoned Mason, who on this occasion was arguing the other side of Webster's case, found himself totally unprepared for the magnetic power of his youthful opponent. As Webster began to speak, Mason recalled years later, "he broke upon me like a thunder storm in July, sudden, portentous, sweeping all before it." Although Mason recovered sufficiently from this jolt to triumph, it was clear that Webster presented a worthy match for his own superb courtroom talents.

Webster was never as deeply read in the law as some of his rivals at the bar. At the same time, many of them found his frequent exhibitions of arrogance offensive. Even so, his leonine bearing and masterfully crafted logic rarely failed to inspire awe, and as he pursued his

practice first in Portsmouth, New Hampshire, and later in Boston, reactions such as Mason's to his courtroom performances became commonplace. Even when he did not win his case, his opponents knew that they had faced an extraordinarily formidable foe, and when attempts were made to record his august manner and eloquence at the bar, writers often could not help but resort to superlatives. While one witness to a Webster courtroom appearance of the 1840s likened his relationship to the other lawyers present to "a schoolmaster among his boys," another contemporary compared the impact of his arguments to "a great three-decker surging into harbor."

Inevitably, Webster's remarkable talents for legal argument brought him before the Supreme Court, where he served as a counsel in almost all the landmark cases of his day and where in later years his appearance invariably assured that the courtroom would be packed to overflowing with admirers. Win or lose, Webster rarely disappointed his audience, but of the some 170 cases he argued before the nation's highest court, perhaps the most memorable was one of his earliest, *Dartmouth College v. Woodward*, which came before the court in 1818.

As a Dartmouth alumnus, Webster had a personal interest in defending this private New Hampshire school against a state legislature claiming the right to revise its original charter of incorporation and, in so doing, authorizing its total reorganization. Of far greater significance, however, was the constitutional question involved—namely, whether New Hampshire's alteration of this 1769 charter represented a violation of the federal Constitution's prohibition against state action "impairing the Obligation of Contracts."

Privately Webster thought that his alma mater had an extremely weak case on this point, and he dearly wished that events had allowed

Dartmouth College, the focus of perhaps Webster's greatest moment before the Supreme Court, as it appeared in the early 1800s.

Watercolor on paper by George Ticknor (1791–1871), 19.1 x 26.7 cm. (7 1/2 x 10 1/2 in.), 1803. The Hood Museum of Art, Dartmouth College, Hanover, New Hampshire

him to argue Dartmouth's cause on other grounds. But given Webster's forensic virtuosity, the perceived tenuousness of his case did not matter in the end, and Webster's argument for Dartmouth has come down in the annals of Supreme Court history as one of its most dramatic events.

Speaking extemporaneously, Webster expounded for five hours, holding justices and onlookers alike spellbound as he ingeniously mixed pathos with reason. By the time he reached the famed emotion-laden words of his peroration—"It is, sir, as I have said, a small college—and yet there are those who love it"—his audience was totally in his power. According to Justice Story, "many were sinking under exhausting efforts to conceal their own emotion," and when Webster was at last done, "it was some minutes before anyone seemed inclined to break the silence." A year later, the Court handed down its decision declaring Dartmouth's original charter intact and in the process setting forth the landmark dictum that no state had the right to alter a charter of incorporation through legislation.

As was often the case with noteworthy moments in Webster's public career, the Dartmouth triumph yielded a portrait of him. Shortly after the Supreme Court announced its decision in 1819, Webster was posing, at the request of his alma mater, for a portrait by the famed Gilbert Stuart. For reasons unknown, however, that likeness was never completed, and as of 1834, Dartmouth was still without a satisfactory image of its legal savior. Finally, in the fall of that year, the school's trustees passed a resolution commissioning the portraits of Webster and his three co-counsels in *Dartmouth v. Woodward*, and in 1835 Webster found himself sitting for a second Dartmouth likeness, this time in the Boston studio of Francis Alexander.

Perhaps the most painted public figure of his generation, Webster had sat for many artists by now and would sit for many more in later years. But of all the likenesses made of him, Alexander's was by far one of the most unusual. For, where other artists tended to portray Webster with placid dignity, Alexander turned his subject into a sort of Byronesque secular god.

The artist never indicated what had moved him to cast Webster in such a singularly theatrical light, but part of the explanation doubtless lay in his encounter with European romanticism during a recent two-year sojourn in the art capitals of Italy, France, and England. At the same time, Alexander's portrait was also a reflection of the remarkable impression that Webster made on his contemporaries, and that inspired one to liken him to "a small cathedral" and another to dub him a "Parliamentary Hercules." In many respects, the self-possessed Webster seen gazing from Alexander's canvas, as if from a wind-swept Olympian height, was a pictorial equivalent to such verbal hyperbole.

Webster often complained about the likenesses done of him, and the year before he posed for Alexander, he had told a sculptor that most of his portraits were mere "caricatures." Apparently, he considered Alexander's Dartmouth picture a happy exception, and upon the picture's completion, he commissioned Alexander to do this replica of it.

HORACE BINNEY
1780–1875

THOMAS SULLY

1783–1872

Oil on canvas

91.4 x 69.8 cm.

(36 x 27¹/₂ in.)

1833

Jenkins Memorial Law Library

By 1837, though still relatively young and destined to live nearly forty years longer, Horace Binney had decided that the time had come to retire from his Philadelphia law practice. For more than twenty-five years he had been regarded as one of the city's foremost jurists, and there were areas of the law, such as those relating to marine insurance liability, where he had no equal. But despite professional recognition and ample financial rewards, Binney was tired of attending to the day-to-day matters that came with a crowded courtroom practice and quite ready to settle into a more leisurely existence as a sometime counsel for other lawyers and a pillar of the community.

Binney's courtroom career, however, was not entirely over, and his finest moment was yet to come.

The time was February 1844. The setting was the chambers of the United States Supreme Court, where Binney had argued with great success many times before and which now was daily crowded to overflowing with onlookers. The case at hand dealt with the validity of one Stephen Girard's will, and among the lawyers opposed to Binney in the matter was the illustrious Daniel Webster.

If Binney felt any resentment at being called out of retirement to be party to this proceeding, he had only himself to blame. Many years earlier, he had assisted Girard in drawing up the first version of the disputed document, which directed that the bulk of this Philadelphia merchant's estate—totaling some six million dollars—should be used to establish a school for white male orphans and that, while the boys' moral education was not to be ignored, they should not be exposed to any sectarian religious teachings. And now several of Girard's relatives were contending that, one, this disposition of their kinsman's wealth violated the Christian foundation on which this country was founded and, two, that American law made no provision for a charity destined for such loosely defined beneficiaries.

Today such assertions hardly seem arguable. In the 1840s, however, the notion that religious teachings of a specific sort ought to be part of education enjoyed far wider currency. As for the second point, no less than the redoubtable John Marshall had, in a decision of 1819, held the view of Girard's kinsmen to be the correct one, and it seemed that in pleading for the upholding of Girard's will, Binney definitely had a hard row to hoe.

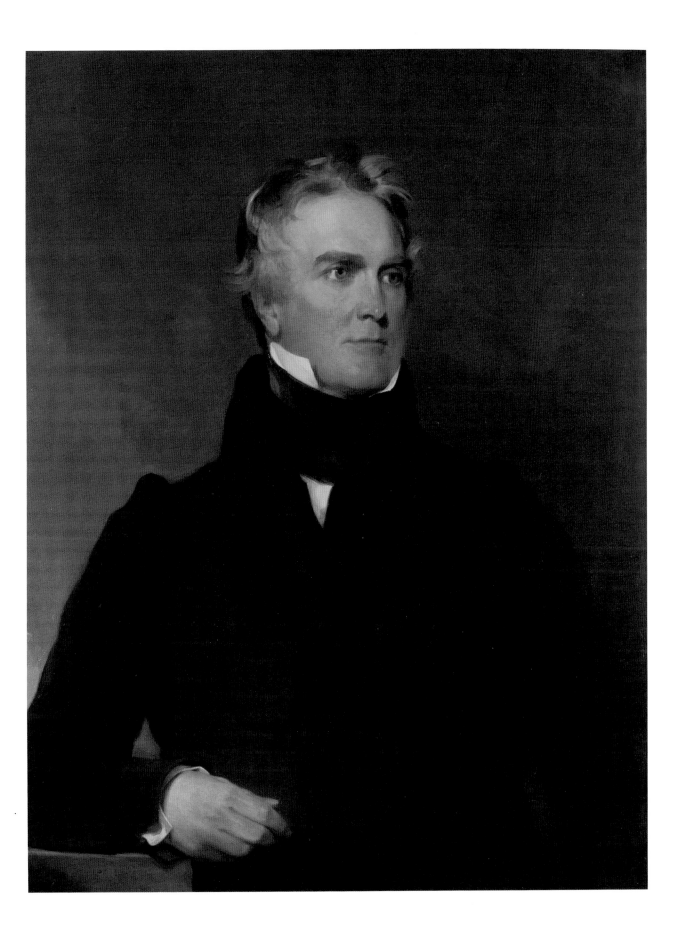

But, if nothing else, Binney was a most diligent researcher and master of tightly woven logic. For four days he kept the Court enthralled as he cited some fifty precedents from the common law contradicting Marshall's earlier decision and demonstrating that the recipients of Girard's largesse would not necessarily all turn into godless free-thinkers. As one newspaper of the day observed, this handsome and self-possessed lawyer from Philadelphia appeared "to have every link in his chain of argument in its place," and in setting it forth, he was taking both justices and opposition into waters so deep that they had all they could do to follow him. At one point Binney bolstered his cause by citing one of Webster's own arguments from a Supreme Court case several years earlier. To that Webster could only reply: "That was a bad case and I had to make my argument to suit my case." Needless to say, the lame rejoinder drew a round of laughter, and by the time Binney was into his third day of speaking, Webster could be seen sitting in the courtroom in a state of "undisguised dismay."

Still, in answering Binney, Webster was at his best. But where Binney had appealed to the justices' reason, the "God-like Daniel" played to their feelings, turning his three-day oration into an emotion-laden sermon in defense of Christian education. In the end, that was not enough to unravel the impregnably "double-and-twisted" logic of his opponent. While the nation's clergy scrambled for printed accounts of Webster's words, the Court unanimously made its decision in favor of Binney and the will that he had helped to formulate. In so doing, it established once and for all the legitimacy of charitable trusts in this country.

For several decades Philadelphia's most sought-after portraitist, the maker of Binney's likeness, Thomas Sully, had a reputation for investing his sitters with dashing good looks even when it was not entirely justified. With Binney that was not the case. Described as an "Apollo in manly beauty," he struck his contemporaries as a nearly perfect embodiment of gentlemanly elegance. In manner, an acquaintance observed, he was a blend of "dignity, ease, suavity, and high refinement." Thus, although some of Sully's portraits may have stretched the truth, his urbane rendering of Binney seems to have been a fair reflection of reality.

JAMES KENT
1763–1847

"The law, I must frankly confess," James Kent remarked in his nineteenth year as he was struggling to prepare himself for a career at the bar, "is a field which is uninteresting. . . . The study is so encumbered with voluminous rubbish and the baggage of folios that it requires uncommon assiduity and patience to manage so unwieldy a work." Despite the onerousness of the task before him, the young Kent persevered, and by the mid-1780s he was practicing his chosen profession in Poughkeepsie, New York. By his own admission, however, he was never particularly good at arguing a case, and in later years he confessed that he "always extremely hated" carrying out the daily tasks required of a practicing attorney. In short, if fate had directed James Kent to earn his living as most of his fellow lawyers did, he might well have ended his life as an embittered mediocrity, eking out a dreary existence in the same "narrow dirty street" where his slender means had forced him to reside upon moving to New York City in 1793.

Kent possessed assets, however, that kept him from traveling that path of quiet desperation. A passionate reader who devoured Ovid and Demosthenes as readily as others might read a daily newspaper, he eventually overcame his youthful distaste for legal tomes. By the year of his arrival in New York City, he was on his way to becoming the most broadly informed student of law that this country has perhaps ever seen. At the same time, his alliance with New York state's Federalist political factions had given him friends in important places, and in 1798 the then-governor of New York, John Jay, appointed Kent to a seat on the state supreme court. So began one of the most distinguished judicial careers of early nineteenth-century America.

On the court, Kent at last had the opportunity to put his ever-deepening dedication to legal scholarship to constructive use in a quarter that until now had addressed its responsibilities in a rather casual and superficial manner. By 1804, when he became chief justice of New York's highest tribunal, his thorough citing of principles and precedents in his opinions—drawn from sources ranging everywhere from the Justinian code to contemporary English and French jurisprudence—had made him the dominant force on the court. At the same time, it was transforming the court itself from a mediocrity into an institution whose views and approach to the law set new standards of precision and excellence for courts throughout the country.

James Kent

FREDERICK R. SPENCER

1806–1875

Oil on panel

109.2 x 85.1 cm. (43 x 33¹/₂ in.)

1834

Hamilton College Collection,

Emerson Gallery

In 1814 this accomplishment led to Kent's appointment as chancellor of New York's court of equity, and once again he found himself reshaping an institution—hitherto characterized by casual procedures and superficial treatment of legal issues—into one known for its exhaustive thoroughness and efficiency. But Kent's obvious merits could not overcome the fact that according to New York's constitution, no judge could remain in office beyond his sixtieth birthday; and in 1823, though still at the height of both his physical and intellectual vigor, Kent was forced to retire from the bench.

The more egalitarian Jeffersonian Democrats of the day, who sometimes resented the archly conservative and somewhat elitist outlook underlying Kent's brand of jurisprudence, viewed his removal from the court of chancery with equanimity. But the less partisan-minded agreed with the appraisal of an English periodical that, like the Emperor Augustus and Rome, Kent had found New York's chancery system made of brick and left it made of marble. For them, his retirement represented a disturbing loss.

Ultimately, however, this event proved a blessing, for it permitted Kent to pursue what may well be the greatest accomplishment of his career. In 1826, after teaching at Columbia University for several terms, Kent began, on the urging of his son William, to organize his many years of thinking and research on the law into book form. The result was a four-volume discourse on various branches of American jurisprudence entitled *Commentaries on American Law.* As was the case with so many of his decisions, this work—written in an unusually fine literary style—represented the best that the young American republic had to offer to the contemporary world of legal scholarship. Until the coming of the twentieth century, it was virtually the Bible for lawyers in this country. Remarking in his diary in 1843 on the fact that *Commentaries* earned royalties of some $5,000 a year, Kent's good friend Philip Hone speculated with some justification that no other book in this country had ever yielded its author such handsome revenues.

Hone once called Kent "one of the loveliest men I ever knew." He was, Hone might have added, also one of the most widely honored, and it would have come as a surprise to no one in 1836 when a group of Boston lawyers and teachers at the Harvard Law School informed Kent that they wished to commemorate his achievements by having a new portrait made of him for Harvard. That image, painted by Asher B. Durand, seems to be the first commission for what in the years following would become quite a large portrait collection at the law school of noted English and American jurists. Although Kent did not relish the "wonderful irksome" duty of posing for an artist, he graciously consented to cooperate in the enterprise.

This was not the first instance where Kent's illustrious reputation had brought him under the portraitist's scrutiny. Nor would it be the last. A few years earlier, when James Herring and James B. Longacre were planning *The National Portrait Gallery of Distinguished Americans,* there was no doubt in their minds that a biography and engraved

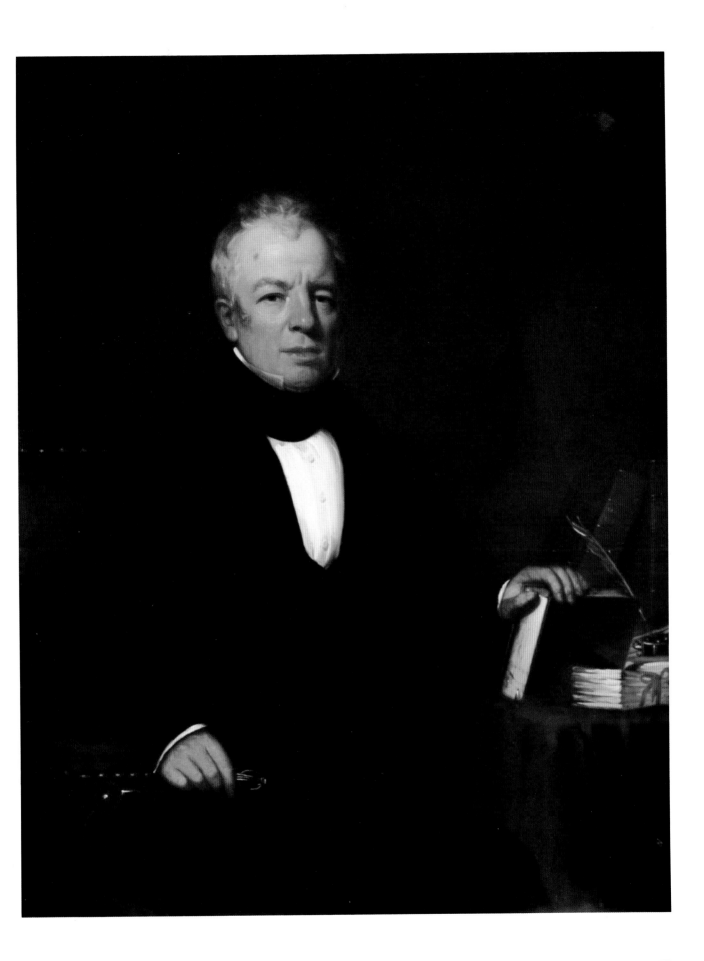

likeness of Kent were musts for this multivolume compendium. To paint the original oil likeness, they hired a young artist named Frederick Spencer. Nothing is known of the subsequent encounter between Kent and this as-yet-unknown artist, but if painter Samuel F. B. Morse's account of doing a portrait of the jurist ten years earlier is any indication, Kent in all likelihood betrayed some restless irritability with having his features recorded. "He is not a good sitter," an exasperated Morse noted on that previous occasion. "He is very impatient and . . . I cannot paint an impatient person." Apparently Kent reserved most of his capacity for patience to those hours of his day given to studying the law.

JOSEPH STORY
1779–1845

First edition of Story's
*Commentaries on the Conflict of
Laws*, 1834. Harvard Law School
Library

When the twenty-two-year-old Joseph Story embarked on the practice of law in Salem, Massachusetts, in 1801, his Jeffersonian outlook did not sit well with the town's more seasoned jurists, who practically to a man subscribed to the decidedly more conservative Federalist view of America's current politics. The situation often made Story feel like a pariah, and indeed there were many in Salem who considered him just that. Yet even in his novice years, Story's talent for his vocation was uncommonly palpable, and it was not long before Samuel Sewall, in whose office Story had studied, was advising a Federalist colleague: "It is vain to attempt to put down young Story. He will rise, and I defy the whole Bar and Bench to prevent it."

But for all his shrewdness in the matter, Sewall doubtless did not foresee just how far and rapidly Story would rise. Nor could he predict the multiplicity of accomplishment on which the future distinction of his onetime protégé would rest. Equipped with a sponge-like mind whose appetite for information seemed to know no limit, Story became, at the age of thirty-two, the youngest individual ever appointed to the United States Supreme Court, and by 1811, when he joined that body, he was already on his way to becoming this country's foremost expert in maritime law.

Once on the Court, Story did not exhibit the ardent Jeffersonian impulse toward tightly circumscribing the scope of federal authority that many Federalists feared he would. On the contrary, it was soon clear that his thinking very much paralleled the nationalistic conservatism of Chief Justice Marshall, the result being that during their joint tenure on the Court, the two men complemented each other extremely well. With Marshall providing the leadership in directing the Supreme Court toward broad constitutional interpretations of federal authority, Story and his encyclopedic knowledge of legal scholarship enhanced the legitimacy of that trend through chapter-and-verse citations of historical precedents. As Marshall once put it, while he could rely on himself for developing the Court's general reasoning in a decision, he counted on "Brother Story" to give credence to that reasoning with learned enumerations of relevant cases "from the Twelve Tables down to the latest reports."

For most individuals, the responsibility of sitting on the Supreme Court would seem quite enough to satisfy the need for professional satisfaction. Story, however, possessed an intellectual energy that was

Joseph Story

CHESTER HARDING

1792–1866

Oil on canvas

92 x 72.5 cm. (36¼ x 28½ in.)

Circa 1828

Massachusetts Historical Society

constantly in search of other outlets. When Harvard asked him in 1829 to fill its newly endowed Dane professorship of law, he readily accepted. From that year until his death in 1845, he found himself leading a dual career as teacher and practicing jurist. But even this was not enough to exhaust the Story stamina; by the early 1830s, when not sitting on the court or instructing students in Cambridge, he was at work on a series of commentaries on various branches of the law that would eventually fill nine volumes.

Though now well into middle age, Story succeeded amazingly well in these new endeavors. While his mere presence quickly enhanced Harvard's position as a leader in legal education, his discursive classroom informality proved the delight of his students. "Those who . . . recite to him love him more than any instructor they ever had before," wrote one of them in 1832. "He . . . omits nothing, which can throw light upon the path of the student. The good scholars like him for the knowledge he distributes; the poor . . . for the amenity with which he treats them and their faults." The reception accorded Story's *Commentaries*, the first of which appeared in 1832, was no less complimentary, and for many years several of them remained the definitive word on their respective subjects. When Massachusetts Attorney General James Austin visited England in 1843 and commented to Lord Chief Justice Thomas Denman on how pleased he was to be at the fountain of the common law, Denman replied: "We must go to you, for your Judge Story has found the living spring, and pours out its waters most liberally."

Recalling his days as a student in Samuel Sewall's law office in an autobiographical sketch of 1831, Story related how, upon finishing his studies of Blackstone, Sewall had directed him to begin reading some of the writings of the great English jurist, Sir Edward Coke. "It was a very large folio," he remembered, "with Butler's and Hargrave's notes, which I was required to read also . . . and after trying it day after day with very little success, I sat myself down and wept. My tears dropped upon the book and stained its pages." Clearly, in the years between those early frustrating moments of incomprehension and the Lord Chief Justice's compliment, Story had traveled a long distance.

Given the crowded nature of his professional life and his many preoccupations as a justice, teacher, and writer, one might expect that from time to time Story had difficulty maintaining a pleasant demeanor toward the world around him. But that was rarely, if ever, the case, and Chester Harding's portrait showing him as he appeared shortly before his fiftieth birthday bears visual testimony to the even-tempered affability that he brought to bear in his human dealings. Yet according to many who knew him, no sculpted or painted likeness could ever do full justice to his boyishly vivacious nature. "His talk would gush out for hours," Englishwoman Harriet Martineau wrote after meeting Story on her American tour of 1834–1835, "and there was never too much of it for us; it is so heartfelt, so lively, so various; and his face all the while . . . showing all the mobility and ingeniousness of a child's. There is not a tolerable portrait of Judge Story, and there never will be."

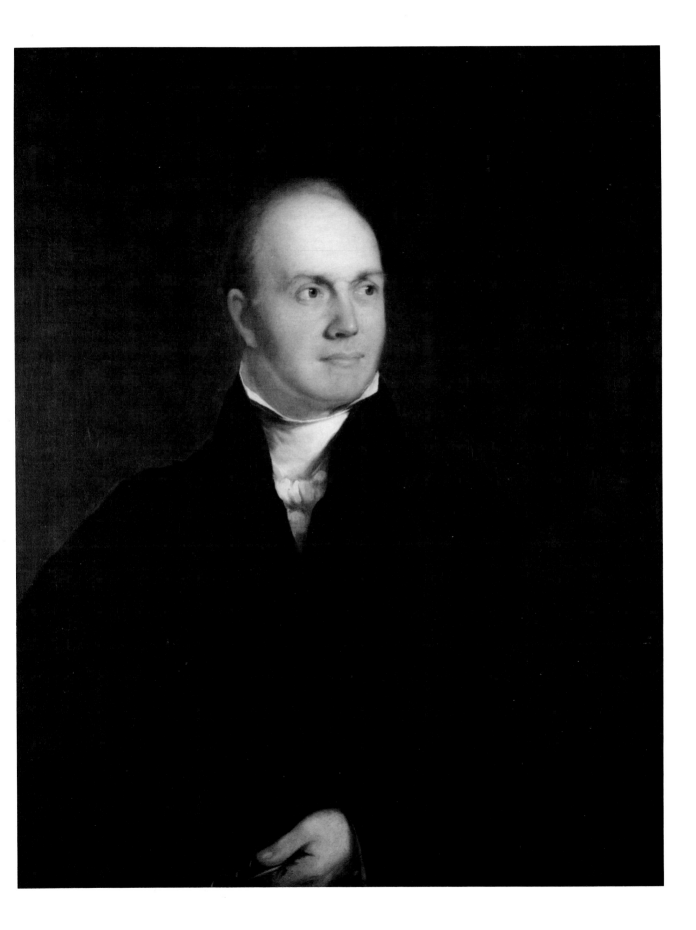

SIMON GREENLEAF
1783–1853

GEORGE P. A. HEALY

1813–1894

Oil on canvas

74.6 x 61.8 cm.

(29³/₈ x 24³/₈ in.)

1848

Harvard Law Art Collection

In 1833, while poor health and want of students were moving James Gould toward his decision to close down the Litchfield Law School, another New England venture into legal education was entering upon a period of remarkable growth. The Harvard Law School in Cambridge, Massachusetts, had begun its first term back in 1817 with only six students, and by the winter of 1829 its enrollment was dangerously near zero. In fact, although there is some disagreement on the question, at some point in that year it may even have reached that unhappy number. During the next few years, however, this unpromising state of affairs sharply reversed itself, and by the early 1830s, the school's annual student population had exceeded thirty. By 1845, with its physical facilities greatly expanded and its library collection more than double what it had been a decade earlier, the number of students had grown to 145, and it was clear that the Harvard Law School's place as one of this country's most eminent training grounds for lawyers was well assured.

In accounting for this dramatic expansion, the name that looms largest is Harvard's first Dane Professor of Law, Joseph Story, and there is little doubt that Story's lustrous reputation, combined with his enormous popularity as a teacher, had much indeed to do with the law school's increasing ability to attract and hold students. But Story's close identification with this enterprise from 1829 to 1845 was not the only human ingredient making for its success. Also instrumental in promoting the school's fortunes was Simon Greenleaf, a widely respected lawyer from Portland, Maine, who at Story's urging had joined the law school in 1833 as its Royall Professor.

Greenleaf—or "Old Green" as he came to be known among students—was not nearly as gregarious as Story. Nor did he share Story's classroom penchant for anecdotal digression from the lessons at hand. Instead, Greenleaf proved in his years of teaching at Harvard to be a model of sober and sharply focused diligence, and while Story with his expansively infectious amiability succeeded in transmitting to students his own passion for the law, it was Greenleaf whose undeviating emphasis on content revealed to them its substance. As one observer once put it, "Story prepared the soil; and Greenleaf sowed the seed."

Though quite different in temperament and instructional approach from the man who brought him to Harvard, Greenleaf got along amazingly well with Story. Musing on the harmony of their professional relationship, Story remarked to Greenleaf in 1842 that "not a cloud has

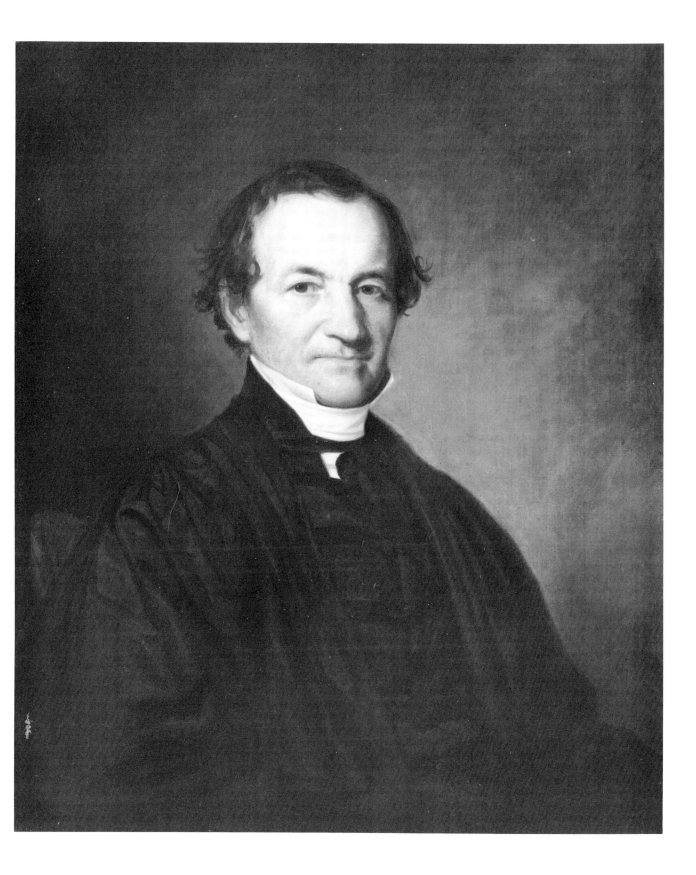

A View of the Bridge over Charles River. MASSACHUSETTS.

Boston's Charles River Bridge, several years after its completion and well before the Warren Bridge began to erode its profits. Engraving by unidentified artist. The Boston Athenaeum

ever passed over our mutual intercourse." Even when they found themselves in disagreement, these two men never seemed to waver in their fondness for each other, and according to one student's recollections, "a vein of humor would appear in each of them whenever they talked upon questions in which . . . they differed."

In light of the potentially divisive situation that had existed at one point in their relationship, such testaments of uninterrupted good will were all the more impressive. For in 1834 Greenleaf had consented to defend the Warren Bridge Company in the historic Supreme Court case known as *Charles River Bridge Co. v. Warren Bridge Co.* and, in doing so, had put himself seriously at odds with Story.

The details of this case, which were thought to have far-reaching consequences for the development of this country's transportation, were complex. Essentially, the Charles River Bridge—a privately held toll bridge linking Boston with neighboring communities that had been chartered by Massachusetts in the 1780s—was seeking an injunction against the Warren Bridge, which roughly paralleled its own structure and which the state had chartered in 1828 on terms thought to be substantially more advantageous to public interests. According to the plaintiff, the legislative authorization of this second concern represented an unconstitutional infringement of its own earlier charter, which, though not openly stating as much, implied that the Charles River Bridge should have no competition for its business. In short, at issue was whether a state

had a right to alter the commercial conditions and implied understandings at the time of one contract by the issuance of another.

Considering that Greenleaf was not only a teacher but a practicing lawyer as well, his involvement in this matter was at first glance unremarkable. But in taking up the Warren Bridge cause, he was opposing the interests of his Harvard employer, which owned a substantial share in the Charles River Bridge and, until the completion of its rival in December 1828, had enjoyed a good annual dividend from that venture. Closer to home, he was also putting a rather severe strain on his warm and easy relationship with his teaching colleague, Joseph Story, who as a member of the Supreme Court would be sitting in judgment on the bridge case and whose conservative faith in the inviolability of contracts was almost certain to place him in sympathy with the arguments of Greenleaf's opposition.

In the end the arguments of Greenleaf and his co-counsel won the day. Early in 1837, speaking through the recently appointed Chief Justice Roger Taney, the Supreme Court held that the perceived but unstated understandings of one charter did not prohibit a state from entering into a future agreement, regardless of the injury that it might do to the interests represented in the original charter.

As expected, Justice Story did not agree with the Court's majority opinion and registered a vigorous dissent, saying in part: "I can conceive of no surer plan to arrest all public improvements founded on private capital . . . than to make the outlay of that capital uncertain and questionable, both as to security and as to productiveness." But more indicative of the depth of Story's negative feelings about the Charles River Bridge decision were his more private commentaries on the subject. Remarking on the case's outcome in a letter to his wife, he claimed that "a grosser injustice . . . never existed." Several months later, still brooding over what he saw as the decision's dire consequences, he told James Kent, "I am sick at heart and now go to the discharge of my duties in the Supreme Court with a firm belief that the future cannot be the past."

Regardless of Story's deep unhappiness in the matter, it apparently never entered his mind to let what he regarded as the decision's disastrous consequences dampen the harmony between him and Greenleaf. Or, if it did, he quickly checked the impulse. Noting Greenleaf's part in the case to law school instructor Charles Sumner, Story reported that his performance before the Supreme Court had won for their school "new *éclat*" and "sounding and resounding fame." Several weeks later, he was writing to Greenleaf himself, congratulating his colleague on his newly found "'fame' abroad" and telling him: "Tomorrow (Monday) the opinion of the Court will be delivered on the Bridge Case. You have triumphed." Thus, even in this moment of deeply divided feeling, the fondness that had made the relationship between Story and Greenleaf so productive at Harvard remained intact, and until Story's death in 1845, their joint direction of the law school continued to enhance the school's growing eminence as a leader in legal education.

Among Greenleaf's most memorable traits as a teacher was his strict insistence that students be well prepared for his classes, and his habit of close questioning in the classroom was much to be dreaded by those who

Joseph Story's warmly congratulatory note to Greenleaf on the latter's performance in the Charles River Bridge case, January 23, 1837. Harvard Law School Library

had been neglecting their assigned readings. "It is," noted future President Rutherford B. Hayes, soon after he began studying at the law school in the 1840s, "impossible for one who has not studied the text to escape exposing his ignorance." Moreover, as practiced by Greenleaf, the exposure often resulted in an embarrassment that was not easily forgotten.

But for all of his rigor, Greenleaf inspired considerable affection among his students. When poor health forced his retirement from the law school in 1848, his current pupils took it upon themselves to write an expression of their appreciation for Greenleaf's many years of service to the school and to ask him to sit for his portrait by George P. A. Healy. In reply, Greenleaf offered his profound thanks for this testimonial, adding that, on the question of posing for a likeness, "I have neither the heart nor the power to decline a compliance with your wishes." The result of that acquiescence was a portrait evocative of the austere gravity that Greenleaf had brought to his teaching and that had been its hallmark.

L E M U E L S H A W

1781–1861

In 1830, Lemuel Shaw was approaching his fiftieth birthday, and as he neared his sixth decade, he could look with complacent satisfaction on his lot in life. During his many years of practicing law in Boston, he had won high respect within his profession, and although his legal skills had not earned him a celebrity equal to the likes of his friend Daniel Webster, his aptitude for the law was nevertheless sufficient to assure him of an unusually comfortable income ranging from fifteen to twenty thousand dollars a year. Moreover, thanks in large part to his pivotal role in drawing up Boston's city charter of 1822, he could justifiably lay claim to being a pillar of his community. In short, Shaw found himself occupying a rather enviable niche; given his unassuming and quiet nature, his ambitions seemed to be more than amply satisfied.

But there were those in Massachusetts who saw things differently, and when the state's chief justiceship fell vacant in the summer of 1830, a consensus quickly developed that Lemuel Shaw was the man for this position. Upon receiving this news from Daniel Webster, however, Shaw almost without thinking received this tribute to his ability as if it were an insult, saying, "Do you suppose that I am going at my time of life to take an office that has so much responsibility . . . for the paltry sum of three thousand dollars a year?" But Shaw was not as insensitive to the tendering of this honor as his initial reaction indicates. Being the civic-minded and ponderously methodical soul that he was, shortly after Webster's visit he undertook, in a memorandum to himself, to weigh the pros and cons of accepting the chief justiceship. The exercise proved illuminating. While loss of income and his own frankly confessed misgivings about his judicial capacities argued against acceptance, he found himself having to admit that his "labors of the Bar begin to become irksome" and that his own reservations about his ability were not shared by others. In the end, these latter considerations carried the day. On August 30, 1830, Shaw—albeit a little reluctantly—began his thirty-year career as state chief justice.

Whatever self-doubts Shaw harbored in coming to this new endeavor, it was soon clear that they were ill founded. Though often slow of speech and almost without humor, he more than compensated for such deficiencies in other ways, and among his virtues on the bench was the fact that no case—no matter how small—seemed unworthy of his court's earnest attention. On one occasion, when the lawyers present betrayed amuse-

Lemuel Shaw

WILLIAM MORRIS HUNT

1824–1879

Oil on canvas

198.1 x 127 cm.

(78 x 50 in.)

1859

Essex County Bar

Association

ment as Shaw soberly discussed whether a newborn calf should be attached in a bankruptcy proceeding, the chief justice suddenly stopped short, chiding, "Gentlemen, this may seem to you a trifling case, but it is a very important question to a great many poor families."

Shaw's greatest strength, however, lay in an ability to reduce even the most complex issues to their simplest terms and in an open-minded readiness to adapt the time-honored principles of common law to the exigencies of changing circumstance. Shaw came to the bench armed with this dual capability at a moment when the need for it seemed more pressing than usual. With the advent of railroads in the 1830s, the simultaneous spread of industrialization, and the rise of the corporation as a favored form of business organization, the traditional relationships between seller and buyer, labor and management, private interests and public good were rapidly giving way to new ones. In the wake of these changes came a host of new legal questions in areas such as liability, the rights of eminent domain, and worker-management relations, for which old answers were not entirely sufficient. Thus, like a good many other members of the American bench during the three decades before the Civil War, Shaw found himself constantly confronted with situations demanding fresh solutions.

But unlike most of his judicial brethren, Shaw proved unusually adept at plowing the new ground. With a clarity uniquely his own, he succeeded in producing a body of decisions that often seemed to strike a remarkably fine balance between entrepreneurial interest and the public good and that became precedents not only for his own Massachusetts but for the nation at large as well.

Though not unkind, Shaw was always too stern and brusque in presiding over his court to inspire much collegial affection among his legal brethren. Nor was he immune to periodic criticism, and when he insisted on strict local compliance with the controversial federal Fugitive Slave Law of 1850, one antislavery crusader accused the chief justice of having "spit in the face of Massachusetts." Nevertheless, there was little doubt that as the years passed Shaw came to enjoy a respect that in many instances seemed worthy of a demigod. Remarking on the fact that the heavyset Shaw was far from handsome, Rufus Choate once told a colleague: "I confess I regard him as the Indian does his wooden log, curiously carved; I acknowledge he's ugly, but I bow before a superior intelligence."

Such reverence extended to the public at large as well. When one of Shaw's fellow judges on the Massachusetts Supreme Court slipped and broke three ribs, the janitor called to assist the hapless jurist attempted to ease the pain with the observation: "Well, Judge Merrick, how thankful you must be it wasn't the Chief Justice."

Out of all the portraits done of noted nineteenth-century American jurists, quite possibly the finest and undoubtedly one of the most memorable is the full-length likeness of Shaw that William Morris Hunt painted for Massachusetts's Essex County Bar Association in 1859. In undertaking this work, Hunt was frankly indifferent to the fee he might receive for it; instead his primary concern was to create a picture that would finally establish his reputation in Boston as an artist of original merit. To a large extent this intention was realized, and in the process the Essex Bar got

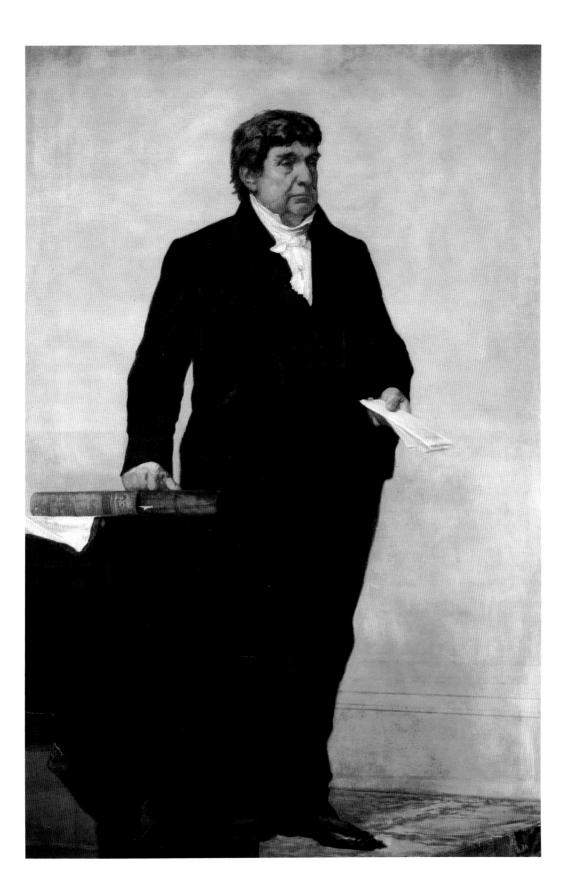

more perhaps than it had a right to expect for the five hundred dollars it eventually paid to Hunt. For the picture proved every bit as monumental as Shaw's reputation and was as much an emblem of what the subject had come to represent in American law as it was a likeness. In its austerely spare composition, the painting also echoed—perhaps unwittingly—the root of Shaw's judicial genius, his unerring instinct for paring down a seemingly complex issue to its very essence.

THOMAS RUFFIN

1787–1870

It is a commonplace in the lives of lawyers that the first several years of practice are often discouragingly lean and that, in the face of low fees, tediously routine business, and precious few clients, more than one young practitioner of this profession has been tempted to scrap his years of training in favor of other endeavors. In the case of Thomas Ruffin, apparently the prospect of ever making a respectable living from the law seemed particularly slight, and following his admission to the North Carolina bar in 1807, a number of his friends—struck by his awkward diffidence in the courtroom—urged him to find another calling. But Ruffin seemed to know something about himself that these well-meaning acquaintances did not. Eventually adopting a daily practice of exercising his powers of reason through the study of mathematical theorems, he was soon winning recognition as a lawyer of more than ordinary consequence. By 1829, when he became a justice of the North Carolina Supreme Court, it was clear that had Ruffin heeded the counsels of his youth, his state would have lost one of its most distinguished jurists of the nineteenth century; four years later, when the chief justiceship of that body fell vacant, it was a foregone conclusion that Ruffin should fill the post.

Ruffin's tenure on North Carolina's Supreme Court ultimately earned him a respect that went well beyond the boundaries of his state, and like Lemuel Shaw of Massachusetts, many of his closely reasoned decisions were often accepted elsewhere as definitive standards. But perhaps his most widely noted decision, *State v. Mann,* was also his most controversial. In this case of 1829, the question to be answered focused on defining how far corporal abuse could go in cases involving the punishment of slaves by their masters before it became illegal.

As a state legislator many years earlier, Ruffin had demonstrated his concern for the welfare of North Carolina's enslaved blacks by sponsoring a law designed to guarantee fair trials for slaves accused of crime. Consequently, it might not have been surprising to find him in this instance seeking some legal ground for prohibiting at least the more extreme forms of physical punishment for slaves. Ruffin, however, was too much the unrelenting logician to let personal predisposition direct his thinking in the matter. Speaking for the whole court, he found that as long as slaves were a legally recognized form of property, the treatment of them—short of murder—was largely their owners' private affair. Nevertheless, in his written opinion in *State v. Mann,* he could not forebear from confessing his own reluctance to arrive at such a finding, and in

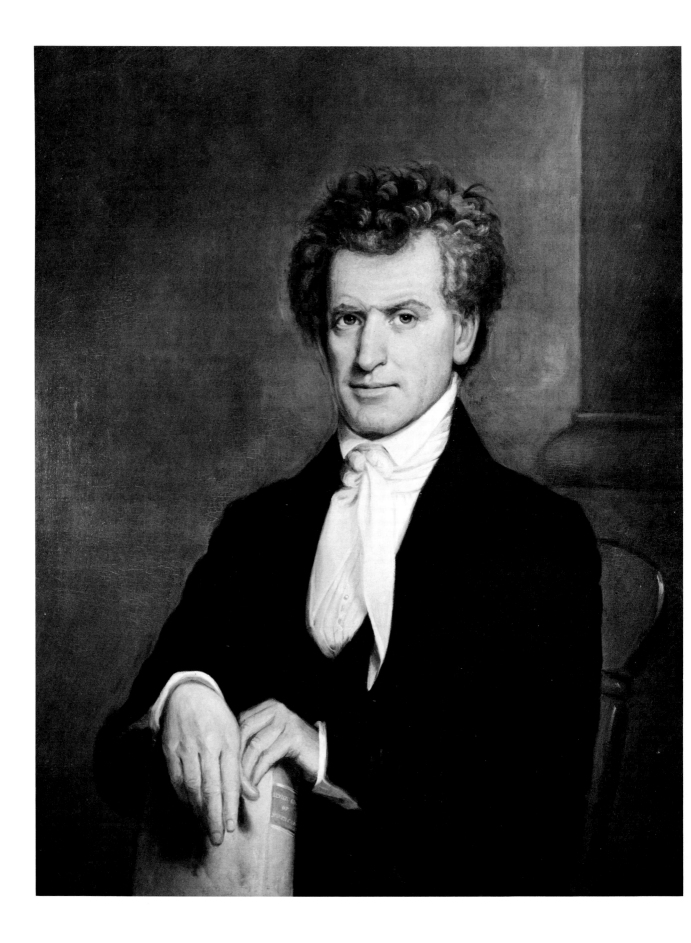

setting forth his reasons for it, he at the same time frankly admitted that, "as a principle of moral right," any person concerned with human decency "in his retirement must repudiate it."

Not surprisingly, as the abolitionist movement of the North escalated its attacks on slavery in the years after 1830, Ruffin's reasoning in *State v. Mann* became the object of heated scorn among its adherents and was often invoked as proof positive of the South's brutal disregard for its black human chattel. Yet, when viewed objectively, even a dedicated antislavery reformer such as Harriet Beecher Stowe could not help but respect the man who framed this decision. Remarking on the contradictory strands of logic and personal repugnance for that logic running through Ruffin's argument, the author of *Uncle Tom's Cabin* wrote in 1854: "It always seemed to me that there was a certain severe strength and grandeur about it which approached to the heroic."

In September of 1840, in recognition of his growing distinction on the bench, Ruffin received a letter from the Dialectic Society at the University of North Carolina, asking him to sit for a portrait. In reply, Ruffin said that he would pose "with pleasure . . . at the first opportunity" but at the same time pointed out that because of the paucity of competent artists in North Carolina, there might be some delay in honoring the society's wishes. As it turned out, the delay was considerable, and it was not until about 1845 that an artist deemed worthy of the commission turned up in Raleigh.

The identity of the painter finally settled upon is not entirely certain. But on the basis of surviving evidence, the portraitist in question was either William Hart or his younger brother James, both of whom had emigrated with their parents from Scotland to Albany, New York, in 1831. In the mid-1840s, the Hart brothers were just beginning their painting careers, and like many neophytes of their profession before them, they both apparently traveled to the South in this period, hoping that the region's short supply of artists would boost their chances for finding commissions.

Regardless of which Hart painted it, Ruffin's portrait has a stiffness about it that bespeaks the artist's inexperience. Still, as an exercise in capturing character, the picture is far from a failure. According to several sources, Ruffin was a tall, angular figure of a man whose passionate feelings and urge to dominate lay only partly concealed beneath a facade of self-restraint. To a large extent, it is that combination of ardor and discipline that the likeness seems to underscore.

Thomas Ruffin

Attributed to JAMES HART

1828–1901

or WILLIAM HART

1823–1894

Oil on canvas

92 x 73.6 cm.

(36¹/₄ x 29 in.)

1845

Dialectic and Philanthropic

Societies Foundation, Inc.

RUFUS CHOATE
1799–1859

THOMAS BALL

1819–1911

Marble

62.2 cm. (24$\frac{1}{2}$ in.)

1861 from an 1859 original

Proprietors of the Social

Law Library

Admittedly, in the roster of noteworthy American lawyers, there are a good many individuals who pursued their profession simply because they loved it. But few have loved it with the all-consuming passion that Rufus Choate did. For this Dartmouth-educated New Englander, born of Puritan stock, it could be said that his diverse courtroom practice was both vocation and avocation. Thus, it never especially mattered to Choate that the cause he was arguing might strike others as minor. Nor was he particularly disturbed that his fee in the situation would be small. Instead, all that mattered was that the case at hand engaged his intellect, and once that was established, like an athlete training for the Olympic games, Choate threw himself into preparing for his courtroom combat with dedicated relish. Even in sleep, his mind was apparently on his work, and, lest he waken in the small morning hours with a new thought bearing on the cause of a client, he always made sure that a light was burning in his study and that pen and paper were close at hand for recording the fresh insight.

This constant preoccupation with his practice did not mean that Choate did nothing with his life other than argue cases. For many years he was a leading figure in Massachusetts's Whig party and for short periods of time even served as a representative and senator in the United States Congress. But he held these offices only reluctantly, always looking forward to the day when he would be free to pursue his lawyer's tasks again. There was one diversion, however, that came close to rivaling his love for the law, and that was reading. Yet even here Choate's passion for his profession was at play. Whether he was perusing the "pregnant pages" of Tacitus or relaxing with Shakespeare's *Antony and Cleopatra*, he seemed ever mindful—subconsciously at least—of how a felicity of phrasing found in the volume he was reading might be put to use before a jury.

Spending most of his career practicing first in Salem and later in Boston, Choate ultimately became one of New England's greatest trial lawyers, and it seemed to many observers that in his hands even the most hopeless of cases could be won. Of this apparent infallibility, an able Boston attorney once lamented, "What's the use of my going on term after term fighting cases . . . with Choate to close on me for the plaintiff? If I have fifty [such] cases," he guessed, "I shan't gain a one."

Part of this singular success hinged on Choate's unremitting diligence. But it also had a good deal to do with the peculiar nature of his

The dream of fame in the political arena seen floating through the mind of the napping lawyer in this picture reflects the aspirations of a good many mid-nineteenth-century American lawyers who saw law practice as merely a way-station on the road to greater things. Rufus Choate, however, never shared that view, and although he sometimes figured prominently in the politics of his day, he was never willing to sacrifice the joys of his day-to-day practice for the chance to achieve political greatness.

The Lawyer's Dream, oil on canvas by David Gilmore Blythe (1815–1865), 61.6 x 51.4 cm. (24¹/₄ x 20¹/₄ in.), 1859. The Carnegie Museum of Art; purchase with S. B. Casey gift and Howard Heinz Endowment Fund and a fund given anonymously for purchase of American representational art, 1959

mental makeup. For Choate had a strong poetic streak and an abhorrence of the commonplace, which sometimes seemed to render him incapable of arguing his causes in pedestrian terms. Speaking before a jury in a case hinging on the alleged unseaworthiness of a ship, for example, he could not bring himself to declare simply that the vessel in question was unsafe. Instead, clothing this fact in a poignantly tragic imagery, he bellowed, "she went down the harbor painted and perfidious—a coffin but no ship." In another case, this time involving the murder of an illicit lover in a Boston brothel, the sordidness of the affair evaporated as Choate's romantic hyperbole transformed the man charged with this crime into Romeo and his alleged victim into a much-beloved Juliet. Though all the evidence pointed to guilt, such idealizing ultimately won the day, and Choate's client went free. Upon hearing yet another of Choate's richly embroidered courtroom harangues, his good friend Daniel Webster remarked to a colleague: "Some of our technical brethren would call that all flimsy humbug; if it be so . . . it is still humbug which stirs men's souls to their inmost depths."

At times Choate's success in beguiling juries to his clients' causes did his public reputation more harm than good, and as the years went by, it appeared to some that on many occasions Choate was playing the part of a justice-subverting siren. In fact, the noted abolitionist Wendell Phillips once described him as the man "of whose health thieves asked before they began to steal."

Generally Choate did not have to pay much heed to this charge, but in one instance it confronted him in a situation of his own making. Defending a man charged with stealing money, Choate found himself examining a witness who, having already confessed to a part in the theft, alleged that Choate's client had been the crime's chief instigator. On this point Choate sought more elaboration, asking, "Well, what did he say?" "He told us," the witness answered, "that there was a lawyer in Boston named Choate, and he'd get us off if they caught us *with the money in our boots!*"

But if laymen—honest or otherwise—sometimes saw Choate as an amoral trickster specializing in the corruption of juries, his own profession held him in only the highest regard, and his later years brought many evidences of that. In the late 1840s, the Harvard Law School offered Choate a professorship; at one point he was also a candidate for a judgeship on the Massachusetts Supreme Court; and when a vacancy occurred on the United States Supreme Court in the late 1850s, his name was placed in serious contention. Choate, however, was far too attached to his daily practice to entertain notions of leaving it, and in all three instances he quickly rejected the honor. For him the chief professional joy of life would always be the challenge of bending a jury to his will. "No gambler," one longtime admirer claimed, "ever hankered for the feverish delight of the gaming table as Choate did for that absorbing game . . . where twelve human dice must all turn up together one way."

In his youth, Choate's contemporaries were often struck by his handsome features. Of the impression left during his early years of practice in Salem, one acquaintance wrote that he was "the most beautiful young man I ever saw." By Choate's middle years, however, the "fresh, personal beauty" that had once characterized his face had given way to a sallow mass of idiosyncratic wrinkles, topped by thick, dark waves of ever-unruly hair. Apparently the change did not bother Choate; upon seeing a photographic likeness of himself, he once quipped: "It is as ugly as the devil; but still I must admit it is like—very like."

Choate's homeliness, however, did not deter interest in recording his features. Shortly after his death in 1859, no less than three Boston sculptors were at work on busts of him. Among these artists was Thomas Ball, who fashioned the portrait reproduced here. Commenting on the virtues of this piece in 1862, the *Boston Transcript* claimed that it was the finest likeness ever made of Choate and an eminently fitting "remembrancer of one whose place cannot not be easily supplied."

RICHARD HENRY DANA, JR.

1815–1882

ANNA PERTZ

active 1880s

Oil on canvas

99 x 81.3 cm. (39 x 32 in.)

Circa 1880

Richard Henry Dana

By the end of his second year at Harvard College, Richard Henry Dana, Jr., was suffering from a severe weakness in his eyes for which there seemed no remedy and which made him think that his days as a student were surely over. Unhappy with the prospect now before him of falling into a life of dependence on his family, Dana arrived at an alternative course that must have shocked some of his more class-conscious college friends. On August 14, 1834, having exchanged the "tight frock coat, silk cap, and kid gloves" of an undergraduate for "loose duck trousers, a checked shirt, and a tarpaulin hat," this scion of one of New England's oldest and most distinguished families was setting sail as a common seaman on the *Pilgrim*, a brig headed for California via Cape Horn. Despite his new garb, Dana later recalled, no one would have mistaken him for a "'regular salt'" as his vessel steered its course from Boston harbor toward the open Atlantic, and between the sheer strangeness of shipboard routine and a dreadful bout of seasickness during the first several days out, the youth could not help but wonder how he would survive the two-year voyage that lay ahead.

But Dana did survive; in 1836 he was returning to Boston a robust and entirely seaworthy young man of twenty-one. Moreover, the malady that had plagued Dana's eyes had disappeared, and he was soon resuming his studies at Harvard. In 1840, having earned his bachelor's degree and spent a year under the tutelage of Joseph Story and Simon Greenleaf at the Harvard Law School, he was establishing himself as a lawyer in Boston.

Dana was at a greater advantage than most neophyte members of the bar. For in that same year, his volume *Two Years Before the Mast*, chronicling his initiation into the seaman's life, had been published, and in the face of wide critical praise for this narrative, he had become something of a literary lion. More to the point, his sympathetic portrayal of the vicissitudes of shipboard life and the cruel corporal punishments sometimes meted out to insubordinate seamen quickly earned him a reputation as the sailor's friend. Thus, whereas many a beginning lawyer was apt to spend days on end waiting for clients who never came, Dana was besieged from the outset with sailor upon sailor coming to him in the hope of gaining legal redress for grievances against captains and ship owners. By the end of a working day, as often as not, his cramped office was filled with the unmistakable aromas of tar, salt water, and tobacco left by his duck-trousered clientele. Had he closed his eyes, he might well

CAUTION!!
COLORED PEOPLE
OF BOSTON, ONE & ALL,

You are hereby respectfully CAUTIONED and
advised, to avoid conversing with the

Watchmen and Police Officers
of Boston,

For since the recent ORDER OF THE MAYOR &
ALDERMEN, they are empowered to act as

KIDNAPPERS
AND
Slave Catchers,

And they have already been actually employed in
KIDNAPPING, CATCHING, AND KEEPING
SLAVES. Therefore, if you value your LIBERTY,
and the *Welfare of the Fugitives* among you, *Shun*
them in every possible manner, as so many *HOUNDS*
on the track of the most unfortunate of your race.

Keep a Sharp Look Out for
KIDNAPPERS, and have
TOP EYE open.

APRIL 24, 1851.

Broadside of April 24, 1851, reflecting the great indignation that Richard Henry Dana and so many other Bostonians felt over the implementation of the Fugitive Slave Law of 1850. Rare Books Division, Library of Congress

have imagined himself back on the *Pilgrim*, preparing to take an evening meal in the ship's mess.

Dana's seaman cases were generally small, involved paltry fees, and—given his propensity for laboring arduously over every detail—often proved more time-consuming than was necessary. In at least one instance, his role as the defender of sailors also became the source of considerable internal turmoil. In 1843, when a client's desire for confidentiality forced him to remain silent on certain facts that almost certainly would have led to a guilty verdict against a ship's captain charged with murdering his steward, Dana confided in his diary the great anguish that came with knowing that a man was about to go free while the "weapon to convict him" rested in Dana's own hand.

Nevertheless, Dana's frequent success in defending the ordinary sailor bore a long-term dividend. By the late 1840s he was coming to be regarded as an unusually knowledgeable expert in maritime law, and his practice was increasingly focused on more lucrative cases involving marine salvage and insurance. Within another few years, there were those who considered him one of the most capable admiralty lawyers in the country.

At the same time, Dana was becoming a specialist in yet another type of case that for awhile threatened to ruin his good reputation among his more conservative brethren. With the passage of the Fugitive Slave Act through Congress in 1850, the South had acquired a potent legal tool for recovering slaves who had sought freedom in northern states. As an abolitionist Dana was bound to dislike this measure, but as a lawyer he abhorred it even more in light of its failure to ensure a runaway's right to a fair courtroom hearing for determining his status as a slave. Consequently, as the antislavery forces of Boston mounted opposition to the Fugitive Law's implementation within their city, Dana was in the thick of it. From 1851 to 1854, while abolitionists more fanatical than he sought to thwart the new law by physically wresting suspected fugitives from the custody of federal marshals, Dana was in the courtroom challenging the validity of the Fugitive Law's Star-Chamber mechanisms for recovering runaways.

In the end, Dana's efforts accomplished nothing for the blacks he sought to protect, but by calling attention to the iniquities of the Fugitive Slave Act, they did contribute to increasing sympathy for the antislavery cause in quarters that had previously eschewed it as a danger to the national good. Shortly after Dana had finished his unsuccessful attempt to prevent the fugitive Anthony Burns from being sent back to his Virginia owner in 1854, he observed: "The change in public sentiment on the Slave Question is very great. Men who were hostile or unpleasant in 1851, are now cordial and complimentary. . . . Then, we were all traitors & malignants, now we are heroes & patriots."

To the world at large, Dana seemed by his middle age to have made a rather substantial success of himself. But Dana himself had always harbored ambitions for wielding great influence in political affairs, and after his own off-putting arrogance had repeatedly coalesced with other factors to block his aspirations in that direction, a feeling gradually crept

over Dana of disappointment in himself. "My life," he told his son in 1873, "has been a failure compared with what I might and ought to have done."

Six years after writing these words, Dana retired with his wife to Europe, where he pursued a life of comfortable leisure until his death in 1882. It was at some point in these final years that he sat for his portrait by the English artist Anna Pertz. In this likeness, there is a sense of melancholic pensiveness that seems to detach Dana from the world around him. Perhaps this was the expression of a purely artistic intention on Pertz's part. Just as likely, it was the result of her subject's late-life ruminations over unfilled ambitions.

CHARLES O'CONOR
1804–1884

EASTMAN JOHNSON

1824–1906

Oil on canvas

76.2 x 61 cm.

(30 x 24 in.)

Circa 1882

The Association of the Bar

of the City of New York

When Charles O'Conor opened his first New York City law office in 1824, his chances at succeeding in his chosen profession did not seem great. The son of a chronically impecunious Irish immigrant whose involvement in the failed Irish uprising of 1798 had forced him to flee his native land, O'Conor had had no more than a few months of formal education, and his legal tutelage under several lackluster New York lawyers had been mediocre at best. In an age and place where prevailing prejudices all too often relegated Irish Catholics to the lowest rung on humanity's ladder, the ethnic background of this ambitious twenty-year-old youth added only further to his liabilities.

Yet, if a cursory education and the wrong cultural origin augured poorly for O'Conor, there was in this youth a grim tenacity that more than compensated for such handicaps. By the 1840s, living an abstemious bachelor's life where the focus was almost exclusively on the study of his current cases and the perfection of his legal knowledge, O'Conor was rapidly emerging as one of New York's most highly esteemed lawyers. Although his combative and humorless nature would have barred him from winning any popularity contests, few would have denied the superiority of his skills.

In the long list of cases undertaken by O'Conor in his nearly sixty years of practice, there were a good many that attracted public attention, but by far the most sensational was the trial of *Forrest v. Forrest*. A divorce suit involving the famed actor Edwin Forrest and his wife Catherine, the case became a national *cause célèbre* in the early 1850s, and as counselor for the vivacious Mrs. Forrest, O'Conor was cast in the role of a gallant out to rescue his client's honor from not-altogether-unfounded charges of adultery.

The part was an unlikely one for this curmudgeonly lawyer, but apparently he was up to it. Countering the attacks on his client's honor with a succession of witnesses testifying that Forrest had himself been unfaithful, O'Conor even showed glimmers of a wry wit. At one point in the proceedings, after O'Conor had established that Forrest had for several years been a regular visitor to one of New York's houses of ill repute, the actor's lawyer hypothesized that quite possibly Forrest had visited this establishment with some "innocent purpose" in mind and that in each instance he had been "disappointed" in that purpose. "Why what a patient and long-suffering gentleman, he

must be," O'Conor rejoined, "staying there sometimes two and three hours, being every time disappointed. . . . Why one would think that he liked to be disappointed." A few moments later, turning to the jury, he declared, "You will say, gentlemen, whether Mr. Forrest went there to say his *pater noster*" for "three hours at a time."

Such arguments had their desired effect. On January 26, 1852, as several thousand curious onlookers milled in expectation outside the courthouse, the jury reported its verdict, exonerating Catherine Forrest of infidelity, declaring her famous husband a philanderer, and awarding Mrs. Forrest with a most handsome alimony.

Forrest himself never stopped believing that he had been unjustly treated in the affair, and he fought the verdict for years. But in the realm of public opinion, it appeared that a woman of good reputation had been saved from the clutches of a libertine. As the man who had done the saving, O'Conor was the hero of the hour. Several weeks after leaving the courtroom with his vindicated client engulfed in a sea of well-wishers, he became the recipient of numerous tributes to his noble service on Mrs. Forrest's behalf—among them an imposing silver vase presented by some thirty New York ladies.

For O'Conor, the law was the be-all and end-all of his existence, and as the years advanced on him, there was little letup in his busy practice. In 1871, now in his late sixties, he undertook one of the greatest challenges of his career, serving as a specially appointed deputy attorney general charged with prosecuting the case against New York City's notorious cabal of public officials and private contractors known as the Tweed Ring. In the next several years, O'Conor and his allies succeeded in finally putting an end to this corrupt clique, which, according to some estimates, may have robbed the public coffers of as much as sixty million dollars. But in O'Conor's view, the victory was Pyrrhic when measured against the facts that the original twelve-year prison sentence of ringleader William Tweed was reduced on appeal to one and that only a small portion of the Ring's plunder was ever recovered. Never one to equivocate, O'Conor eventually aired his disgust with the whole affair in a volume unmincingly titled *Peculation Triumphant: Being the Record of a Four Years' Campaign against official Malversation in the City of New York.*

In the last few years of his life, O'Conor retired to Nantucket. There he sat for his portrait by Eastman Johnson, who for some time had been coming to this seaside community to paint a series of pictures portraying its everyday life. O'Conor was now nearing eighty and in declining health. Nevertheless, the fiercely combative instincts that had once served him so well in the courtroom were still very much alive. Upon arriving in New York for a short visit in early 1884 to consult with a doctor about some of his current ailments, he hired a hack and quickly found himself locked in heated argument with its driver—so heated, in fact, that O'Conor finally hired another carriage. Upon taking his seat in the new vehicle, he told his companion, "I feel better already; it was worth coming to New York to beat that fellow."

This urn is one of the three ornate pieces of presentation silver that various groups of New York's citizenry gave to Charles O'Conor for defending the virtue of Catherine Forrest in her divorce suit. The New York Law Institute

ROGER B. TANEY

1777–1864

When President Andrew Jackson sent a message to the Senate in late 1835 announcing his appointment of Roger B. Taney as Chief Justice of the United States, the outcry of indignation, in certain quarters at least, was deafening. As Jackson's attorney general and later as his secretary of the treasury, Taney had done as much as anyone to block the congressional rechartering of the Bank of the United States, and in subsequently ordering the removal of federal deposits from that institution, he had eroded significantly its influence on the nation's economic affairs. While many Jacksonians roundly applauded Taney's part in destroying an enterprise that in their view had become corrupted by its own power, the conservative forces ranged against Jackson, which were emerging as the Whig party, saw Taney as a malevolent instrument in the assault on America's commercial well-being. Thus, the news of this gaunt Marylander's possible elevation to the country's highest judicial post struck these anti-Jacksonians as yet another blow to public good. Just as Taney had jeopardized the country's financial stability, they gloomily predicted, his presence on the court was certain to undo—in the name of Jacksonian egalitarianism—the precedents laid down by the late Chief Justice Marshall, designed to foster federal ascendance over states and to protect the nation's private entrepreneurial interests against the vagaries of democracy. "The pure ermine of the Supreme Court," one Whig newspaper railed shortly after the Senate had endorsed Taney's appointment in early 1836, was now about to be "sullied" by a "political hack."

But if the term political hack was meant to suggest that Taney had only his Jacksonian loyalty to recommend him for the chief justiceship, nothing could have been farther from the truth. In fact, Taney had spent many years as a practicing lawyer and in the process had earned a considerable reputation within his profession. Of his faultless logic and subdued courtroom manner, the redoubtable William Wirt had once said that they were like the moonlight of the Arctic, which "gave all the light of day without its glare."

More to the point, Taney was by no stretch of the imagination the *sans culotte* usurper that his Whig detractors painted him. Although this scion of a patrician Maryland family may not have shared many of Marshall's predispositions, he was never intent on sacrificing private enterprise to equality or nationalism to localism. As the years of his

Roger B. Taney

EMANUEL LEUTZE

1816–1868

Oil on canvas

147.3 x 113 cm.

(58 x 44¹/₂ in.)

1859

Harvard Law Art Collection

chief justiceship passed, however, it became clear that Taney subscribed to notions of state and federal sovereignty and private and public interests that called for qualifying some of the landmark decisions of the Marshall Court. Consequently, where Marshall had established federal preeminence in the regulation of interstate and foreign commerce, the Taney Court, in cases such as *Cooley v. Board of Wardens of the Port of Philadelphia*, declared that local governments had a right to control limited aspects of that trade for the sake of local welfare; and where Marshall had defended the sanctity of corporate charters against any state encroachment, Taney gave voice in *Charles River Bridge v. Warren Bridge* to the opinion that no agreement was so irrevocably sacred that it should be allowed to jeopardize progress and the common good.

In retrospect, such crucial qualifications made Taney's tenure on the Supreme Court almost as significant as Marshall's. For, while many of Marshall's decisions had made dynamic union under the Constitution a viable possibility, the Court under Taney's aegis did not so much check that possibility as strengthen it with its temporizing concerns for local autonomy and public interest.

By the mid-1850s the furor over Taney's appointment had long been forgotten, and in 1855 the *New York Tribune* went so far as to say that "the loss of Judge Taney . . . would be a public calamity." By early 1857, however, the Supreme Court was preparing to hand down a decision that was destined to raise a bitter rancor against Taney, far exceeding the barbs he had endured on becoming Chief Justice back in 1836. The case was known as *Dred Scott v. Sanford*, and it involved the question of whether a slave by the name of Dred Scott could claim his freedom as a result of many years of residence with his master in the western territories that, by the terms of Congress's Missouri Compromise of 1820, had been declared free. In speaking for the Court, Taney probed further into the issues than perhaps was wise in light of the increasingly impassioned debate over slavery between North and South. Taney, however, was not one to sidestep in the face of possible public disapproval, and on March 7, 1857, he read his opinion to the Court, declaring: one, that Scott did not have the right of a citizen to sue in court because the Constitution conferred such privileges only on whites; and, two, that the Missouri Compromise's ban on slavery in many frontier territories represented an unconstitutional exercise of congressional power.

The response to these dictums was immediate and strong. In the South apologists for slavery cheered wildly, while in the North abolitionists labeled the day of the Scott decision one of the darkest ever in the history of the republic. Here was one Supreme Court finding, cried one antislavery journalist, that "Cannot be Obeyed."

The opprobrium heaped on Taney in the wake of the Scott case was equal to the attacks on the decision itself. The *New York Tribune*, which only two years earlier had considered the thought of Taney's removal from the Court almost too horrible to contemplate, now referred to the nearly eighty-year-old Chief Justice as a "cunning chief"

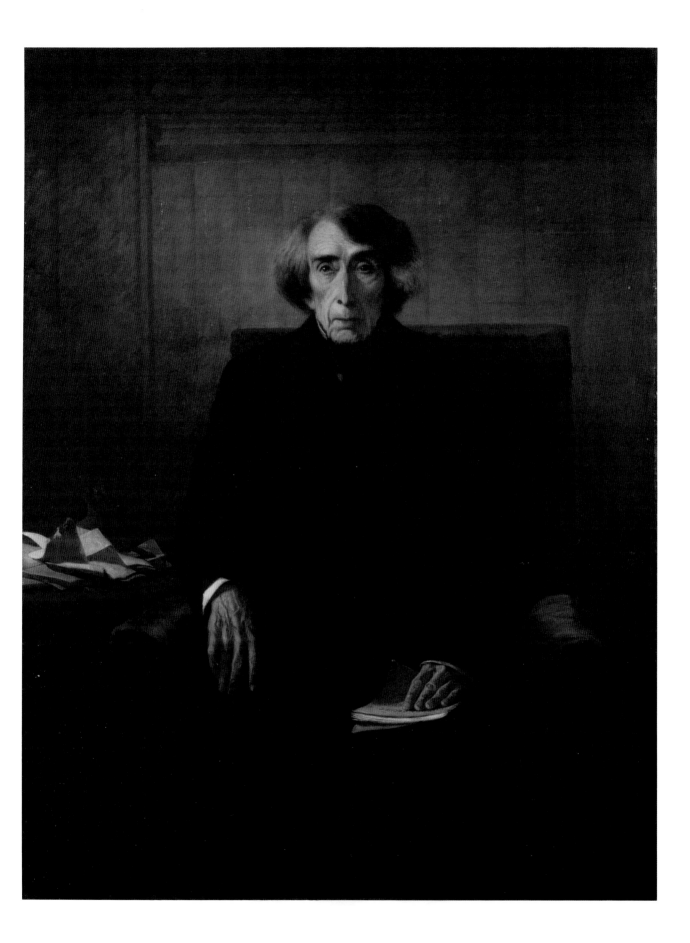

Broadside calling a public meeting to protest the Supreme Court's "atrocious" decision in the Dred Scott case, 1857. Special Collections, Langston Hughes Memorial Library, Lincoln University

A PUBLIC MEETING
WILL BE HELD ON
THURSDAY EVENING, 2D INSTANT,

at 7 o'clock, in ISRAEL CHURCH, to consider the atrocious decision of the Supreme Court in the

DRED SCOTT CASE,

and other outrages to which the colored people are subject under the Constitution of the United States.

C. L. REMOND,
ROBERT PURVIS,

and others will be speakers on the occasion. Mrs. MOTT, Mr. M'KIM and B. S. JONES of Ohio, have also accepted invitations to be present. All persons are invited to attend. Admittance free.

Dred Scott as he appeared about the time that the Taney Court handed down its decision on his claim to freedom.

Photograph, albumen print by an unidentified photographer, 1858 (negative Por S-127). Missouri Historical Society, St. Louis

trafficking in "historical falsehood and gross assumption." Yet another paper claimed that Taney "out-Herods Herod himself."

Despite such damning criticism, Taney remained steadfastly on the Court until his death in 1864. In these last seven years, he delivered what in retrospect have come to be viewed as two of his finest decisions—*Abelman v. Booth*, a fugitive slave case where he firmly denied the right of a state court to set aside a federal law, and *Ex parte Merryman*, where he offered a skilled analysis of the protections of civilians who were suspected of subversion during the Civil War. But both were wound up with the highly charged subject of slavery, and were perceived by many northerners at the time as simply more evidence of how Taney truckled to the slave powers of the South. As a result, even in death Taney could not redeem his once-good reputation. Shortly after he died in 1864, an anonymous pamphleteer observed that "he was, next to Pontius Pilate, perhaps the worst that ever occupied the seat of judgment among men."

Taney was always an unpretentious and intensely private man, devoted to his family and for the most part little interested in cultivating a public image. Throughout his tenure on the Supreme Court, he therefore had no use for the social aspects of life in the nation's capital to which his office gave him entree, and whenever it was possible to avoid public functions, he did. The desire for anonymity also extended to portraiture, and in response to a publisher's request for a likeness of him for reproduction in a book, he once wrote: "I have no ambition to be distinguished in that way; nor any vanity that would be gratified by the association you propose." Nevertheless, when the desire for a portrait came from within his family circle, he would not deny it, and in

late 1859, at the behest of his son-in-law James Campbell, Taney was posing in Washington for a likeness by the German-born painter Emanuel Leutze.

Even in his younger days, Taney's contemporaries had described him as a painfully thin, stooping man with a consumptively hollow voice. As the years passed, the frail, emaciated aspects of his appearance were only accentuated, and in Leutze's picture of him at age eighty-two, no effort was made to hide that fact. Yet somehow the enfeebled exterior recorded there also seemed to evoke something of the fundamental toughness that had seen Taney through torrents of criticism and that would enable him to weather the slings and arrows that continued to come his way in his remaining years.

WILLIAM M. EVARTS
1818–1901

EASTMAN JOHNSON

1824–1906

Oil on canvas

130.8 x 100.3 cm.

(51$\frac{1}{2}$ x 39$\frac{1}{2}$ in.)

1885

The Union League Club,

New York

His thoughts came out in long, convoluted sentences that defied the parser's art. Once he was launched into argument, he would often hold forth at far greater length than many in his audience felt necessary, and on one occasion he inspired the conjecture that he belonged to that forensic school which held that to be "immortal" a speech must also be "eternal."

Yet despite these idiosyncracies of self-expression, William M. Evarts never suffered from a want of clients or, for that matter, respect among his fellow lawyers. Even as a student at the Harvard Law School, he had struck no less than Joseph Story as an individual of "very uncommon talents and professional attainments." In 1842, just a few short months after his admission to the bar in New York City, when his senior co-counsels tapped him to make the opening argument in their defense of a notorious forger, the twenty-four-year-old Evarts measured up to that flattering appraisal. Although his client ultimately was convicted, the stamping feet and clapping hands that greeted this maiden effort in courtroom persuasion signified a personal triumph that in the annals of struggling young lawyers may well be unique. Almost before it had begun, Evarts's quest for professional recognition was over, and he was set on a path to eminence that was remarkable for its lack of obstructions.

Through much of his career, Evarts mixed law practice with heavy dosages of politics, eventually serving as a special emissary to England during the Civil War, as Rutherford B. Hayes's secretary of state, and as a United States senator. But the law remained his major preoccupation, and his talents for it made him party to many of the most notable legal imbroglios of his time. Thus, pitted against Charles O'Conor in the widely publicized Lemmon Slave Case of 1860, he succeeded in persuading a New York court that a slave brought from the South to a northern free state even temporarily was, by virtue of this change in residence, made free. After the Civil War, the government enlisted him to prosecute the Union's case of treason against the Confederacy's president, Jefferson Davis, and as attorney general for a short time in Andrew Johnson's administration, he played a central role in dropping the charges against Davis in the name of healing the nation's wounds. Several years later Evarts was in Geneva, Switzerland, preparing to defend America's claims against England for tolerating within its juris-

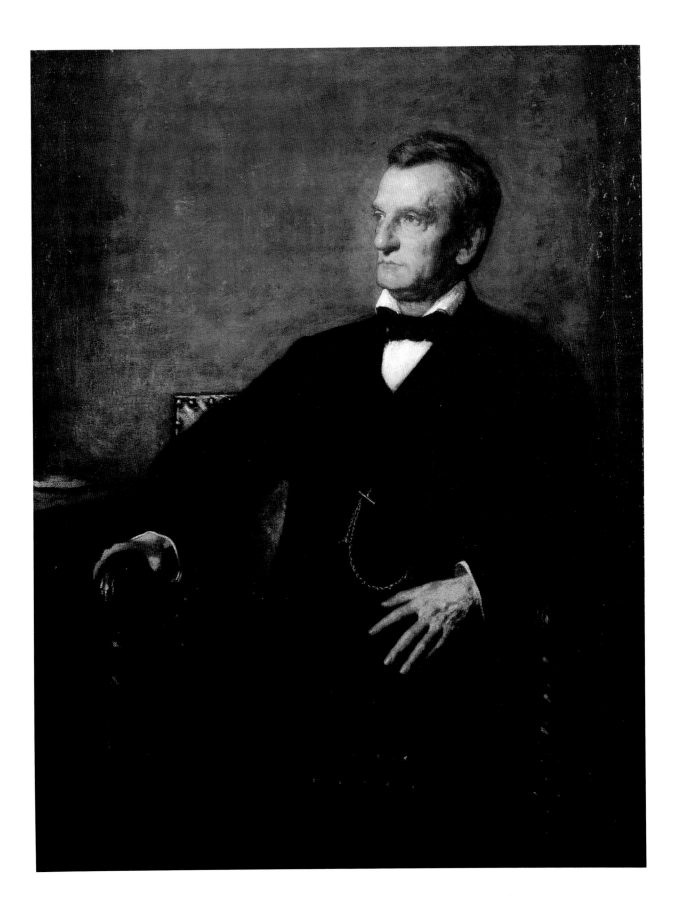

diction the construction of Confederate armed cruisers that had severely damaged northern shipping interests during the Civil War. In the end America's success in establishing British financial liability on this occasion rested largely on Evarts's learned exposition of the points in international law bearing on a neutral nation's obligation to restrain her private citizens from interfering in the affairs of warring powers.

Of all the scores of cases in which Evarts took a prominent role, the best remembered today is the impeachment trial, instituted by Congress in March of 1868, to remove President Andrew Johnson from office. In the rancorous battle between Johnson and the Republican-dominated Congress over the political reconstruction of the South after the Civil War, Evarts had generally approved Congress's attempts to replace Johnson's lenient policies with more stringent measures designed, among other things, to ensure the rights of newly freed slaves and to punish leaders of the Confederacy. In fact, at a Republican meeting in New York in October 1867, Evarts had stood before a banner declaring Johnson a "Traitor, Renegade, and Outcast" and had roundly chastised the President for his continued unwillingness to cooperate with Congress in this matter.

But for Evarts the campaign to undermine Johnson had its limits. When Congress sought grounds for a presidential ouster by passing the Tenure of Office Act, prohibiting the nation's Chief Executive from dismissing a cabinet adviser without Senate consent, and when Johnson then violated the new law on the grounds that it was uncon-

In this depiction of Andrew Johnson's Senate impeachment trial, the President's counsel, William Evarts, is seated at the table in the foreground on the far left.

Harper's Weekly, April 11, 1868. Division of Prints and Photographs, Library of Congress

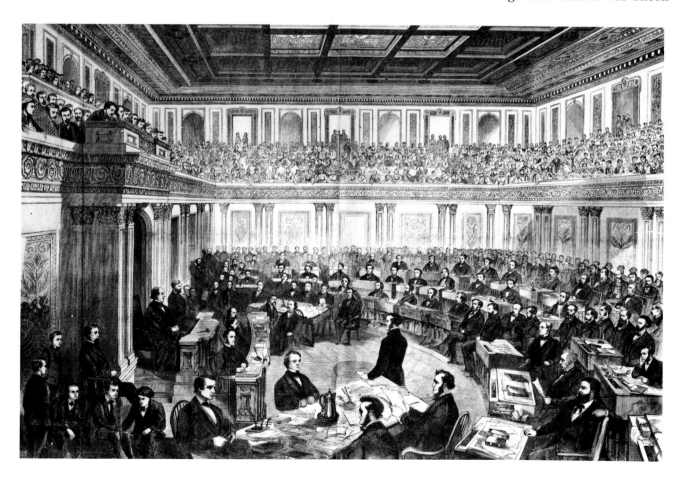

stitutional, those limits were reached. When this sequence of events culminated in impeachment proceedings against Johnson, Evarts readily agreed to serve as one of the beleaguered President's counsels.

Initially, Johnson had expressed deep reluctance to entrust his fortunes to this man who had openly attacked him only a few months earlier. In the end, however, he must have been thankful indeed that he had acquiesced to those advisers urging Evarts on him. Of the five counsels arguing Johnson's case before a hostile Senate in the spring of 1868, Evarts proved by far to be the most effective. In his summation—remaining ever true to his penchant for prolixity—he spoke for the better part of four days. But in doing so, he was shrewd enough to sense that, while a thorough answer to the charges against his client was necessary, the occasion demanded another tack as well. Playing masterfully to the packed Senate galleries, Evarts thus adroitly alternated his sober discourse on the facts of the case with well-timed flights of lambent wit that brought gales of laughter at the expense of Congress's anti-Johnson forces.

Just how much of a part this virtuoso performance played in bringing about Johnson's acquittal by one vote several weeks later is debatable. Nevertheless, of Evarts's complete command over the situation there was no question. His arguments, noted the *New York Tribune*, had "set the whole superstructure" of impeachment "ablaze . . . the flames hissing and crackling with alarming effect." Several days later a Cincinnati journalist noted, "The sentences fall from his lips, slow and rounded, like drops from a fountain, in a steady, easy succession, every word in its place, every clause polished. . . . His whole manner is that of perfect ease. . . . Nothing, it seems, could disconcert his easy dignity and self-possession." But a more telling compliment—albeit backhanded—came from Massachusetts Congressman Benjamin Butler, one of the prime movers in the attempt to unseat Johnson. According to Butler, Evarts "had stolen the livery of Heaven . . . to serve the devil."

No one ever described Evarts as a handsome man, but like Abraham Lincoln, whose raw narrow features resembled his own, there was a dignity about him that, as the years advanced, rarely failed to impress. Writing early in 1884 about a photograph she had recently made of him, Marion Hooper Adams surmised that a picture of "Moses and Solon combined" could not have looked more "judicial." When Eastman Johnson completed a likeness of Evarts shortly thereafter, the portrait seemed to echo that appraisal. In fact, as far as one observer was concerned, Johnson's success in imbuing Evarts with a law-giver's solemn air had been bought at the expense of veracity. Soon after the picture was installed at the National Academy of Design's annual exhibition of 1885, where Johnson's high reputation as one of America's most gifted portraitists had earned it a place of prominence, a Boston critic noted: *I cannot say that Eastman Johnson's portrait of William M. Evarts . . . is as good as most of this artist's work. Mr. Johnson has dignified and ennobled his subject, filling out the hollows and smoothing out the wrinkles . . . until one wonders and looks at the date of the canvas to see if the picture was not painted twenty-five years ago.*

BELVA ANN LOCKWOOD
1830–1917

NELLIE MATHES HORNE

1870–?

Oil on canvas

177.1 x 101.6 cm.

(69 ³/₄ x 40 in.)

1913

National Portrait Gallery,

Smithsonian Institution;

transfer from the National

Museum of American Art;

gift of the Committee on Tribute

to Mrs. Belva Ann Lockwood

through Mrs. Anna

Kelton Wiley, 1917

Even as an adolescent growing up in the rural environs of western New York State in the 1840s, Belva Ann Lockwood seemed unusually well endowed with ambition, intellectual curiosity, and sensitivity to perceived social iniquities. But in an age that declared woman's place to be in the home ministering to the needs of father, husband, and children, her prospects for giving full expression to these traits seemed dim. Lockwood, however, also had more than her fair share of determination. In 1853, when the death of her husband left her at age twenty-three an impoverished widow with an infant to support, she resolutely set about making her independent way in a world that not only frowned on such a course but generally blocked it as well. By the eve of the Civil War, having earned her B.A. degree at Genessee College, she was serving as preceptress of Lockport, New York's Union School. Within another several years, she had become the proprietor of her own female seminary in Oswego.

At the same time, inspired in equal parts by her own successes and the rhetoric of the nascent feminist movement led by Elizabeth Cady Stanton and Susan B. Anthony, Lockwood was becoming an outspoken advocate for permitting women to embark on any activity they chose. Consequently, she was not impressed when members of the communities she served advised her that girls were physically incapable of pursuing certain activities. Before long she was—to the chagrin of some and the amusement of others—introducing her female charges to the challenges of public speaking and a rigorous program of gymnastics.

In 1866 Lockwood sold her school in Oswego for a comfortable profit and moved to Washington, D.C., where she established a new academy and became a leader in local feminist circles. By 1870, doubtless remembering well her anger years earlier, when she discovered that her beginning teacher's salary was only half of her male counterparts', she was lobbying Congress for a law guaranteeing equal pay for equal work in the federal government.

But apparently teaching, mixed with a little agitation in the halls of Congress, was not enough to satisfy Lockwood. Soon after committing what she later cryptically called the "indiscretion" of marrying for a second time in 1868, she was embarking in her spare time on a regimen of self-study in the law. All went well in the new endeavor until Lockwood sought more formalized instruction, and it was only after three schools had rejected her application for admission to their law

course that the National University Law School finally consented to overlook the unsettling fact of Lockwood's sex and take her in.

This, however, was only the beginning of Lockwood's battle to become a lawyer. Having successfully completed the National University's legal curriculum, she failed to receive her diploma, and not until she dispatched a letter of protest to President Ulysses Grant did she finally receive that document. With that, Lockwood was admitted to the bar of the District of Columbia and permitted to practice in its local courts. But, when her rapidly growing caseload took her into the United States Court of Claims and later to the United States Supreme Court, the barriers of sexual discrimination redescended precipitously. While the judge in the Court of Claims banned her from his tribunal with the declaration that "woman is without legal capacity," the Supreme Court dismissed her with the declaration that it knew "no English precedent for the admission of women to the bar."

Recalling her moment of rejection in the Supreme Court many years later, Lockwood noted that "no pen can portray the utter astonishment" she had felt. But her dazed surprise was not paralyzing. Soon Lockwood was petitioning Congress for a bill permitting women to practice in any federal court with the single proviso that their training and experience qualified them to do so. On March 3, 1879, just a few days after this bill became law, Belva Ann Lockwood—wearing a "plain, black velvet dress . . . and blue cloth coat, cut *à l'homme*"—became the first woman to be admitted to practice in the United States Supreme Court. Three days later she was gaining the same privilege in the Court of Claims.

Lockwood could not claim to be the first woman to earn admission to the bar in the United States; that honor belonged to an Iowa woman named Arabella Mansfield. But in carrying out her campaign to win professional entry into the federal courts, she had broken significant new ground.

Achieving the right to argue cases in the Supreme Court, however, did not sate Lockwood's appetite for being in the feminist vanguard. In 1884, noting that, although women did not yet have the vote, there was nothing barring them from seeking the nation's highest office, she was taking time off from her law practice to run for the presidency. Few took her efforts seriously, and her campaign became the source of much newspaper levity. One journalist with a taste for sartorial punning, for example, reported that Lockwood intended to reward supporters with candy. "Bustle about girls," he thus counseled her followers, "and hoop things up if you want a caramel. Belva is going to fight it out on this crinoline if it takes all the rickrack in America." Nevertheless, Lockwood herself regarded her campaign as an effective means for dramatizing the cause of women's rights, and the fall of 1884 found her earnestly courting the nation's male electorate on a tour of several major cities.

In the end, Lockwood garnered a mere 4,149 votes in this contest, but the poor showing did not deter her from announcing her presidential candidacy again in 1888. By then, however, she was turning her attention to other endeavors. In the years following, when she was not

seeing to her legal practice, she was giving attention to promoting the cause of world peace and spearheading movements to liberalize the District of Columbia's laws regulating the rights of women.

Inevitably, the accomplishments of the pioneer bring honors. In this Lockwood was no exception. On February 10, 1913, Lockwood—now in her eighties—was joining a group of her admirers at a hotel in Washington to witness the unveiling of her portrait by Nellie Mathes Horne. In the several speeches delivered at this ceremony, some of the tributes exaggerated Lockwood's achievements, and one speaker identified her as "the original impetus to the woman's suffrage movement"—a description that any number of other feminists deserved with far greater justification. But one accolade was entirely warranted. As the woman who had won the right for her sex to practice law in the federal courts, she was indeed a "National Portia."

THOMAS M. COOLEY
1824–1898

LEWIS T. IVES

1833–1894

Oil on canvas

116.8 x 92.1 cm.

(46 x 36¹/₄ in.)

1885

The University of

Michigan Law School

The Michigan jurist Thomas M. Cooley was too mild and reticent in his outward mannerisms to cut much of a figure as a courtroom lawyer. Had circumstances confined his legal career exclusively to private practice, he would most likely be remembered, if at all, as a typical example of the scores of middlingly successful attorneys found handling minor cases of mostly local significance in small Midwestern towns in the mid- to late nineteenth century. But Cooley was marked for quite a different fate. Blessed with a sponge-like intellect, which enabled him to compensate for the meager rural schooling of his youth with remarkable efficacy, he led a career that in its multiplicity hearkened back to the indefatigable Joseph Story. Ultimately his accomplishments included twenty-one years as a justice on the Michigan Supreme Court, a large body of writings on the law, and, as one of the first faculty members at the University of Michigan Law School, a significant part in making the school a success. But the parallel with Story went deeper than that: Like this earlier jurist who was ending his career just as Cooley was beginning his, Cooley brought a level of excellence to his threefold endeavors that made him one of the most formidable legal influences of his day.

As a teacher at the Michigan Law School, Cooley was known for the simplicity and clarity of his lectures, and it was said that an abstract principle of law, once it had been restated in his words, required no illustration to underline its meaning. As for Cooley's performance during his tenure as a state supreme court justice from 1865 to 1885, the *American Law Review* commented at his death that his many judicial opinions were "in every respect models" that had "rarely been equaled [and] never surpassed."

For students of American legal history, however, Cooley's greatest single contribution to the law of his times lay in his book, *A Treatise on the Constitutional Limitations Which Rest upon the Legislative Powers of the States of the American Union.* First published in 1868, just as America was launching into a period of unequaled industrial expansion, the work struck a note that eventually made it a kind of Bible in many quarters of the legal community. For in tandem with the rush of economic growth came corporate practices relating to competition and the treatment of labor that all too often seemed to sacrifice public interest and welfare to profit. In the wake of this development, pressures for regulation of American business mounted, and as

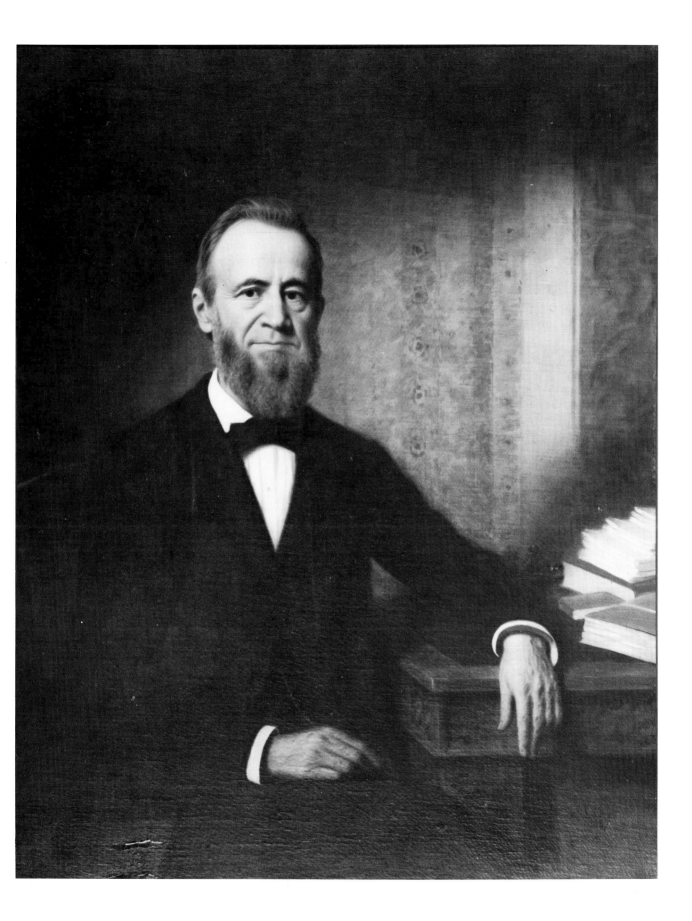

laws designed for that purpose passed through legislatures, the country's more business-oriented jurists felt a need for a theoretical framework for combating these new restraints. For many, that framework was to be found in *Constitutional Limitations* where, with characteristic precision, Cooley identified the constitutional protections of due process as a bulwark against unreasonable legislative encroachments on private property rights and asserted the right of the courts to determine whether a given business regulation seemed excessive.

In short, Cooley's book planted the seeds of that theory that ultimately became known as "substantive due process," and by 1900 it was being routinely invoked to invalidate laws meant to protect both the general public and workers from corporate practices deemed harmful to their well-being. In the process, his name became synonymous with the late nineteenth century's laissez-faire school of jurisprudence, which in the name of freedom of contract and property rights held that free enterprise ought to be left largely unfettered in its pursuit of profit.

Interestingly enough, Cooley himself was not among the most ardent implementers of this outlook. A firm believer in judicial self-restraint, he at once recognized the need for new legislative remedies to meet the exigencies of our rapidly changing economic institutions and subscribed to the opinion that the court's right to invalidate such measures should be used only sparingly. "A mere doubt," he once said, "of the validity of what the law-making department of the government has undertaken is no ground for annulling it," and he was deeply disturbed when fellow judges demonstrated an increasingly promiscuous inclination to let their doubts—born of personal prejudices in favor of business interests and clothed in the rhetoric of due process—undo a piece of reasonable legislation. Giving vent to his anxiety over this trend, he remarked in an opinion rendered in the Michigan Supreme Court in 1884: "There is ground for the belief that statutes have been assaulted by courts on objections that purported to be grounded in the constitution, but which, if plainly stated, would resolve themselves into this: that the judges did not like the legislation."

In 1887 Cooley's recognition of the need for governmental curbs on the nation's private enterprise was amply demonstrated when he became chairman of the newly created Interstate Commerce Commission. Established by Congress to halt a host of discriminatory and collusive practices among railroads in setting their rates, the commission represented the first federal venture into the active oversight of business. Cooley labored hard and effectively to make this experiment a success, and when ill health—brought on largely from overwork—forced his retirement in 1891, another member of the commission told him that, "in a field and for a class of questions where all was chaos before," he had succeeded at last in bringing some order. By the turn of the century, however, two Supreme Court decisions involving the ICC had for the most part shorn that agency of its power to curb railroad abuses. Ironically, the instrument for accomplishing this emasculation lay in an antiregulatory rationale that could trace a good deal of its inspiration to Cooley's landmark *Constitutional Limitations*.

CHRISTOPHER C. LANGDELL
1826–1906

Page one of Langdell's prepublication copy of *A Selection of Cases on the Law of Contracts* (1870), his first attempt to create a student text based on the case study approach. Harvard Law School Library

When the members of Harvard's Board of Overseers and Corporation first heard in 1870 that their school's recently appointed president, Charles W. Eliot, wished to appoint one Christopher Langdell to a law professorship, it seemed to many of them as if Eliot was arbitrarily pulling a name from thin air. No one had ever heard of this individual, and when Harvard's two governing bodies learned that, since his graduation from Harvard Law School in 1854, Langdell had closeted himself away in a New York office to serve mainly as an adviser to other lawyers in their practices, the wisdom of Eliot's choice seemed hardly more credible. Moreover, although the hermit-like Langdell was quite receptive to returning to Harvard as a member of its law faculty, he did not help his chances by turning down requests from the overseers to meet him.

But while the corporation and overseers remained a bit leery and mystified in this matter, President Eliot was certain that Langdell was his man. Although Langdell was not widely known even among his fellow lawyers, the few who were acquainted with his professional skills were mightily impressed, and for those whom he advised, he invariably proved to be an invaluable ally. Perhaps a more important factor in Eliot's decision to name Langdell, however, was Eliot's own recollection of encounters with Langdell back in the early 1850s. At the time, Eliot was an eighteen-year-old Harvard undergraduate, and Langdell was a student at the law school. Recalling how chance had on several occasions exposed him to some of Langdell's spirited discourses on law, Eliot years later noted that even as "a mere boy" he had sensed that he was listening to "a man of genius." So Eliot stuck to his choice, and in the end the corporation and overseers gave their reluctant blessing to Langdell, who shortly after accepting his professorship became dean of the law school as well.

Few events in the history of professional education in America have proved as significant as Langdell's arrival at Harvard. Up to 1870, the law school had been largely a genteel enterprise with few objective standards. In general all that was required of a young man entering its curriculum was that he be of a sound moral character. As for tests designed to measure how much students had learned in their courses, it was thought that since all of them were honorable gentlemen, such things were unnecessary. Under Langdell, all that was to change. During his tenure as dean, the school's eighteen-month course of study

Christopher C. Langdell

FREDERIC VINTON

1846–1911

Oil on canvas

127.3 x 102.2 cm.

(50$^{1}/_{8}$ x 40$^{1}/_{4}$ in.)

1892

Harvard Law Art Collection

was lengthened to two years and then to three; admissions standards were set and over the years became more rigorous; and a system of annual examination of students was finally instituted. At the same time, Langdell saw to it that the law school's long-neglected library finally received the attention it deserved, and by the early twentieth century its collection of legal writings had become one of the most distinguished in the country. In short, by the time Langdell retired from his deanship in 1895, the Harvard Law School had gone a considerable distance in setting new standards of excellence in legal training, and its success had made it a much-copied model for similar moves toward reform at other American law schools.

Important as this was, Langdell's greatest impact in altering the course of legal education was in classroom methodology. On coming to Harvard in 1870, Langdell was already firmly convinced that the time-honored lecture methods, whereby students were simply told *ex cathedra* the main guiding principles of the law, were largely ineffective. Instead, the most enduring learning took place, he maintained, in the firsthand examination of actual cases, where through their own powers of analysis students could discover for themselves not only the principles involved but also their origin and the reasoning behind them.

Today, Langdell's view seems quite reasonable. But when he instituted this approach in his course on contracts in 1870, the bulk of his students were miffed, and classroom attendance plummeted as he socratically attempted to lead them toward self-enlightenment. Before long, Langdell was commonly thought to be little more than an eccentric "old crank."

Part of the explanation for this negative response could be laid to Langdell's personal idiosyncracies. A patient and coldly logical plodder, Langdell once remarked that he had the "virtues of a slow mind," and when his dry, deliberative manner was brought to bear in the classroom, one student later recalled, he seemed quaintly "medieval."

Archaic manner or not, Langdell could be, as another Harvard dean once noted, "as *intransigeant* as a French Socialist," and he was not about to let the criticisms of students cow him into a teaching strategy in which he had no faith. In the years following, he brought to Harvard a number of new professors sympathetic with his approach, who employed the case method more effectively than he. By the 1890s, the case study had become the primary instructional vehicle at the law school. Within another few decades, it would become the dominant means of teaching law in most American schools.

Students were not the only ones to balk at Langdell's zest for change. As he sought to raise entrance and exit standards during his early days at Harvard, for example, some of the school's officials predicted that his tenure at the law school would mark an irreversibly disastrous decline in enrollment, and for awhile there was in fact a fall in student numbers. Yet others shared in the lament of a midwestern law journal that the school had become so fond of escalating its requirements that if any future John Marshall came "knocking at its

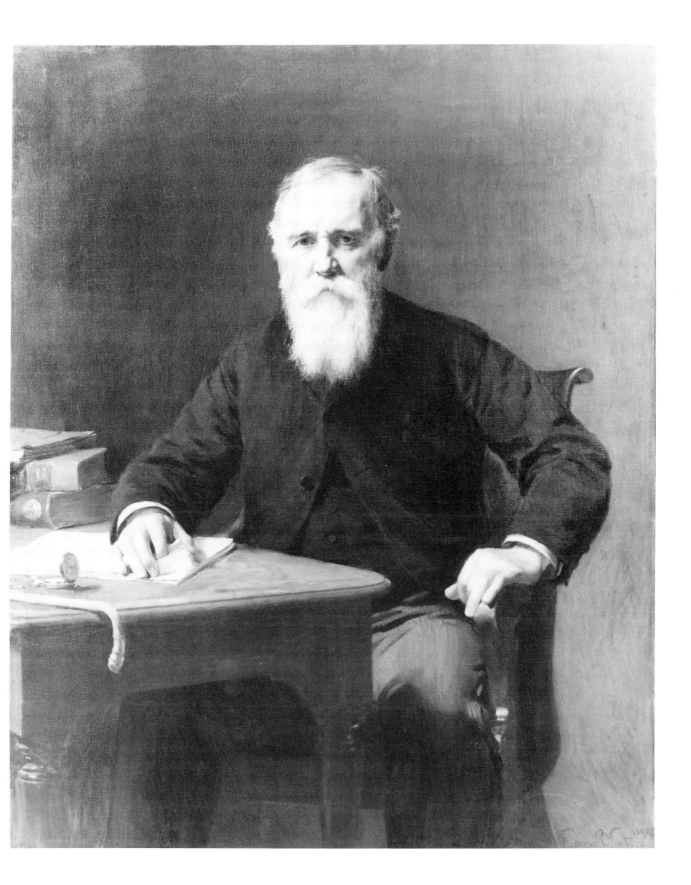

classic doors," he would find himself turned away for want of proper preparation.

In the end, however, the plaudits far outweighed the brickbats. In 1892 the Harvard Law School Association was preparing to honor Langdell's accomplishments by commissioning the currently fashionable Boston artist, Frederic Vinton, to do a portrait of him for the school. Several years later, he became the first living person in the history of Harvard to have a professor's chair named for him. But the most meaningful tributes to Langdell's achievements came from his students. In 1889 one of the first to be exposed to his novel teaching methods, a young lawyer named Louis Brandeis, wrote: *When the end of the chapter of cases is reached, the student stands possessed of the principles in their full development. Having attended as it were at their birth, having traced their history from stage to stage, the student has grown with them and in them; the principles have become part of his flesh and blood. . . . Like swimming or skating, once acquired, they cannot be forgotten.*

JOSEPH H. CHOATE
1832–1917

When Joseph Choate left his native Massachusetts in 1855 to establish himself as a lawyer in New York City, he carried a letter from his father's cousin Rufus to William Evarts, describing him as an individual of "extraordinary promise" and ending with the prediction that "if you can do anything to smooth the way to his steps, the kindness . . . will yield all sorts of good fruit." Rufus Choate's roseate recommendation was largely unnecessary, however. For even as a largely untested youth, Joseph Choate seemed well able to stand on his own. Salutatorian of Harvard's class of 1852 and a graduate of the Harvard Law School, he had, with the possible exception of a monied background, every asset needed for worldly success—intelligence, good looks, an unusually robust constitution, and a natural social ease that in years to come would make him a much-loved fixture in the upper reaches of New York society.

Upon joining Evarts's law firm as clerk, Choate demonstrated his worth quickly and within three years was being offered a partnership. By the late 1870s, he had become one of the leading members of New York City's bar, and in 1893 the *New York Tribune* was informing its readers that it had for some time now been a commonplace that "the great lawyers who are Mr. Choate's contemporaries divide among them one-half of the business of the first magnitude, and Mr. Choate has the other half to himself."

The *Tribune's* claim was, of course, an exaggeration. Nevertheless, the long roster of cases handled by Choate in his career at the bar included an unusually large number of noteworthy ones. A counsel for both Standard Oil and the American Tobacco Company in various historic antitrust proceedings brought against them, he was also involved in much-publicized litigation over the wills of railroad moguls Cornelius Vanderbilt and Leland Stanford. At the same time, he could take a large share of the credit for reserving the Bell System's patent rights on the telephone and for winning sanction for the building of the Brooklyn Bridge.

In later years, Choate always considered his finest moment as a lawyer to have been his successful effort in 1879 to gain reversal of a Civil War court martial finding that had declared Union General Fitz John Porter guilty of "treasonable activity in the presence of the enemy." Reconstructing the evidence some sixteen years after Porter's original trial, Choate claimed, was a truly Herculean effort. But there were those

who believed that the greatest test of Choate's powers did not come until 1895, when in the case of *Pollock v. Farmers' Loan and Trust Company* he undertook to convince the Supreme Court that the federal law levying a tax on incomes in excess of $4,000 was unconstitutional.

Perhaps Choate himself did not think as highly of his part in the income tax case as he did of his role in vindicating Porter, because he was so unequivocally certain of his ground in *Pollock* and therefore able to frame his arguments easily. At any rate, given the dollar's much greater value in the 1890s, the recently established income tax mainly affected only the rich, and in Choate's estimation, as long as it was allowed to stand, it represented the first leveling step toward communism.

So believing, Choate girded himself for his attack on this revenue measure as if preparing for Armageddon, and in early March of 1895 he was entering the Supreme Court chamber armed with every line of argument his fertile mind could muster. Mixing statistical analysis of America's current income distribution with sardonic barbs at his opposition's reasoning and constitutional logic with emotion-laden portrayals of widows laid helplessly low by the tax, his performance was, according to some, fully equal to Daniel Webster's in the Dartmouth College case. "And when he sat down," the *New York World* reported, "everyone . . . present felt that . . . the income tax had had its worst blow." If by some outside chance it had survived Choate's "splendid assault of close-armored, close-ranked arguments," the paper opined, then it could withstand anything.

The *World's* assessment proved correct. A month later, the Supreme Court—by a five to four majority—declared the income tax null and void, and it was not until the passage of the Constitution's Sixteenth Amendment in 1913 that it finally became legal.

To a large extent, the qualities—keen intellect, diligence, and forensic ease among them—that made Choate a good lawyer were the same ones that have accounted for the rise of a good many other notable American jurists. But there was also a streak of acerbic impudence in Choate that in others would have been a liability but in his case seemed to be just another professional asset. On finding himself in the 1880s, for example, summing up a case before a judge who periodically stopped listening to engage in his own side conversations, Choate suddenly stopped, and casting disapproving eyes toward the bench, declared: "Now, if Your Honor please, under your time allowance, I have just forty minutes in which to close the argument of this very difficult and vitally important case, and I must insist upon having Your Honor's undivided attention every moment of that time." "You have it, sir," came the embarrassed response, and Choate won his case. On yet another occasion, a judge threatened to cite Choate for contempt if he dared to repeat what he had just stated. "I have said it once," the object of this chastisement brazenly replied, "and it is unnecessary to say it again."

In 1899 Choate temporarily forsook his law practice to become ambassador to England and eight years later was heading the American delegation to the Second Hague Conference on international arbitration. Apparently his haughty audaciousness placed him in good stead on these missions, and of his role at the Hague, a European commentator wrote:

Joseph H. Choate

JOHN SINGER SARGENT

1856–1925

Oil on canvas

147.3 x 96.5 cm.

(58 x 38 in.)

1899

Harvard Club of

New York

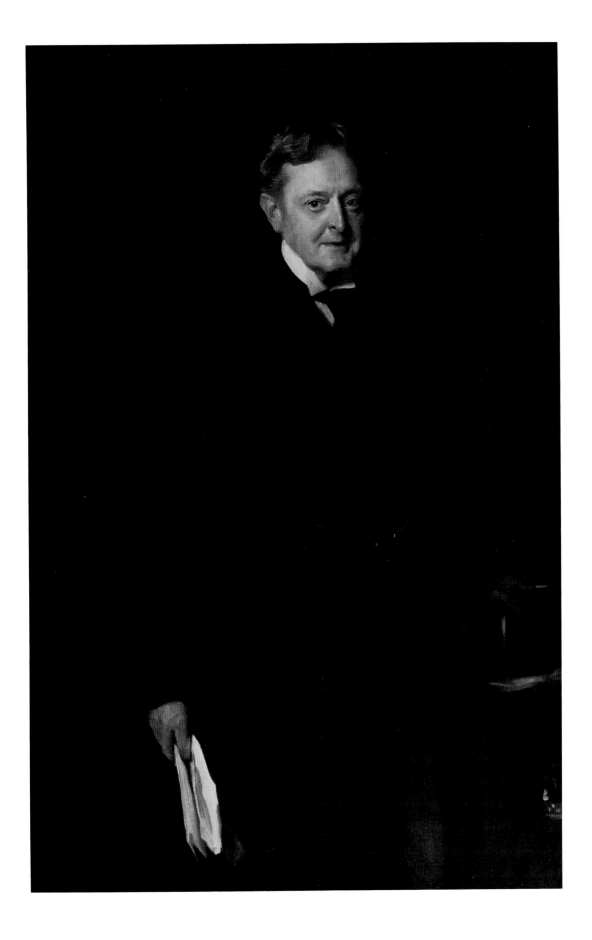

"He it is who . . . inserts a few cold words which effectively shatter the grandiloquent bubbles of his colleagues."

When Choate arrived in London to take up his diplomatic duties at the Court of St. James's, one of his first tasks was to pose for his portrait. Commissioned for New York City's Harvard Club, of which he had been president, the picture was the work of John Singer Sargent, the American expatriate painter whose reputation as the preeminently fashionable portrayer of the Anglo-American elite was at full tide. Sargent's low-keyed interpretation of the new ambassador was by no means the most dramatic example of the "dashing manner" and "clever brushwork" that had given rise to the term "Sargentolatry." Yet it did seem to capture something of the urbane authoritativeness that Choate seemed to carry into all his endeavors.

JAMES C. CARTER
1827–1905

John Singer Sargent's portrait of Joseph Choate—noted previously—has for many years hung side by side at New York's Harvard Club with another Sargent likeness of similar composition and size, the only difference being that the man seen in this second picture faces in the opposite direction. The subject of this other canvas, completed in London the same year as Choate's, is James C. Carter, and clearly from the day it was finished it was intended to be shown with Choate's portrait. The reasons for this juxtaposition were several, for the parallels between Choate and Carter were remarkable. Having graduated from Harvard College and Harvard Law School at about the same time, the two men had reached the top ranks of America's legal profession roughly simultaneously, and like Choate, Carter had served as president of the Harvard Club. But perhaps the most interesting connection between these two successful New York lawyers lay in the parts they had played in the income tax case of 1895. On that occasion, while Choate marshaled his intellectual resources to convince the Supreme Court that the tax was invalid, Carter was bringing his to bear in defense of such a levy. Thus, although the pairing of their Sargent portraits might well have occurred without this face-off, it is difficult to believe that these pictures were not meant, in part at least, to commemorate Carter and Choate's adversarial relationship in this momentous piece of litigation.

But if Carter had a good deal in common with Choate, much set him apart, and indeed this lifelong bachelor pursued his profession with a single-minded and humorless dedication that was unique. Living by the maxim that a lawyer must "really believe what he says," he embarked on each case as if there were no legitimate view other than his own, and with a combative abrasiveness that brooked no disagreement, he hammered unremittingly away at his opponents. According to Choate, this tendency to dismiss the opposition argument out of hand often placed Carter at a disadvantage because it frequently blinded him to the wisdom of shoring up his own case against unanticipated attacks. But although Carter's bombastically self-righteous approach lost him a good many cases and temporarily alienated some of his fellow lawyers, it did not seem to diminish his clientele. On the contrary, as the years advanced, Carter became to the law what the leading physician was to medicine: the more critical the case, the more his services were deemed indispensable.

At the same time, Carter's affinity for strong argument drew him into

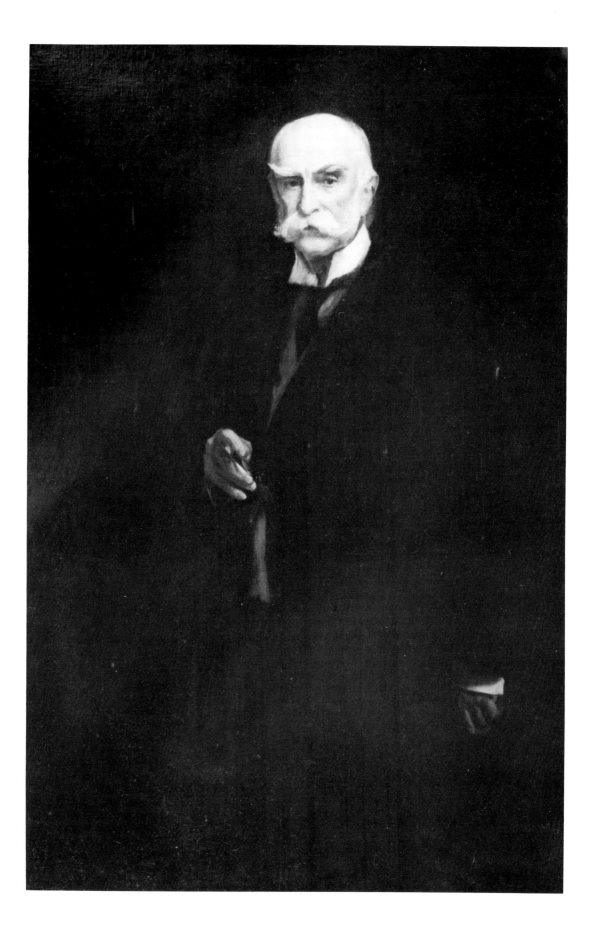

debates outside of his practice, the most notable of which focused on the nineteenth-century effort to streamline American law. Following the Revolution, the courts of this country had continued to rely for the most part on the English common law custom of basing their findings largely on examinations of judicial decisions of the past. For some, however, such a system seemed unduly complex and, given the large and sometimes diverging body of precedents that could be brought to bear in a given situation, mystifyingly arbitrary as well.

As a result, a movement emerged calling for the replacement of common law with legislatively enacted codes, and when New York State began considering the adoption of a civil code regulating the transactions of private individuals in the mid-1870s, the strong-minded Carter inevitably had some passionately felt thoughts on the matter. By the early 1880s, he was at work on *The Proposed Codification of Our Common Law*, a blistering attack on the notion of reducing the complexities of common law to statutes. Premised on the belief that codification was a borrowing from the "systems of despotic nations" and a threat to the American legal system's flexibility in adapting fundamental principles of justice to particular situations, this volume made Carter the primary spokesman opposing this reform.

Ultimately, the campaign led by Carter to defeat the civil code in New York succeeded. But by then Carter had so warmed to the argument that he was loath to let the matter drop, and for a number of years he took every occasion afforded him to spread his anti-code gospel to other states. "Nothing is ever decided until it is decided right," he was fond of saying, and if he had anything to say about it, clearly this issue was not going to prove the exception to that assertion.

James C. Carter

JOHN SINGER SARGENT

1856–1925

Oil on canvas

147.3 x 96.2 cm.

(58 x 37⁷/₈ in.)

1899

Harvard Club of New York

JOHN MARSHALL HARLAN
1833–1911

PIERRE TROUBETZKOY

1864–1936

Oil on canvas

114.9 x 76.8 cm.

(45¹/₄ x 30¹/₄ in.)

1908

Collection of the Supreme

Court of the United States

From its beginnings, members of the United States Supreme Court have generally kept outward demonstrations of emotion carefully in check, and if disagreements over decisions have engendered feelings of personal animosity between justices, expressions of this ill-will have by and large never reached the public. In 1895, however, onlookers at the Court witnessed one of the most extraordinary exceptions to the time-honored rule of judicial self-control. In the spring of that year, pounding his desk and periodically shaking an outraged finger at no less than the Chief Justice himself, one of the justices threw decorum to the winds, delivering his minority dissent in the case at hand "in a tone and language more appropriate to a stump speech . . . than to an opinion . . . of law."

The occasion for this harangue was the income-tax case *Pollock v. Farmers' Loan and Trust,* and its author was Justice John Marshall Harlan, who saw the Court's majority decision to void a national levy on incomes over $4,000 as a dangerous emasculation of Congress's power to ensure the dynamic character of this country's federal system of governing. But if *Pollock* afforded one of the most dramatic examples of Harlan's dissenting vehemence, it was by no means either the first or the last. In the course of his tenure on the Court from 1877 to 1911—a span of service exceeded by only two other justices—this Kentucky-born jurist registered disagreement with the majority of his Supreme Court brethren many times. In fact, of the more than one thousand opinions written by him, his minority dissents are the ones that are best remembered and most studied today.

For many years a lecturer on law at Washington, D.C.'s Columbian University, Harlan once told his students that, if he and his fellow justices did not like a law, "we don't have much trouble to find the grounds for declaring it unconstitutional." Although this comment suggested that it was possible to invoke legal rationales to suit just about any personal bias held by the justices, it did not mean that Harlan himself was always in accord with the practice. Thus, when the pro-business outlook began prevailing on the Court in the 1890s to sharply circumscribe federal legislation designed to curb American corporate excesses, he often found himself entering vigorous dissents. In doing so, he reflected to some extent his own prejudices, which were simply at variance with the rest of the Court's. But on occasion he also went beyond that to articulate a theory of judicial self-restraint, which held that it was not a court's

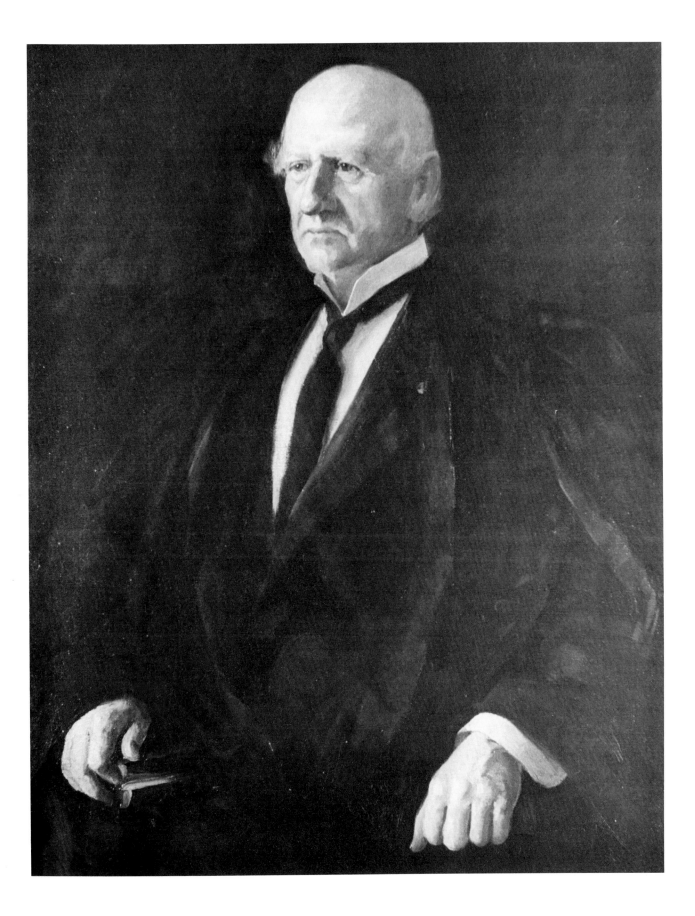

prerogative to amend the intent of a given legislative measure by reading into it qualifications that were never there in the first place. Speaking to this point in the landmark case of *Standard Oil Co. v. United States* of 1911, where the Court ruled Standard's monopoly on oil production illegal because it represented an unreasonable restraint of trade, he pointed out that the distinction between reasonable and unreasonable was not mentioned in Congress's antitrust legislation. That being so, his fellow justices had no right to put it there. This privilege, he asserted, was reserved to the people, who, "upon reflection and through the legislative department of government," might in time decide that such an alteration was in order.

Following the Civil War and the elimination of slavery, Congress passed the Fourteenth Amendment to ensure that the nation's newly freed blacks would enjoy the same full complement of civil rights that whites did. By the early 1880s, however, the Supreme Court—along with the nation as a whole—had chosen to ignore the amendment's original intent, and as cases challenging the legality of various discriminatory measures instituted against blacks came before it, the majority of its justices were increasingly disposed to let the measures stand.

Strangely enough, one of the strongest critics of this trend was Harlan, who had himself once been a slaveholder and a foe of both emancipation and the Fourteenth Amendment. By the 1880s, however, he had not merely reconciled himself to the amendment; he had become an ardent champion of enforcing it with scrupulous vigor. Consequently, when cases came before the Court challenging such practices as denial of accommodations to blacks in hotels and theaters, he took the Court sharply to task for its willingness to uphold discrimination and accused it of killing the Fourteenth Amendment's "spirit and substance" with "subtle and ingenious" interpretation.

Harlan's most masterful dissent from the Court's sanguine acceptance of racial discrimination came in the 1896 case of *Plessy v. Ferguson*, involving the validity of a Louisiana law requiring separation of blacks and whites on passenger trains. In upholding this statute, the Court's majority invoked the concept of "separate but equal," which meant that segregation by race was entirely in keeping with the Constitution so long as accommodations were on a par with each other. For Harlan, the reasoning behind this principle was pure sophistry, designed to pave the way for a Court-endorsed caste system. By definition, he said, any segregation imposed on blacks by the white power structure stamped them automatically "with a badge of inferiority." Moreover, he predicted, "the judgment this day rendered will, in time, prove to be quite as pernicious" as the Dred Scott decision of 1857, which, in reserving the rights of citizenship guaranteed in the Constitution to whites only, had fed the fires of disunion and civil war.

In his own day and for years thereafter, Harlan was widely regarded as an eccentric, easily dismissed maverick. But eventually many of the views aired in his minority dissents gained currency, and by the late 1930s his call for self-restraint in passing on the validity of legislation was widely accepted as the proper judicial stance. More significant, however, Harlan's outlook on civil rights ultimately found vindication when in

1954 the Supreme Court banned racial segregation in American schools and by a vote of 9 to 0 declared "separate but equal" an unacceptable formula for regulating this country's race relations. Not surprisingly, this turn of events had a dramatic effect on Harlan's reputation, and in 1972 a survey of experts listed him among the twelve great justices of the Supreme Court.

When Harlan posed for his portrait by the Russian émigré artist Pierre Troubetzkoy in 1908, he was in his mid-seventies, but advancing years had not diminished the air of cocksure conviction that made it seem "as if the whole world belonged to him." A deeply religious man, Harlan retired at night, a colleague on the Court once claimed, "with one hand on the Constitution and the other on the Bible, safe and happy in a perfect faith in justice and righteousness." In its ramrod posturing Troubetzkoy's likeness suggests that, figuratively at least, that may well have been the case, and it requires no great leap of imagination to believe that the man seen in the canvas was the same one who thirteen years earlier had accusingly wagged his finger at a Chief Justice for failing to see the law as he did.

CLARENCE DARROW
1857–1938

JO DAVIDSON

1883–1952

Bronze, 44.7 cm.

(17⁵/₈ in.)

1929

National Portrait Gallery,

Smithsonian Institution

In 1887, bored with the commonplace character of his practice, Clarence Darrow closed his modestly prosperous law office in the rural Ohio town of Ashtabula and set out for Chicago in the hope of carving out a more interesting professional life for himself. Chicago, however, was filled to overflowing with young lawyers on the make, and the thirty-year-old Darrow—trained in a country law office and claiming no influential connections—initially had trouble envisioning how he was going to survive in this burgeoning metropolis.

But the anxieties engendered by Chicago's hustling bigness daunted Darrow only momentarily. Although the first year of practice in his new home earned him no more than about three hundred dollars, a penchant for liberal causes and a gift for public oratory soon made him a familiar figure in the city's more reform-minded circles and something of a power in the Democratic party. By 1889 he was serving as corporation counsel for the city. Within another two years he had become an attorney for the Chicago & Northwestern Railway, and in 1893 a newspaper in his native Ohio informed its readers that "Clarence Darrow is now a leading lawyer of Chicago."

Having inherited the egalitarian and anti-establishment instincts of his freethinking father, however, Darrow found certain aspects of his comfortable niche troublesome. When he was faced, for example, with defending Chicago & Northwestern in personal-injury suits brought by employees and members of the general public, his sympathies lay less with his client and more with the plaintiffs, whom he saw as victims of corporate rapaciousness. For awhile Darrow avoided the strain that such cases placed on his conscience by leaving them to other company attorneys. But ultimately this strategy could not down the uneasy feeling that, in industrial America's growing battle between labor and corporate interests, he had become "a hypocrite and a slave" to the wrong side.

Finally in 1894 the inevitable happened. When workers at the Pullman Company's railcar plant near Chicago struck over a wage cut, and American Railway Union members voted in sympathy to stop working any trains using Pullman cars, the nation found itself facing the possibility of labor violence and widespread paralysis in its transportation network. For railroad management and government authorities, the solution to the crisis was clear: In the name of ensuring the flow of interstate commerce and the safety of railroad property, the ARU, led by Eugene V. Debs, would be enjoined to desist from its secondary boycott,

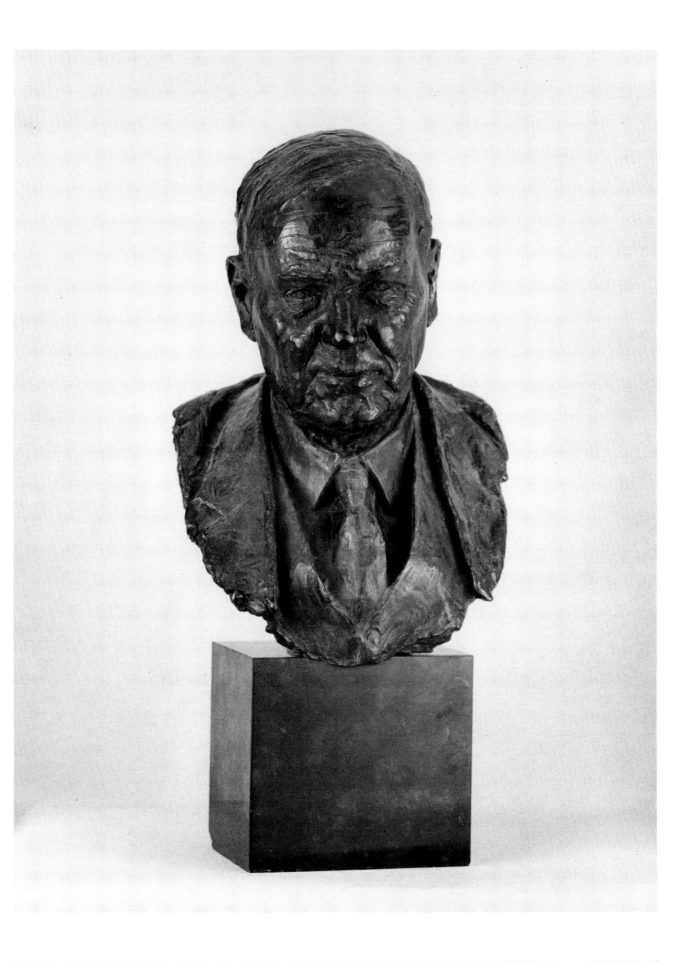

BIG BLUE BOOK NO. **B-20**
Edited by E. Haldeman-Julius

Clarence Darrow's Plea in Defense of Loeb and Leopold

(August 22, 23 and 25, 1924)

my good friends
m men for Davidson
you can
Clarence Darrow

Camp P421-1930

HALDEMAN-JULIUS COMPANY
GIRARD, KANSAS

Through Darrow's three-day closing argument in his defense of Loeb and Leopold, the packed courtroom hung on his every word. According to one biographer, it was his most "masterly oration . . . saved from cheapness by his ability to move not just others but himself, and from tawdry sentimentality by his own spontaneous emotions."

Copy of Clarence Darrow's *Plea in Defense of Loeb and Leopold,* presented to Darrow's portraitist Jo Davidson. Manuscript Division, Jo Davidson Papers, Library of Congress

and if it persisted, its leaders would be imprisoned on charges of criminal conspiracy to break the civil peace and violation of a court injunction. For Darrow, however, the proper course ran in another direction. When Debs found himself imprisoned in the wake of his refusal to call off the strike, Darrow immediately resigned from the Chicago & Northwestern and with impassioned zeal enlisted himself in the ARU's cause.

In the end, Darrow's vehement courtroom castigation of railroad management proved so effective that the criminal conspiracy charges against Debs were dropped, but on the charge of violating a federal injunction he was found guilty. In one respect, however, this half-victory proved a total triumph. Once Darrow had leapt to the workers' side of the labor-management chasm, there was no jumping back. For the next fifteen years or so, this onetime corporate lawyer would be organized labor's most vociferous and best-known legal spokesman.

Darrow's strategy in his newfound role as labor's courtroom champion relied primarily on emotional diatribes portraying workers as victims of "great, monstrous, greedy corporations" bent on "corrupting the life blood of the nation." In many instances this approach worked well and in the process made him the workingman's hero. But in 1911 Darrow's good repute in labor circles came to an end in the much-publicized McNamara case, in which union organizers James and John McNamara were accused of orchestrating the bombing of the offices of the rabidly anti-union *Los Angeles Times.*

In taking on the defense of these brothers, Darrow led unionists, who had raised many thousands of dollars to pay his fees, to believe that he thought the McNamaras innocent. At the trial, however, on his advice, his clients entered, to everyone's shock, a plea of guilty. Moreover, in the course of these proceedings, Darrow himself became open to charges of jury tampering. As a result, although he was later acquitted of any wrong-doing, and although the guilty plea had resulted from clear and convincing evidence implicating the McNamaras in the bombing, the labor organizations who had rallied to the McNamaras' defense felt that Darrow had betrayed them.

With that, Darrow lost his longstanding welcome within the labor cause, and, following his final jury-tampering hearing in 1913, it appeared that at age fifty-six he was washed up. In fact, the most celebrated phase of Darrow's career was yet to come. By the early 1920s his legal specialty had shifted to criminal law, and in 1924 he took on a case that would mark him as America's legendary "attorney for the damned."

On this occasion, his clients were Nathan Leopold and Richard Loeb, the privileged scions of wealthy Chicago families, who, in an effort to demonstrate their genius for committing the perfect crime, had cold-bloodedly murdered a youth by the name of Bobby Franks. The perfect crime, however, did not go undetected for long, and when questioned by police, Loeb and Leopold quickly confessed. Thus, by the time Darrow entered the case, saving these two young men from the death penalty on grounds of insanity had become the defense's main objective.

In an atmosphere charged with bitter pretrial prejudice against his clients—spawned largely by their families' substantial wealth—this was no easy task. But Darrow proved a master at savaging the prosecution's

assertions of Loeb and Leopold's sanity. At the same time, he turned the case's wealth factor from a liability into an asset, claiming that, had Loeb and Leopold been poor, "not a state's attorney" in all Illinois would have hesitated a minute to forgo the death penalty in exchange for a guilty plea. Most important, Darrow argued his case with a spellbinding emotionalism, and when the court ultimately sentenced his clients to life imprisonment, it was clear that the tenor of his pleading had been as crucial to saving them from the gallows as its substance.

At the time of the Loeb-Leopold proceedings, Darrow was sixty-seven. Nevertheless, his great moments in the courtroom were not over. In the summer of 1925 he was in Dayton, Tennessee, where, in the midst of sweltering heat and carnival brouhaha, he defended the right of high-school teacher John Scopes to teach biological evolution. Technically Darrow lost the case. In doing so, however, he also devastated the biblical literalists who had prompted Tennessee's prohibition against teaching Darwinian theory, and his brutal sparring over the book of Genesis with Scopes's prosecutor William Jennings Bryan became a classic in American legal annals practically before it was over.

By the late 1920s Darrow had generally withdrawn from active practice and was devoting most of his energy to the lecture circuit. He was also giving some thought to posterity's view of him, and around 1928 he was sitting for a portrait by his longtime friend, sculptor Jo Davidson, with an eye, it seemed, to presenting it to a public institution. Well known for his frank and penetrating likenesses of the famous, Davidson was quite pleased with his interpretation of Darrow, and upon seeing it in final cast form, he enthusiastically wired Darrow that "everyone acclaimed it a masterpiece." Darrow himself, however, did not join in the accolades. In June 1929 he wrote to the artist: "About the bust Mrs. D does not like it ... [and] somehow I don't either," and eventually the portrait was returned to Davidson. Possibly as a means of healing any hurt feelings in this matter, Darrow later sent the artist autographed printed copies of arguments from two of his most famous cases.

Why Darrow did not like Davidson's portrayal was never stated. But perhaps it had something to do with the bust's frankness. By now, Darrow was not so much interested in candor about himself as he was in bolstering his reputation. In writing his autobiography, *The Story of My Life*, which appeared in 1932, for example, he proved notably reticent about revealing the details of his career, and it may have been that the worn craggy features seen in Davidson's likeness, unlike his own written self-portrait, disclosed more than he wanted the world to see.

OLIVER WENDELL HOLMES
1841–1935

Holmes's own copy of his groundbreaking *The Common Law* (1881). Harvard Law School Library

When it fell to Theodore Roosevelt to select a new justice for the United States Supreme Court in 1902, his main concern—like that of many another President before and since—was to settle on a candidate of reasonable competence whose views were compatible with his own. Thus, when his friend Henry Cabot Lodge recommended Massachusetts Chief Justice Oliver Wendell Holmes for the position, Roosevelt was not particularly concerned with probing the theoretical underpinnings of Holmes's legal outlook. Instead, Roosevelt's focus was on three other considerations: one, Holmes appeared, like himself, to be a regular Republican; two, his support for the rights of labor in one of his Massachusetts opinions seemed to mark him as sympathetic to Roosevelt's determination to curb big business monopoly; three, Holmes's views on civil rights of native inhabitants in America's recently acquired island territories also seemed to assure support for Roosevelt's posture in this matter on the Court. Accordingly, once Roosevelt was satisfied on these points, Holmes's appointment became a certainty, and shortly thereafter the Senate voted its approval.

Holmes's elevation to the Court had, in other words, hinged largely on the same litmus test of political loyalty that had dictated so many federal judicial appointments since the early years of the republic. Doubtless, when the *Literary Digest* yawningly passed off this event as "more interesting than momentous," it was largely reflecting that fact.

Had the *Digest* researched Holmes more thoroughly, however, it might have realized that his appointment was perhaps not as prosaic as it appeared. Among other things, this Brahmin New Englander had spent much of his early legal career pondering the nature of the law. In the process he had arrived at a theory much at odds with the generally accepted premise that the viability of Anglo-American law rested upon adherence to certain time-honored absolutes. Holmes claimed that the survival of our legal machinery depended—and always had—upon its capacity to remold itself according to the demands of ever-changing social and economic needs. In exploring this relativistic notion in all its ramifications in his volume of 1881, entitled *The Common Law*, Holmes had by no means made his name a household word. But within the legal profession's more philosophically minded circles, he did win a reputation as a remarkably capable and original thinker. More to the point, had the *Digest* recognized the full meaning of Holmes's outlook as expressed in his book, it might well have read greater implications into his arrival on the Supreme Court.

In any event, Holmes was not long in demonstrating those implications. Armed with his belief that interpretation of the law was hemmed in by no eternal truths, he quickly took issue with the Court's all-too-frequent habit of invoking allegedly immutable principles to strike down statutes that its majority seemed to find inimical to their private and generally conservative convictions. Thus, over the next three decades, as Court majorities negated both federal and state laws seeking to alleviate such perceived inequities in America's industrial order as child labor, low wages, and long hours, Holmes registered vigorous dissents that were distinguished for their epigrammatic clarity. In doing so, he was often identified as a liberal partisan of the economic underdog. But in fact he was simply carrying to its logical conclusion his conviction that this country's constitutional framework was flexible enough to tolerate society's collective attempts to find new solutions to its current needs. Summarizing this most central element of his thinking, he remarked toward the end of his life: "About seventy-five years ago, I learned that I was not God. And so, when the people . . . want to do something I can't find anything in the Constitution expressly forbidding them to do, I say, whether I like it or not, 'God-damit, let 'em do it!'"

Although Holmes espoused tolerance for governmental experiments in economic regulation, he often had little patience with legislative or judicial efforts to limit the guarantees of free speech found in the Constitution's First Amendment. Privately he liked to summarize his interpretation of First Amendment freedoms as the right of the "fool to drool." But before the Court he clothed that sentiment in a simple but eminently memorable eloquence. When, for example, the Court upheld a guilty verdict in *Abrams v. United States*, against Russian-born aliens charged with subverting the war effort during World War I through pamphlets opposing this country's intervention in the Russian Revolution, Holmes dissented, declaring in part: *When men have realized that time has upset many fighting faiths, they may come to believe even more than they believe the very foundations of their own conduct that the ultimate good desired is better reached by free trade in ideas—that the*

The lunch pail used by Oliver Wendell Holmes during his tenure on the Supreme Court. Harvard Law Art Collection

A year or so after sitting for Hopkinson's painted portrait, Holmes began posing for the Russian sculptor Sergei Konenkov, who had arrived in this country in the mid-1920s. Holmes's only complaint about Konenkov's interpretation of him was that the artist had somewhat understated his famous long and flowing mustache, and in a later marble replica Konenkov gave more prominence to that feature.

Bronze by Sergei Konenkov (1874–1971), 45.7 cm. (18 in.), 1931. Harvard Law Art Collection

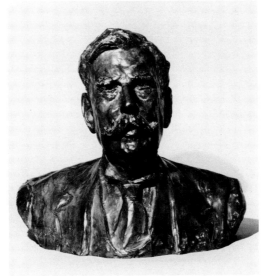

best test of truth is the power of the thought to get itself accepted in the competition of the market.

Writing in 1906 of Holmes's failure to join the Court's majority in finding the Northern Securities railroad holding company in violation of the nation's antitrust laws, Theodore Roosevelt called him a "bitter disappointment." Considering the reputation Holmes ultimately acquired, Roosevelt's sour-grapes attitude seems small-minded indeed and contains more than a little irony.

Holmes came to the Supreme Court when he was sixty-one and did not leave it until he was nearly ninety-one. In the years intervening, despite the fact that in so many crucial cases he found himself in disagreement with the majority of his brethren, his influence can hardly be characterized as negligible. For it was in his dissents that he had exercised some of his most noteworthy impact. By the time he retired from the bench in 1932, his lucidly worded minority calls for more scrupulous judicial objectivity in weighing the constitutionality of regulatory legislation and for greater care in protecting First Amendment rights had gained wide respect throughout the legal community. In fact, there were many who thought that Holmes was the most formidable figure to wear a justice's robe since John Marshall, and in the late 1920s Felix Frankfurter dubbed him the "philosopher become king," to which legions of fellow jurists would have said "Amen!"

But the professionals were not the only ones offering such panegyrics. As the years advanced, Holmes became a kind of national treasure, known to the public at large as much for his irreverent wit and seemingly perpetual vitality as for his legal erudition. On Holmes's seventy-fifth birthday, journalist Walter Lippmann declared him "a sage," who "with the bearing of a cavalier ... wears wisdom like a gorgeous plume, and likes to stick the sanctities between the ribs." Fifteen years later, Holmes's charms had not diminished. As he began his tenth decade of life, another journalist remarked: "He is one of us. . . . It is hard to think of a future he will not share."

Accompanying the accolades that marked Holmes's final years were several requests for his portrait, among them one from Harvard Law School, where he had once been both a student and a teacher. Painted by Charles Hopkinson, Harvard's picture was not intended to be merely a good likeness; it was also meant to be an icon-like symbol of its subject's stature. Accordingly, Hopkinson painted his full-length rendering of Holmes on a canvas almost exactly the same size as the large portrait of John Marshall that Harvard had acquired back in the 1840s. When Holmes's picture was duly installed in a law school reading room early in 1930 directly opposite Marshall's, the message was inescapable: Here, facing each other across nearly a century, were the two greatest Supreme Court justices in history.

Holmes was not insensitive to this flattering juxtaposition. "While in Boston," he wrote his longtime English correspondent, Sir Frederick Pollock, "I ran out to the new and rather magnificent law school building to see my portrait ... which pleased me mightily. It is hung as the pendant to one of Marshall, which of course was the handsomest compliment that they could pay."

CHARLES SYDNEY

HOPKINSON

1869–1962

Oil on canvas

241.3 x 151.1 cm.

(95 x 59$^1/_2$ in.)

1930

Harvard Law Art Collection

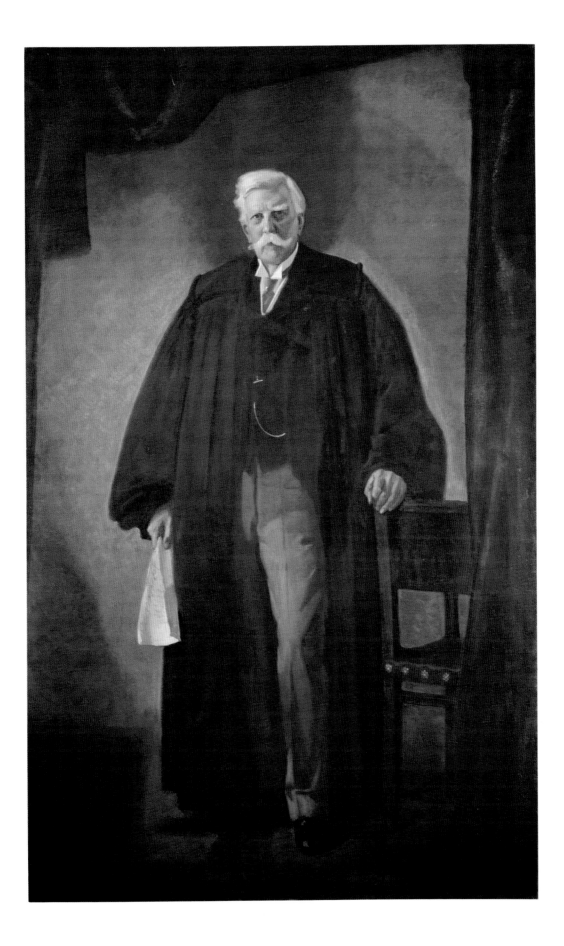

LOUIS D. BRANDEIS
1856 –1941

ELEANOR PLATT

1910–1974

Bronze, 43.2 cm. (17 in.)

1942

Harvard Law Art Collection

When Louis Brandeis entered the legal profession in the late 1870s, he had all the assets that seemed to mark him for conventional success—a precocious mind, a Harvard law degree, reasonably promising social connections, and an ingratiating manner. Indeed, as he settled into a busy and lucrative Boston practice over the next ten years, it appeared that whatever distinctions Brandeis gained, they would most likely arise from an expertise in serving the legal interests of prosperous businessmen and corporations.

Brandeis, however, had been reared in a family whose social conscience had bred in him an acute sense of democratic idealism that was waiting for something to activate it. That something came in 1892, when the management of the Carnegie steel works at Homestead, Pennsylvania, brought in armed Pinkerton agents to protect strikebreakers crossing the picket lines of workers who had walked out in protest over a severe wage cut. The confrontation between the Pinkerton men and the strikers ultimately led to bloodshed, several deaths, and the defeat of the strikers' cause. In the process, it also moved Brandeis to a realization that America's new industrialized order was weighted heavily in favor of corporate interests and that the welfare of the ordinary man found itself too often being sacrificed to high profits and dividend yields. Moreover, as he saw it, his own profession had become a primary agent in promoting this trend. While the "leaders of the bar" were, in the name of laissez-faire capitalism, "ranged on the side of the corporations," he noted several years later, the defense of the people against such things as price-fixing and harsh working conditions was being left to "men of very meager legal ability."

A democratic idealist to his very marrow, Brandeis was not about to accept this situation passively once it was perceived. Beginning in the 1890s, the effort to place industrial workers and the public at large on a more equitable footing with modern capitalism became the ruling passion of his life. Before long he was investing much of his energy in a myriad of causes that included the exposure of unfair pricing practices in the life insurance industry; a crusade to lower gas utility rates in Boston; the mediation of labor disputes; and a protracted struggle to curtail monopoly in New England's railroad system.

Known by the early 1900s as the "people's advocate," Brandeis became in the course of these battlings a master at marshaling masses of economic and sociological data supporting his causes, and he once noted

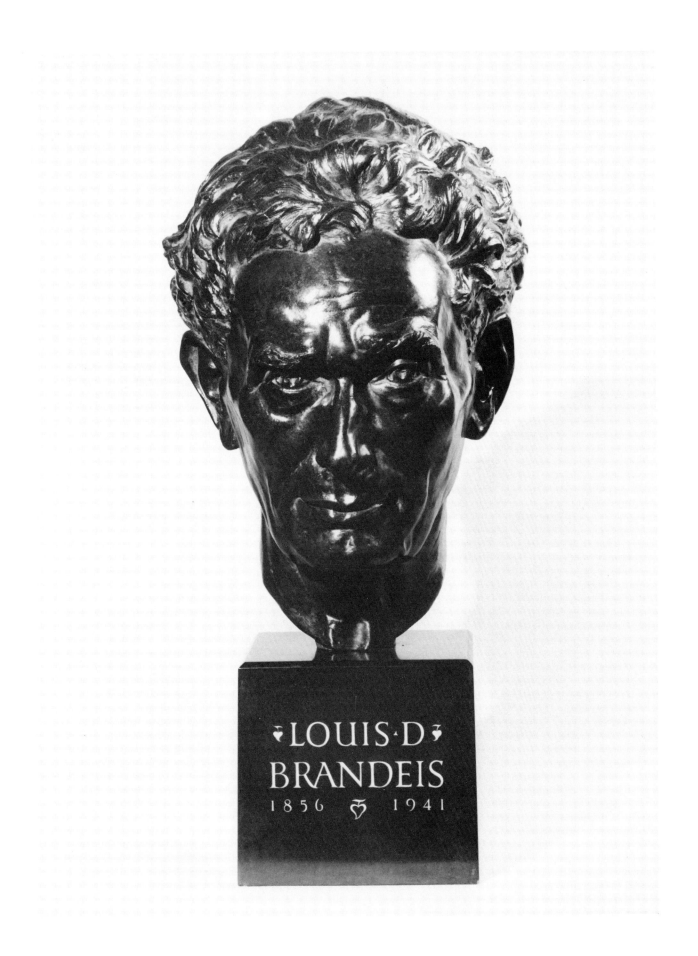

·LOUIS·D·
BRANDEIS
1856 🙶 1941

that "it has been one of the rules of my life that no one shall ever trip me up on a question of fact." This reliance on facts won Brandeis many victories in his various crusades. More significant, however, in 1908 it also helped to alter the course of American jurisprudence. In that year Brandeis undertook, in the Supreme Court case of *Muller v. Oregon,* to defend the constitutionality of an Oregon law limiting work hours for women. Only a few years earlier, the Court had overturned a similar New York law related to that state's baking industry on the grounds that it violated the freedom of contract between employee and employer, and it seemed likely that the Oregon statute would meet the same fate. In Brandeis's view, however, no legal abstraction could be held forever inviolable when the physical welfare of individuals was at stake, and if properly informed of the practical reasons for protecting women from long working hours, even the Court's most conservative members—for whom any regulation of private business was anathema—could be led to seeing the wisdom of Oregon's law. Thus, Brandeis's brief for *Muller v. Oregon* concentrated not so much on constitutional argument as it did on demonstrating the harmful effect that long hours could have on women, and citing data gleaned from a vast array of medical studies and factory inspection reports, it flooded the justices with proof upon proof of the social benefits of the statute in question.

For a tribunal that was accustomed to hearing arguments confined primarily to expositions of legal principle, Brandeis's reliance on current sociological and medical data was a novel experience. But it was not so novel that it could be overlooked, and in the end the Court not only

A portrayal of the deplorable working conditions that prevailed in much of American industry at the turn of the century and impelled Brandeis's rise as the "people's advocate."

Photograph of a New York sweatshop in a Ludlow Street tenement by Jacob Riis (1849–1914), circa 1889. Courtesy, Museum of the City of New York

upheld the Oregon law; in its majority decision it also overtly stated its willingness to accept the facts of current social realities as rationales for its findings. In doing so, it legitimized a new approach in American constitutional law. Inherent in what has come to be known simply as the "Brandeis brief" was a conviction that the validity of a law must rest as much on the day-to-day exigencies that it was designed to meet as it did on abstract legal principle.

In 1912 Brandeis's prominence in efforts to curb big business and promote the welfare of workers drew him into the campaign to elect Woodrow Wilson President on a platform of progressive reform. Following victory at the polls, he became one of Wilson's most trusted advisers and a major architect of several key administration measures, the most notable of which was the establishment of the Federal Reserve. It was largely in recognition of these services that Wilson announced in 1916 the nomination of Brandeis to the Supreme Court.

News of this unleashed an unprecedented flood of protest and indignation, which some thought was owing largely to the fact that Brandeis was Jewish. But, while anti-Semitism was probably a covert factor, the openly stated arguments against his nomination focused mainly on his opposition to business interests during his many years as a reforming activist and his somewhat unorthodox and decidedly liberal approach to law. According to former President William Howard Taft, the prospect of Brandeis on the Court inflicted "one of the deepest wounds" that he "as a lover of the Constitution" had ever suffered. In the midst of such bitter outcries, the Senate debate over his nomination stretched on for weeks, and only after four months did that body finally confirm it.

To a large extent, the conservatives' antipathy to Brandeis was well founded. Over the next several decades, he became known for his frequent willingness to support the constitutionality of state and federal laws intended to promote the rights of labor and the public interest and to circumscribe business practices. In manifesting this tendency, Brandeis was indisputably following his personal sympathies. More important, he was acting on a principle of judicial behavior that he shared with his fellow justice and longtime friend, Oliver Wendell Holmes. Like Holmes, Brandeis subscribed to the notion that in a free society, the courts must allow the law to evolve according to changing conditions and needs, and if this were not permitted to happen, the system's fundamental democratic underpinnings would surely be eroded.

In his early years on the Court, this outlook often placed Brandeis in the minority in many crucial decisions. By his retirement from the bench in 1938, however, his dissents from earlier Court invalidations of such measures as minimum wage laws and statutes protecting union activity had become the basis for overturning those rulings. As one biographer put it, Brandeis had the rare distinction of becoming a prophet "in his own time," and it was largely in recognition of that fact that admirers— including Franklin Roosevelt—often likened him to the Old Testament prophet Isaiah.

For Brandeis the major focus of his life was always his work, and he had little time for extracurricular endeavors. As a result, when artists asked him to pose for his portrait, the answer was no. When, for example,

the Harvard Law School commissioned his oil portrait in the 1930s, the painter in question was compelled to work from a combination of photographs and quick sketches made from afar as Brandeis sat listening to cases during sessions of the Supreme Court. Perhaps the most successful rendering of Brandeis's thin, Lincolnesque features under such adverse circumstances was a bust by Eleanor Platt, begun soon after Brandeis died and based largely on a death mask. The original version of Platt's work was unveiled at the Supreme Court in 1942; several years later a group of his former law clerks presented another version to Harvard Law School.

JOSEPH HENRY BEALE

1861–1943

When Harvard law professor Joseph Henry Beale began teaching one of his courses, he often opened it with an advance apology for the ruthlessness that his new students would have to endure from him for the remainder of their time in his classroom. Doubtless this portent of things to come struck fear in a good many. But as time passed, Beale's students became accustomed to his fiercely aggressive Socratic techniques that one observer likened to "a fencing match in which the clash of steel never stops." More important, they came to like it, and during his years of teaching, from 1890 to 1938, it has been said that no classroom at the Harvard Law School was more electric or alive to the joys of learning the law's secrets than Beale's.

Physically Beale seemed to be an unlikely practitioner of "teaching by combat." On the contrary, his round and short stature suggested a rather phlegmatic temperament. But appearances proved deceptive, and once he was launched into argument with students, the lightning agility of his verbal thrusts and parries often left his young opponents gasping for breath. But although Beale's teaching style sometimes seemed to overpower, it inflicted no lasting scars, and stories abounded at the law school testifying to the good-humored conviviality that his bellicosity could never entirely hide. On one occasion, for example, Beale began his attack on a student's position in the discussion at hand by declaring, "Show me one case, just one case that holds what you say." Then, realizing the potentially dangerous position he was placing himself in, he added, "and I'll show you a case that's wrong!" Yet another time, shortly after he had finished voicing a theory pertaining to certain types of cases, a student objected, "But Mr. Beale, the rule that you've formulated is very difficult to apply," to which Beale replied, "I haven't advertised this as a cinch course."

Beale's impact as a teacher was in and of itself substantial, but the classroom was not his only vehicle for exercising influence on America's legal profession. A founder of the *Harvard Law Review* during his own Harvard student days in the 1880s and a tireless writer, Beale ultimately laid claim to the authorship of no less than twenty-seven books on the law. By far his greatest contribution to this country's body of legal literature was his three-volume *Treatise on the Conflict of Laws*—an exhaustive examination of the problems spawned by the variations in law from one jurisdiction to another. Published in 1934, this work, according

to one reviewer, was regarded as "epoch-making even before its publication," and although some experts dismissed some of its terminology and underlying theory as archaic, more often than not they found themselves compelled to agree with Beale's ultimate conclusions.

Just as Beale's appearance seemed somewhat at odds with his reputation for aggressive argument, so, too, did it make him an unlikely candidate for a distinguished portrait. In fact, recalling his painting of Beale's portrait for Harvard in the late 1920s, artist Charles Hopkinson noted years later that he had found the rotund Beale "almost grotesque." Nevertheless, Hopkinson's likeness—showing "Little Joey" at a table draped with an academic robe connoting his honorary degree from Cambridge University in 1921—proved to be a striking tour de force.

In large part this was a reflection of Hopkinson's career-long conviction that a good portrait must not only present a reasonable facsimile of its subject; it must also be sufficiently engaging in its composition and lighting to stand on its own as simply an original work of art. As Hopkinson once put it—perhaps thinking of Titian's arresting *Man with a Glove*, which had been an early inspiration for his own work—"no portrait which is not interesting aesthetically has stood the test of time." In the case of Beale's likeness, he seems to have carried this belief to its ultimate limit and, in the process, created an illusion that the viewer is momentarily sharing in Beale's quiet world of legal thought.

Joseph Henry Beale

CHARLES SYDNEY HOPKINSON

1869–1962

Oil on canvas

114.4 x 99.7 cm.

(45 1/16 x 39 1/4 in.)

1927

Harvard Law Art Collection

JOHN W. DAVIS
1873–1955

PHILIP A. DE LÁSZLO

(1869–1937)

Oil on canvas

86.4 x 61 cm. (34 x 24 in.)

1920

Julia Davis Adams

By the 1950s, when John W. Davis was nearing the end of his life, his reputation as one of America's most respected, versatile, and suavely polished lawyers was unassailable. Back in the mid-1890s, however, as he nervously undertook the argument of his first case, that reputation seemed so remote as to be virtually unattainable. The venue for this maiden venture into the art of legal persuasion was a country store in his native West Virginia, which had temporarily been commandeered to serve as a bar of justice; the issue at hand involved the alleged theft from his client of an old turkey hen and twenty-nine chickens. When his more seasoned opposing counsel asked for a writ of prohibition on the grounds that this makeshift tribunal had no jurisdiction in the matter, a thoroughly mystified Davis thought that the request must have "something to do with alcohol." A quick retreat, following the court's adjournment, to his law offices to clear up that misapprehension and frame a reply proved futile. The next day, he was back in court listening as a circuit judge ruled in favor of his opponent's claim.

The outcomes of Davis's next two cases—one involving a client's cow killed by a train and the other, the purchase of an anatomically faulty horse—proved no more successful, and after suffering his third defeat, he tearfully declared to his lawyer father, "I'm going to quit this business." But eventually Davis pulled himself together, and within a few years he was thoroughly enamored of the challenges that the rough-and-tumble ways of West Virginia's somewhat rustic justice system afforded him. What was more, he ultimately proved far more adept at his chosen line of work than his early courtroom debacles had seemed to portend. By the time he won election to the United States House of Representatives in 1910, he was thought to be the best lawyer in his state.

Though much respected as a congressman, Davis found the slowness of the legislative process onerous, and when newly elected President Woodrow Wilson asked him to serve as the Justice Department's solicitor general in 1913, he welcomed the chance to return to the courtroom.

A constitutional conservative by nature, Davis did not always like taking the liberal stance that his new role as the nation's chief appellate lawyer sometimes compelled him to assume, and he once mused to his father that "I should like to get some . . . question [on] which I could feel free from doubt." But even when he had personal qualms about the wisdom of his position in a case, he invariably acquitted himself well—

so well that Chief Justice Edward White once quipped that "no one has due process of law when Mr. Davis is on the other side."

Among Davis's more notable triumphs as solicitor general were his successful defenses of federal authority to control public lands and to limit the hours of railroad workers. But his most significant accomplishments were his contributions to the Supreme Court's overturning of the "grandfather" clause in Oklahoma's voting laws designed to disenfranchise blacks, and of an Alabama statute condemning blacks convicted of petty crimes to peonage for terms far in excess of their original sentences.

Davis's careful pretrial preparation and smooth oral arguments as solicitor general engendered admiration among many, not least of whom were the nine members of the Supreme Court; and at one time or another most of the justices made known to Wilson their hopes for seeing him one day elevated to the Court. Instead, in 1918 Wilson appointed him ambassador to England. For the next two years or so, the main preoccupations in Davis's life revolved around guiding Anglo-American relations through the sometimes-difficult readjustments that followed in the wake of World War I.

In 1920 Davis's record as congressman, solicitor general, and diplomat gave rise to a groundswell of interest among some Democrats in running him for President. In that year the movement for Davis did not get very far. Four years later, however, at a deadlocked convention, he emerged as the Democrats' compromise choice for the White House on the 103rd ballot; but in the ensuing campaign against popular Republican incumbent Calvin Coolidge his cause proved hopeless practically from the start.

Never possessed of strong presidential ambitions, Davis was rather relieved with his 1924 defeat. Besides, it was not as if Coolidge's overwhelming victory at the November polls had left Davis with no purpose in life. Since leaving the English ambassadorship in 1921, he had established himself in New York City as one of the nation's leading corporate lawyers, and he was now free to return to a private practice that had long since become an abiding passion.

Throughout most of his career, Davis's approach to the law was conservative. While many American jurists of the 1920s and 1930s increasingly embraced the view that the law must adapt itself to changing conditions, he remained loyal to the older notion that law was built on fixed principles that, among other things, prohibited extensive legislative interference in the nation's free enterprise system. Thus, when Franklin Roosevelt's New Deal introduced a wave of government measures in the 1930s seeking to monitor private business and labor-management relations, he shared his conservative corporate clients' belief that these innovations went well beyond the bounds of constitutional propriety. Inevitably he found himself allied to the movement, both in and out of the courtroom, to invalidate them. Davis's contributions to the effort to undo the New Deal met with only limited success. But that did not detract from his growing reputation as one of the nation's most skillful all-around lawyers. By the 1940s, few who heard one of his arguments before the bench would have disputed Oliver Wendell Holmes's judgment of many years earlier that no courtroom advocate was "more elegant, more clear,

more concise or more logical" than Davis. His effectiveness in pleading a case, in fact, was sometimes such that it seemed to jeopardize all semblance of judicial objectivity. "I do not like to have John W. Davis come into my courtroom," federal Circuit Judge Learned Hand once confessed to a friend. "I am so fascinated by his eloquence and charm that I always fear that I am going to decide in his favor irrespective of the merits of the case."

Davis continued in active practice until his death and was in his late seventies when he took on two of the most significant cases of his career. In the first—argued before the Supreme Court in 1952—Davis defended the steel industry against a presidential order to seize it in the face of a possible industry-wide strike during the Korean conflict. On that occasion the Court supported Davis's claim that such an action was constitutionally unjustifiable. But he proved less persuasive when he undertook to defend public-school segregation in the Supreme Court proceedings of the early 1950s that are commonly known as *Brown v. Board of Education.*

In that instance, a good many of his friends were disturbed that Davis's deeply rooted conservatism should draw him into arguing the cause of "separate but equal," and ultimately the Court ruled against him unanimously. Nevertheless, even Thurgood Marshall, who opposed him in the case, could not help but admire him. Recalling his unflagging respect for Davis in an interview years later, Marshall recounted how as a law student he had often cut classes just to observe Davis in court, and how he invariably wondered if he could ever equal the man he came to watch. "And every time," Marshall said, "I had to answer, "'No, never.'"

At the time of his involvement in the school desegregation cases, a journalist remarked that Davis seemed "type-cast" for the part of a great lawyer, with his mane of white hair and scrupulously tailored clothes. As his portrait of 1920 by Philip de László indicates, Davis had carried himself with an air of distinguished elegance for many years. In fact, in his first portrayal of Davis, done for the American embassy in London, de László was not satisfied that he had captured the full measure of his subject's impressive bearing. To make amends for this failure, he painted the second version of his Davis likeness, seen here.

ROSCOE POUND
1870–1964

CHARLES SYDNEY

HOPKINSON

1869–1962

Oil on canvas

134.6 x 109.2 cm. (53 x 43 in.)

1929

Harvard Law Art Collection

Having learned to read at the age of three and begun the study of German at six, the precocious Roscoe Pound seemed almost certainly marked for a life of high achievement from early on. But in what field that achievement lay remained for many years an open question. While young Pound himself initially favored the pursuit of botany, his lawyer father harbored hopes of a legal career for him. Consequently, from his mid-teens through his late twenties, Pound found himself alternately indulging his own preferences for the natural sciences and yielding to parental urgings that he take up law.

Ultimately, of course, Pound had to choose between these two endeavors, and when he received a doctorate in botany from the University of Nebraska in 1897 and another botanist hailed his dissertation as a pioneering work, it seemed that science had at last won out. But, between obtaining his bachelor's degree in 1888 and earning his Ph.D., Pound had also taken a deep liking to the law, and in 1890, following a year at the Harvard Law School, he had been admitted to the Nebraska bar. Within another two years he was a partner in his father's firm. By 1900, although the reasons for it are not quite clear, Pound had pretty much forsaken his scientific interests in favor of a full-time commitment to law.

Among Pound's greatest legal talents was a peculiar genius for absorbing difficult abstractions and making their practical implications understandable. In 1903, after four years as an intermediate appellate judge for the Nebraska Supreme Court, he started putting that gift to use as dean of Nebraska's College of Law and so began his rise as the "Schoolmaster of the American Bar."

Pound's first great moment in this role came three years later, when he undertook, in a paper titled "The Popular Dissatisfaction with the Administration of Justice," to outline for the American Bar Association what he saw as the deficiencies in the nation's court system. Only some 370 lawyers heard this speech, addressing such problems as the day-to-day inefficiencies of courts and the failure of legal interpretation to keep pace with society's changing needs. But although the audience was relatively modest, the impact of Pound's words was not, and more than one expert has suggested that many of the alterations occurring in the American judicial process over the next several decades were at least partly a result of Pound's urgings of 1906.

In the short term, however, the speech exercised its most perceptible effect on Pound himself. An unknown until now in most legal circles, he

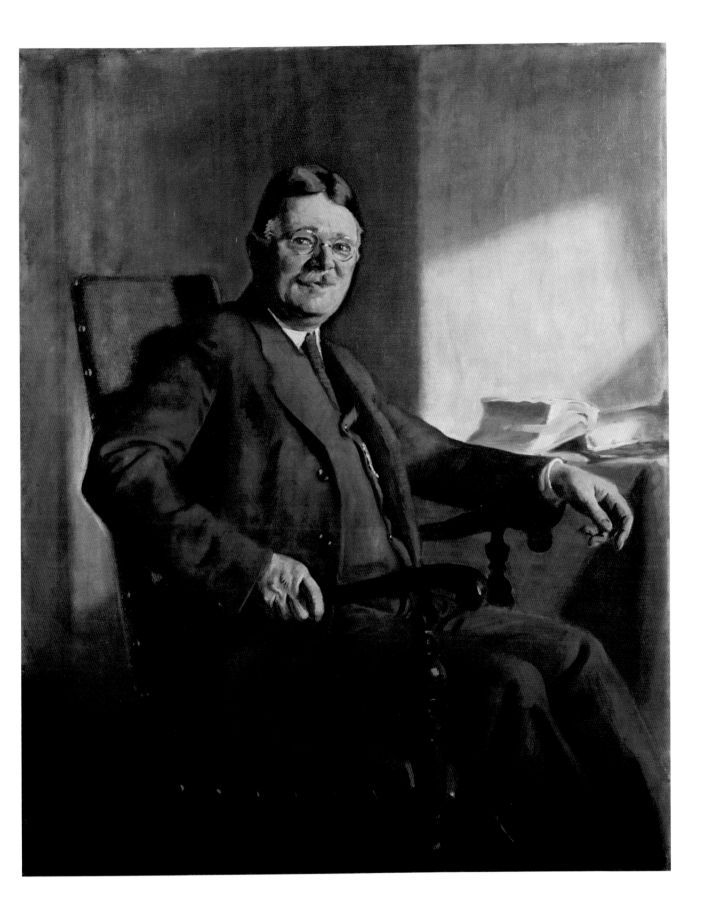

was suddenly a highly valued commodity in the field of legal education, and in 1910, after short periods of teaching at Northwestern University and the University of Chicago, he joined the Harvard Law School faculty. Six years later, he was assuming the responsibilities of dean of that institution, a post he was to hold for the next twenty years.

Under Pound's guidance, the Harvard Law School entered a golden age, marked by the adoption of more rigorous academic standards and quantum leaps in its prestige as a center of innovative thought. In regard to that second development, one of the chief catalysts was doubtless Pound's own prodigious outpouring of legal scholarship, which continued long after his retirement as dean and, in fact, did not stop until shortly before his death at ninety-three. Of his writings, none proved more salient than those calling for greater flexibility in the application of time-honored legal principles to ever-changing conditions and needs of the society they served. Although Pound was not alone in voicing this point of view—commonly referred to as sociological jurisprudence—he was one of its most persuasive champions, and his declaration that the "law must be stable, and yet it cannot stand still" remained for many years one of the most oft-quoted summaries of that school of thought.

In accounting for Pound's influence, however, it was not just what he said, but who he was as well. Looking like an overgrown rosy-cheeked elf, Pound absorbed knowledge with much the same ease that a magnet draws iron filings, and Oliver Wendell Holmes once noted that his wide-ranging erudition "drives me silly." Yet Pound carried his learning without pretension, supporting his points with "homey illustrations" and "amusing stories."

During his tenure as dean at the Harvard Law School, Pound made it his business to expand and enrich the school in virtually every respect. Among his proudest achievements was the transformation of its library into one of the greatest repositories of legal writings in the world. He also took great interest in enlarging the school's portrait collection of noted jurists, which had been begun back in the days of Joseph Story, with the acquisition of a picture of James Kent. Thanks largely to Pound, the school boasts today the largest and most distinguished assemblage of sculpted, painted, and engraved likenesses of legal notables in Anglo-American law to be found on either side of the Atlantic.

Pound's own portrait by Charles Hopkinson was added to the collection in 1929. A lifelong resident of Cambridge and a graduate of Harvard, Hopkinson portrayed so many members of his alma mater's faculty that by the end of his life he was known as the university's "court painter." One of his chief attractions for Harvard was the conventional realism of his style, which minimized the possibility of anyone taking umbrage at his treatment of a beloved professor. At the same time, however, Hopkinson brought to his portraiture an abiding passion for discovering new ways of employing light and shade that set him apart from other traditional portraitists and often created strikingly different effects within his own body of work. In his rendering of Pound, that innovative impulse led to a picture where a slanting shaft of soft light from an unseen window became the main vehicle for defining his subject's features.

B E N J A M I N N. C A R D O Z O
1870–1938

Benjamin Cardozo was by nature shy and retiring, and throughout his life he assiduously avoided any situations that might demand professional or social intercourse of a broad sort. Instead he preferred the existence of a semi-recluse, limiting his human relationships wherever possible to a small circle of family and friends.

For most individuals such a choice guaranteed certain anonymity or at best only limited public recognition. Cardozo, however, proved an exception. Graduating from Columbia University in 1889 and admitted to the New York bar two years later, this unassertive hermit seemed to generate plaudits and respect almost in spite of himself. By the turn of the century, Cardozo was one of New York City's most widely esteemed legal minds, and although he remained little known to the general public, other members of his profession had come to rely heavily on him as an adviser and appellate lawyer in their more complex cases.

Cardozo was perfectly content with this lot, and had it been left to him, most likely he would have devoted the rest of his career to quietly cultivating his growing reputation as a lawyer's lawyer. In 1913, however, admirers of his probity and skill nominated him for a seat on the New York Supreme Court and, despite the fact that Cardozo himself remained passively aloof from the appeal to voters that followed, managed to engineer his election. But Cardozo had barely settled into his new judicial office before yet another unsolicited honor came his way. Within a month of coming to the supreme court, he found himself, on the unanimous recommendation of his fellow judges, elevated to a seat on New York's highest tribunal, the court of appeals.

So began Benjamin Cardozo's rise as one of this country's most profoundly influential members of the bench. For, diffident though he was, Cardozo possessed a quietly ingratiating manner and depth of legal knowledge that quickly won him ascendence on the court. And those assets, combined with a pragmatic conviction that the law's vitality hinged on its capacity for reshaping itself to new conditions, made much of his work on the Court of Appeals landmarks in adapting common law tradition to twentieth-century needs.

It was not, however, the substance of his decisions alone that gave Cardozo his preeminence; it was also the form in which he stated them. "I am told," he once lamented, "that a judicial opinion has no business to be literature. The idol must be ugly, or he may be taken for a common man. The deliverance that is to be accepted without demur or hesitation

must have a certain high austerity which frowns at winning graces." But Cardozo subscribed to quite a different school of thought. The force of a judicial opinion, he claimed, depended no less on verbal artistry than poetry did, and as such it too should strive for literary merit. As a result, many of his own decisions were noted for their elegant phraseology. "To read his opinions today," one legal scholar has suggested, "is, in a sense, to string pearls."

But for many the most significant source of Cardozo's distinction lay in his philosophizings about the relation of law to modern life, the most notable of which was *The Nature of the Judicial Process.* Published in 1921, this volume offered a lucid examination of law as a force for both continuity and change and quickly came to be regarded as one of the most penetrating prescriptions for judicial decision-making ever written. There are those today who claim that it "still possesses the same validity and vitality" as it did when it first appeared.

Between his work on the Court of Appeals and his writings, Cardozo had by 1930 become the object of a respect that bordered on hero worship, and when the revered Oliver Wendell Holmes retired from the United States Supreme Court in 1932, it was commonly thought that Cardozo was his "only possible successor." President Herbert Hoover, however, was reluctant to appoint him, largely because there were two New Yorkers on the Court already. Nevertheless, those advising in the matter kept coming back to Cardozo, and finally, throwing concern for geographical diversity to the wind, Hoover sent his name to the Senate for what may well have been the quickest confirmation in the history of judicial appointments. "Up he goes," noted a periodical shortly after Cardozo took his place on the Court, "the entire country cheering his name."

Cardozo served on the Court for only six years. But although his tenure there proved short, it coincided with the Supreme Court's historic battlings over the constitutionality of Franklin Roosevelt's New Deal attempts to remedy the Great Depression. Given Cardozo's pragmatic tolerance for legislative experimentation in finding new solutions to society's problems, he often found himself in the dissenting minority as the Court struck down one Roosevelt innovation after another. Ultimately, however, it was his view that prevailed, and among Cardozo's last opinions on the Court was one written for the majority, endorsing the New Deal's Social Security Act.

In September 1931 Cardozo reported that his "chief recreation" of late had been sitting for a bust destined for the Columbia Law School. The artist modeling this likeness was the Russian sculptor Sergei Konenkov, who had come to this country in 1924 as one of the promoters of a New York City exhibition of contemporary Soviet art. Konenkov's own pieces in that show—inspired largely by the peasant woodcarving tradition of his native country—drew considerable praise, and doubtless this warm reception was a factor in his decision to remain in this country for an extended period.

Among Konenkov's admirers in New York was Karl Llewellyn, a noted legal theorist and Columbia law professor, and probably it was he who conceived the idea of commissioning Konenkov to do Cardozo's

Benjamin N. Cardozo

SERGEI KONENKOV

1874–1971

Bronze

53.3 cm. (21 in.)

1931

Harvard Law Art Collection

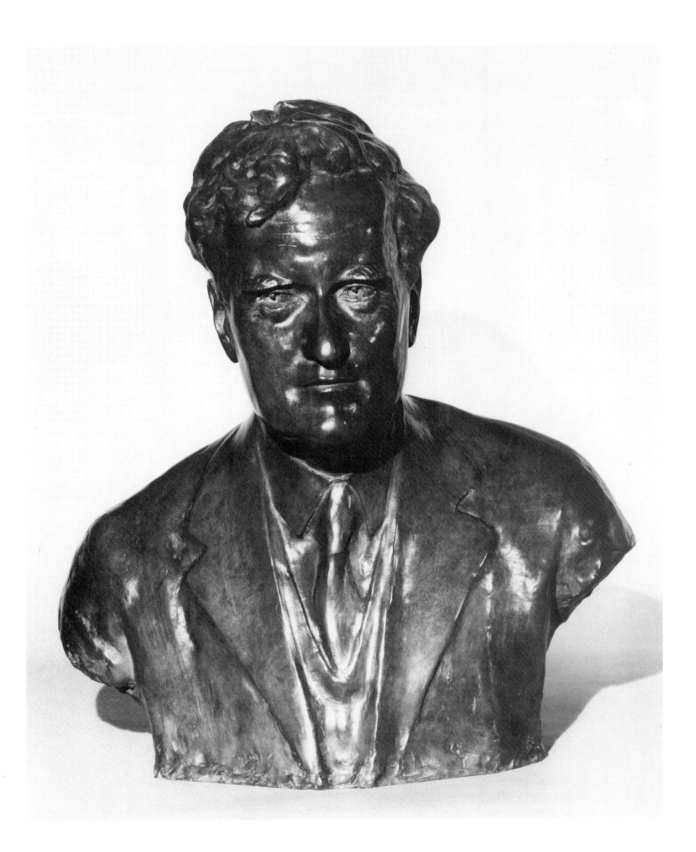

portrait. No record of the bust ever going to Columbia exists, but in 1932 the Harvard Law School acquired the bronze version of it seen here.

Shortly before his encounter with Konenkov, Cardozo had sat for a painted likeness by Augustus Vincent Tack, done for the Court of Appeals in Albany. On its completion, Cardozo told Tack that "you've made me look like a saint," and to a cousin he noted that "I get a shock every time I look at [the picture]." Konenkov's interpretation of his features, on the other hand, proved to be more earthbound, and presumably Cardozo found its matter-of-fact quality a bit easier to live with.

ZECHARIAH CHAFEE, JR.

1885–1957

On April 2, 1917, the United States officially entered World War I and within days was mobilizing its industry and fighting forces to defeat the German-Austrian alliance. In the wake of this sudden conversion to wartime footings came the perception of a need for emergency constraints on civilian activity, and in June Congress was passing the Espionage Act prohibiting various forms of opposition to the nation's war effort. Eventually, however, this law came to seem dangerously lenient; in the following year the more sweeping Sedition Act went into effect, declaring any open criticism of either America's constitutional system or its war policies a crime, punishable by fines of up to $10,000 or imprisonment of up to twenty years.

For most Americans this unprecedented abridgment of the First Amendment's guarantees of free speech and debate appeared eminently reasonable in light of the crisis, and they looked approvingly on as many hundreds of individuals daring to fault aspects of this country's war efforts and institutions faced prosecution for their subversive views. For Harvard Law School professor Zechariah Chafee, however, the Sedition Act represented a disturbing blight on this country's free-speech traditions. In late 1918 he was publishing his first article on the subject in the *New Republic*, where among other things he declared that speech must be left free and open even in wartime so long as it did not promise "to cause direct and dangerous interference with the conduct of the war."

Later Chafee would confess that until this law's implementation he had never given much thought to the First Amendment and that pondering it was for him "an acquired taste like olives." But once savored a few times, the question of how far and in what circumstances this constitutional assurance of unhampered interchange of ideas should apply became something of an overriding preoccupation. By 1920 his thoughts on the subject had jelled into a book entitled *Freedom of Speech*, where he again urged that, regardless of how inimical an ideology or political point of view might seem to the majority's well-being, its espousal must in most situations be tolerated.

Given Chafee's libertarian views in this matter, one might almost assume that he must have had some sympathy for the pacifistic, anarchical, or socialistic radicals who had been the primary victims of the Sedition Act. On the contrary, however, he shared with most Americans a conservative faith in their institutions, and as one raised and educated in comfortable—even privileged—circumstances, he wished no drastic

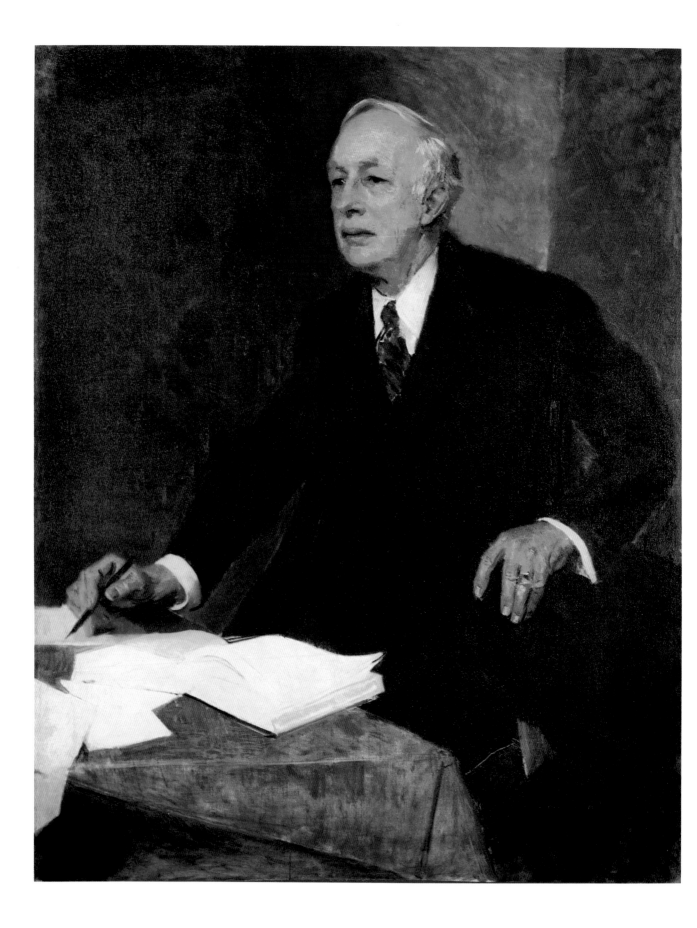

Zechariah Chafee, Jr.

GARDNER COX

1906–1988

Oil on canvas

152.3 x 127 cm. (60 x 50 in.)

1952

Harvard Law Art Collection

alteration in this country's way of life. Nevertheless, central to maintaining the status quo and assuring its future viability, he believed, was a healthy respect for any and all shades of opinion. As he once put it, there was rarely any reason why he "should be out mountain climbing and enjoying life while some other chap who started life with less money and gets angrier and a little more extreme should be shut up in prison."

When Chafee began articulating his thoughts on the First Amendment, he doubtless hoped that the conventionality of his personal politics would give his latitudinarian views credibility, and most likely it did in some quarters. Nevertheless, in the years immediately following World War I, a wave of reactionism, spawned largely by the communist overthrow of moderates in the Russian Revolution of 1917, had left many thinking that urging tolerance for radical opinion was very nearly as subversive as the opinion itself. As a result, in 1921 influential Harvard alumni were charging Chafee with publishing false statements in his attack on the guilty verdict in one wartime dissent case and with being an unfit teacher.

Eventually Chafee was exonerated of these charges at a formal hearing, which because of its Boston venue was ever after known as the Harvard Club Trial, and in the following years his liberal views on the First Amendment gained wider currency. Still, as he continued to write about free speech, not everyone was comfortable with his outlook. In fact, when fears over the spread of communism unleashed a crusade in the early 1950s against hundreds of figures suspected of subscribing to un-American ideals, the movement's spearhead, Senator Joseph McCarthy, identified Chafee as one of the seven most dangerous people in America. By then, however, Chafee's tolerance for diversity of opinion was, in legal circles at least, widely shared. When a noted legal scholar claimed in 1957 that no one had done more than Chafee "to define the nature of personal liberty and to measure the scope of governmental power to restrict its exercise," he was not too wide of the mark.

When the Boston artist Gardner Cox undertook a portrait of Chafee for Harvard in the early 1950s, his subject struck him, he recalled years later, as a "high minded fellow," and in the finished likeness he endowed Chafee's features with the somewhat remote look of an idealist. Nevertheless, Chafee had a very convivial side to him as well, and by his retirement from Harvard in 1956, his rich fund of amusing stories had long since earned him a reputation as "the Scheherazade of the law school." On occasion he also demonstrated a talent for coining the memorable bon mot. When in the course of his sittings with Cox, a friend expressed the hope that his new portrait would do him justice, Chafee quickly replied: "I don't want justice; I want mercy."

LEARNED HAND
1872–1961

GARDNER COX

1906–1988

Oil on canvas

89.5 x 69.8 cm. (35¹/₄ x 27¹/₂ in.)

1947

Mrs. Mary Hand Darrell

During his undergraduate years at Harvard, Learned Hand had concentrated on the study of philosophy and, after receiving his bachelor's degree in 1893, had gone on to earn a master's degree in that field. But, if he harbored any hope of turning his love for metaphysical inquiry into a professional calling, the force of familial tradition soon put that ambition to rest. By 1895, following in the footsteps of his grandfather, father, and two uncles—all of them well-respected jurists of their day— he was enrolled at Harvard Law School, preparing to make his way in life as his kinsmen had before him.

Initially it appeared that Hand might have done well to break with family custom, for in his early years of private practice he proved to be only moderately successful, if that. More unpromising yet, Hand simply did not have much taste for the cases that became his lot as an attorney, first in Albany, New York, and later in New York City. Long afterward, when he invoked the term "bucketshop" to describe the law firms with which he had been affiliated in this period, he was not so much venturing an estimation of their true character as he was reliving his own deep dislike for the nature of their business.

But, although Hand was not well suited to law practice, it did not mean that there was no room for him in his profession. On the contrary, there were some among his legal colleagues who thought that his keenness of intellect and speculative turn of mind held considerable potential. In 1909, on the recommendation of several of Hand's more influential friends, President William Howard Taft appointed him judge of the United States District Court for southern New York. So began a judicial career that was to span fifty-two years, lead to a chief judgeship on the federal court of appeals for the country's second district, produce nearly three thousand written opinions, and transform Hand into as much of a legend in the history of American jurisprudence as John Marshall and Oliver Wendell Holmes.

The sources of Hand's distinction were many and had as much to do with style as with substance. On the one hand, like Holmes, he proved a model of judicial restraint, claiming that, so long as acts of legislation seemed to be reasonably plausible exercises of constitutional power, it was not for judges to overturn them merely because they disapproved of their intent or suspected their wisdom. In one of his most noted decisions, *United States v. Aluminum Company of America*, in 1945, for example, Hand at once questioned and defended

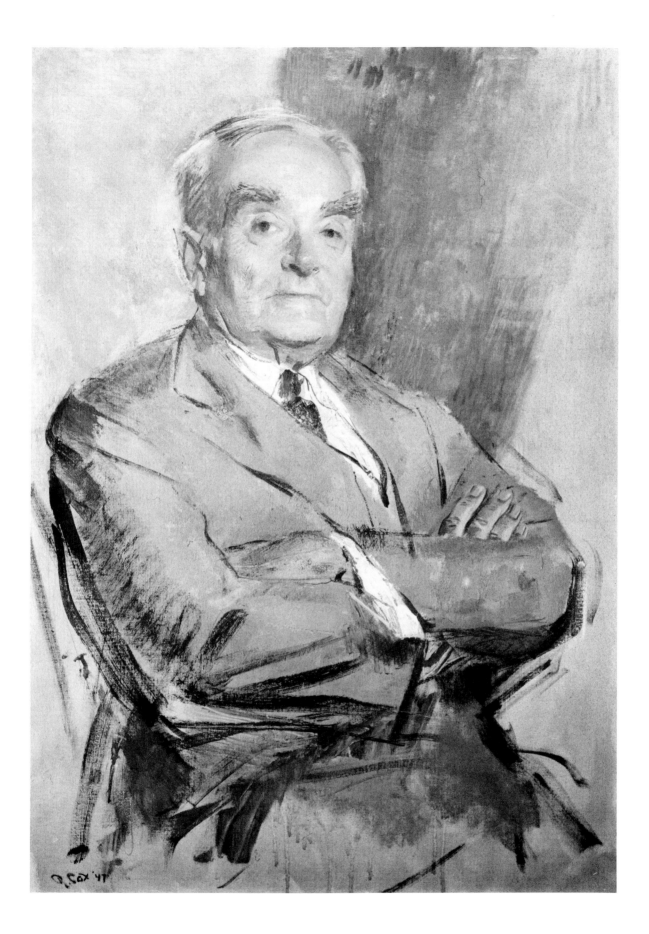

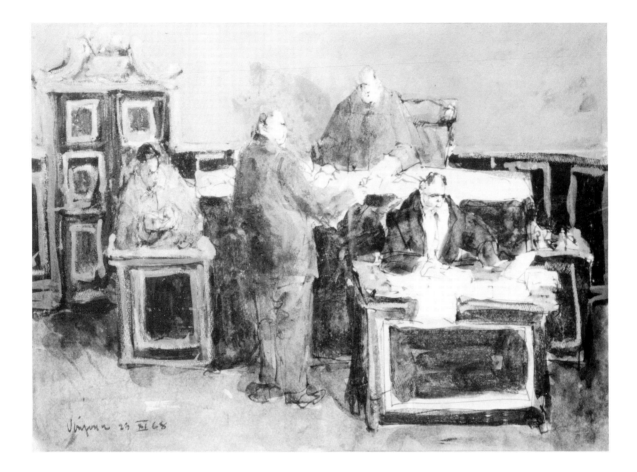

Courtroom Scene, ink, gouache, and oil pastel on paper by Hank Virgona (born 1929), 32 x 45.7 cm. (12 ⅝ x 18 in.), 1968. Mr. Edward I. Elicofon

the antitrust regulations being invoked against the country's main aluminum producer. "There are two possible ways of dealing with [industrial monopolies]," he observed in a memo on the case, "to regulate or forbid them. Since we have no way of regulating them, we forbid them. I don't think much of that way, but I didn't set it up." It was this circumspect forbearance, combined with the precision of his final opinions, that made Hand for many years the most oft-cited authority in Supreme Court decisions and that inspired some to speak of him as that body's "tenth Justice."

But the mystique that came to engulf Hand by the end of his life rested on factors of personal style as well. Known off the bench for his Rabelaisian sense of humor and gift for mimicry, he also possessed a talent for unceremoniously cutting through specious argument. Not infrequently lawyers appearing before him found their points suddenly stripped of their validity with an oracular, but nevertheless down-to-earth, "Rubbish!" At the same time, however, there was a decidedly more elegant dimension to Hand's judicial character. Subscribing to Benjamin Cardozo's view that decision-writing was a literary art form, he labored carefully over the composition of his opinions, often re-writing them three and four times. The result was a body of decisions that according to one admirer often read like sonnets.

But, for all this conscientious attention to his craft, Hand was skeptical of the significance of what he did on the bench, particularly when it came to the efficacy of his profession's role as a main safeguard for the fundamental personal rights on which this country's institutions rest. Though a believer in these rights, he nevertheless seriously doubted the capacity of courts to preserve them in the absence of a strong popular consensus willing their survival. Of all the words he penned in his long career, none proved more compelling than a speech, made in 1944, exploring this conviction. Warning that "no constitution, no law, no court" could ensure individual rights without widespread popular commitment to them, he termed that commitment the "spirit of liberty" and ended his remarks by saying: *What then is the spirit of liberty? I cannot define it; I can only tell you my own faith. The spirit of liberty is the spirit which is not too sure that it is right; the spirit of liberty is the spirit which seeks to understand the minds of other men and women; the spirit of liberty is the spirit which weighs their interests alongside its own without bias; the spirit of liberty remembers that not even a sparrow falls to the earth unheeded.*

A few weeks after uttering these words, Hand began sitting for a sculpted portrait, a bronze casting of which a group of his former law clerks presented to Harvard Law School. On meeting Hand for the first time, the artist doing the likeness, Eleanor Platt, effused, *"He is a magnificent subject!* Made for my kind of work! . . . I am artistically thrilled!!!"* Given the combination of Hand's convivial wit and ruggedly impressive features, he was indeed a portraitist's delight, and when Gardner Cox portrayed Hand in oil three years later, he proved no less enamored of his subject than Platt had been. Apparently the pleasantness of the sittings worked to good effect on the artist. In estimating the virtues of his portrayal of Hand many years later, Cox singled it out as "one of the good ones," and noted that the picture's public exhibition ultimately led to a good many other commissions.

AUGUSTUS NOBLE HAND
1869–1954

SIDNEY E. DICKINSON

1890–1980

Oil on canvas

124.4 x 99 cm. (49 x 39 in.)

Circa 1947

Harvard Law Art Collection

Sharing as he did the same familial heritage of legal distinction that ultimately drew Learned Hand into the lawyer's profession somewhat despite his personal inclinations, it was almost inevitable that Learned's cousin, Augustus Noble Hand, should also have found his calling at the bar. It was less inevitable, however, that Augustus's career should follow a path that was in many respects identical to the one traveled by his cousin. But in fact that is exactly what happened. In 1914, five years after Learned had taken his seat as a federal judge for the court of the southern district of New York, his kinsman was receiving an appointment to that tribunal. In 1927, three years after Learned had made the same leap, Augustus was assuming his place as judge on the United States Court of Appeals of the Second Circuit. Finally, as the years advanced, it was clear to many that Augustus was very nearly equal to his cousin in judicial capability.

But the parallels between these two jurists had their limits. Where Learned's decisions were famous for their stylistic eloquence, Augustus's were noted for their thorough and scrupulously fair assessment of the facts. Where the magic of Learned's dynamic personality combined with his judicial accomplishments to make him one of the most widely known legal figures of his time, Augustus's more stolidly subdued manner kept him from achieving a similar measure of notoriety.

Yet for Augustus Hand, who once described himself as a man "abundantly without ambition," falling short of his cousin in the fame department mattered little. Instead he was quite content with leaving his mark on the law in his own mild and understated way. Nevertheless, the mark proved substantial, and one of the primary testimonies to that claim is that during his years as an appeals judge he dissented only rarely from the court's majority. This was not the result of any abhorrence for disagreement; rather, his fellow judges had so much confidence in the solidness of his outlook that they frequently simply accepted his lead.

Ultimately this admiration for Hand spread, as many of his opinions—reflecting at once respect for precedent and readiness to adapt the law's interpretation to modern conditions—found their way into the casebooks. By the end of his career the advice once jestingly offered by a bench colleague to other jurists that they should "always quote Learned and follow Gus" had become more than just an amusing witticism.

Augustus Hand's sober restraint on the bench did not mean that he

The cousins Learned and Augustus Hand, flanking their fellow court of appeals judge for the second judicial circuit, Thomas W. Swan, 1953. Harvard Law Art Collection

was incapable of expansive expression of personal feeling. While his utterances from the bench were invariably models of decorously stated objectivity, his private observations on his work were not always so detached. After the 1934 case, for example, in which his court was called upon to rule on the alleged obscenity found in James Joyce's *Ulysses*, Hand privately and rather disdainfully dismissed the book as "a swill-pail tragedy of the human soul at low ebb." But, of course, in his opinion for the court, declaring *Ulysses* not obscene, it would have been an unheard-of aberration if any traces of that sentiment had been perceptible.

By the late 1940s the value of Hand's contribution to American jurisprudence was well recognized, at least by the cognoscenti, and in 1948 the Harvard Law School, from which he had graduated in 1894, added his portrait by Sidney Dickinson to its collection of distinguished jurists. Though fairly conventional in composition, this broadly painted picture nevertheless makes an exceptionally engaging and powerful statement on the subject. The leftist radical Max Eastman, who during World War I had faced charges of subversive activity in Hand's court, remembered Hand in a memoir as "a judge who could have upheld in a hurricane the dignity of the law." Quite clearly Dickinson viewed Augustus Hand in much the same way.

ARTHUR T. VANDERBILT

1888–1957

Shortly before Arthur T. Vanderbilt graduated from the Columbia University Law School in 1913, the school's dean, future Chief Justice of the United States Harlan F. Stone, told him that he did not have the necessary drive or toughness to be a successful practitioner of law and instead suggested that he was best suited for a career of teaching and scholarship. Vanderbilt, however, ignored this friendly advice and in the fall of 1913 was sending out printed cards announcing the establishment of his general practice in Newark, New Jersey. In this case at least, the intuition of youth proved superior to the wisdom of experience; within a few short years Vanderbilt had begun to accrue a reputation as an uncommonly adroit lawyer, specializing in corporate and insurance law. Gazing toward a carelessly dressed Vanderbilt seated during his early years in a court of chancery, another lawyer remarked to a colleague: "See that fellow over there? He looks like a farmer, but don't let it fool you. He's one of the shrewdest lawyers in the state."

The advancing years only reinforced that perception. It is said that the day after it became public in 1947 that Vanderbilt was to be appointed chief justice of the New Jersey Supreme Court, a longtime corporate client appeared at his doorstep, promising to write him a check for a quarter of a million dollars. All Vanderbilt had to do to earn this munificent sum was reject the chief justiceship and continue to be the man's lawyer.

But Harlan Stone's estimation of Vanderbilt's abilities was only half wrong. Vanderbilt subscribed to the notion that the best way for a practicing lawyer to master his profession was to teach it to others, and as a professor at New York University's School of Law from 1914 through the early 1940s, he proved to be one of the school's most popular and respected instructors. Moreover, as dean of the school from 1943 to 1948, Vanderbilt became the main force in transforming it into one of the leading centers for legal studies in the country. Among the more significant innovations during his deanship was the establishment of the Law Center, a forum where judges and attorneys could meet with business and labor leaders to seek solutions to current problems in the nation's legal system.

Vanderbilt's dual distinction as educator and practitioner would have been quite sufficient to ensure his inclusion in the ranks of noteworthy American jurists. His greatest accomplishment, however, lay

Arthur T. Vanderbilt

JAMES McBEY

1883–1959

Oil on canvas

125.7 x 95.8 cm.

(49¹/₂ x 37³/₄ in.)

Circa 1947

New York University

School of Law

in his many years of campaigning for reform in the nation's court systems, whose archaic and unduly complex procedures spawned in the 1930s a mounting crisis in public confidence. Drawn into the movement for streamlining court practices in 1930, when he became chairman of the Judicial Council of New Jersey, Vanderbilt ultimately came to personify this cause, and it was largely due to his exertions that by 1940 the workings of the nation's courts were beginning to undergo significant alteration.

Vanderbilt's most impressive contribution to court reform came when he took his seat as chief justice of the New Jersey Supreme Court in 1948 and in the process became the state's chief judiciary administrator. Under his guidance the state's court system—long notorious for excessive delay and inefficiency—seemed to transform itself almost overnight. Within two years its backlog of more than 2,700 cases, a good many of which had been pending for more than a decade, had been almost entirely cleared away. At one time the words "Jersey justice" had been used to describe the tendency among New Jersey's judiciary for meting out harsh penalties to the guilty. By the early 1950s, however, this phrase had, thanks to Vanderbilt, become synonymous with an efficiency that became the inspiration for court reforms in other jurisdictions.

In bringing about this change, Vanderbilt was often accused of riding herd on the state's lower courts with unreasonable harshness. But, for him, "justice delayed" amounted to "justice denied," and eventually he accepted the barbs philosophically. "One man in this set-up has to be a son-of-a-bitch," he once confided to United States Supreme Court Justice William Brennan, "and I'm it."

The artist commissioned to paint this portrait of Vanderbilt in the late 1940s was the English-born James McBey. McBey was best known for his etchings, and in his oil portrayal of Vanderbilt he delineated his subject with the same straightforward draftsmanship that characterized so many of his prints. At the same time, the picture seemed to capture a sense of the stalwart, and sometimes imperious, determination that Vanderbilt brought to bear in his crusade for judicial change. Clearly here was a man who was not easily brooked, and McBey's interpretation lends visual credibility to the story of Vanderbilt's reaction to news that a gathering of lawyers had just voted overwhelmingly to oppose one of his reforms in the workings of New Jersey courts. Smiling, Vanderbilt turned to the bearer of these tidings and said, "Why didn't you persuade them to be unanimously against me? The slaughter would be so magnificent."

FELIX FRANKFURTER
1882–1965

GARDNER COX

1906–1988

Oil on canvas

114.3 x 114.3 cm. (45 x 45 in.)

1960

Harvard Law Art Collection

In his later years Felix Frankfurter was fond of repeating the boyhood promise he once made to his mother that he would "never commit vealth." Indeed, this son of Austrian-Jewish immigrants never did enlist his precocious intellect in a quest for material gain. Instead, following his graduation from Harvard Law School in 1906, Frankfurter quickly rejected the possibility of pursuing a private, and probably quite lucrative, law practice in favor of a career largely devoted to public service and teaching at Harvard.

Although this choice did not bring Frankfurter fortune, it did win him fame. By the early 1920s, armed with a passionate sympathy for society's underdogs and a seemingly inexhaustible vitality, he had acquired a considerable reputation as an advocate of such causes as the rights of organized labor and the protection of civil liberties.

In a period noted for its conservative reactionism, Frankfurter's often outspoken concern for these matters inevitably made him something of a controversial figure, and in the wake of his prominence in defending foreign-born political extremists against deportation and in several other well-publicized cases involving organized labor during the years immediately following World War I, he became branded in many quarters as an irresponsible radical. But Frankfurter was no radical. Rather, the impetus for his activism grew out of a conviction that the nation's system of justice was not living up to its responsibility for safeguarding the rights of individuals who did not conform to mainstream American thinking.

At times Frankfurter's identification with radicalism seemed to jeopardize the security of his Harvard professorship. But even that did not diminish his inclination for controversial causes. By 1927 he had become a central figure in one of the most hotly debated issues of the day—the case of Nicola Sacco and Bartolomeo Vanzetti, two Italian-born anarchists found guilty in a Massachusetts court of robbing and killing a company paymaster.

For many, the question of Sacco and Vanzetti's guilt was settled when the judge presiding over their trial sentenced them to death. Others, however, believed—with some justification—that the pair's conviction had resulted less from solid evidence than it had from the fact that they subscribed to political views that were anathema to most Americans. As a result, soon after the trial ended, a groundswell of protest arose, claiming that Sacco and Vanzetti had been the victims of

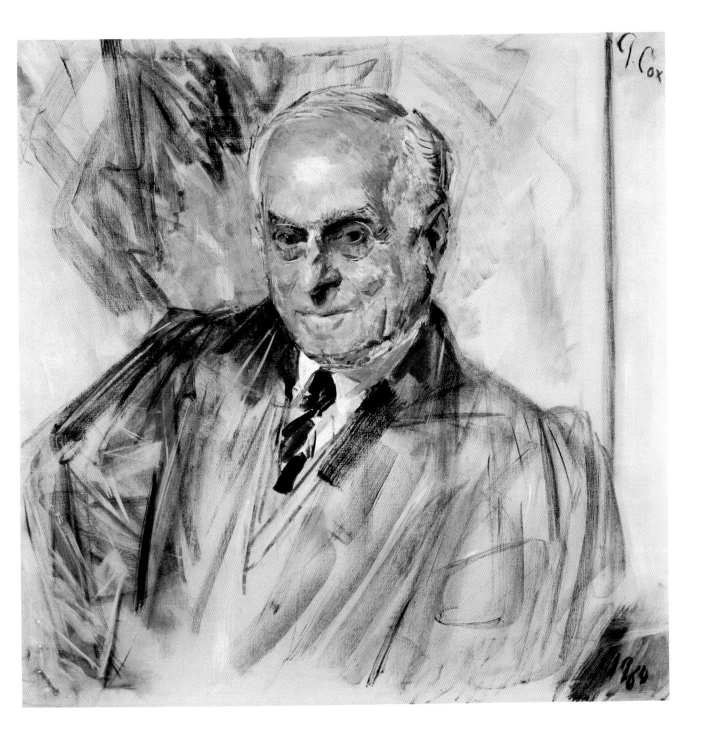

intolerance and demanding a new hearing for them.

Frankfurter did not associate himself with this movement immediately. But after delving into the trial's record, he became increasingly disturbed by what he saw as a gross miscarriage of justice, and in an *Atlantic Monthly* article of 1927 analyzing the evidence, he described the proceedings leading to the Sacco-Vanzetti conviction as a "farrago of misquotations, misrepresentations, suppressions, and mutilations."

The force of Frankfurter's unequivocating characterization of the trial transformed the Sacco-Vanzetti affair from a largely local matter into a worldwide *cause célèbre*. But, unfortunately for Sacco and Vanzetti, who were awaiting the outcome of a final appeal for a new trial, it failed to move Massachusetts's judicial establishment. On August 27, 1927, the pair was executed. Remembering that day many years later, Frankfurter claimed that he could not remember it without still feeling some of the "searing pain" he had experienced then.

Frankfurter's frank castigation of Massachusetts justice greatly offended some of the more establishment-minded at Harvard. But apparently it did not disturb his longtime acquaintance Franklin D. Roosevelt, who as governor of New York in the late twenties and early thirties made him an informal counselor on various legal and political matters. The two men much admired each other, and when Roosevelt was elected President in 1932 Frankfurter became one of his advisers.

Frankfurter, however, enjoyed his teaching at Harvard too much to accept a post in FDR's administration and instead preferred a role as unofficial consultant. Nevertheless, his impact on Roosevelt's New Deal proved substantial. In addition to framing major legislation designed to regulate various phases of the economy, he sent many of his prized students at Harvard to Washington to serve the administration, thus giving rise to the term "Happy Hot Dogs." Speaking of these direct and indirect influences on Roosevelt, one observer of the New Deal in its early stages described Frankfurter as "the most influential single individual in the United States," while another claimed that he played "Jiminy Cricket" to Roosevelt's "Pinocchio."

Although the offer of a post in the New Deal administration failed to lure Frankfurter from the comforts of Harvard Yard, the prospect of a seat on the Supreme Court did, and in 1939 Frankfurter accepted without hesitation Roosevelt's appointment of him to that body. Given Frankfurter's liberal reputation as defender of civil liberties and a framer of governmental controls over the nation's business community, conservatives were initially disturbed at this turn of events. But ultimately it was some of his fellow liberals whom he at times most alienated in his new position. For, once on the Court, Frankfurter ceased to be the sometimes vehement advocate of a particular point of view and became instead a forceful and often eloquent spokesman for judicial self-restraint. Thus, the man who had once argued against the deportation of individuals because of their allegedly subversive convictions found himself, as a Supreme Court justice, voting to sustain government measures seeking to curtail communist activities in this country. Similarly, although he privately deplored the death penalty,

Just above this preliminary sketch for his portrait of Frankfurter, artist Gardner Cox noted that the justice's smile was "almost hard in its sharpness" and that there seemed to be a "diabolical" impishness in his friendly demeanor.

Pencil on paper by Gardner Cox (1906–1988), 26.6 x 20.3 cm. (10 $\frac{1}{2}$ x 8 in.), 1960. Estate of Gardner Cox

he felt as a justice that he had no choice but to uphold convictions requiring that severest and most final of punishments. As Frankfurter himself once put it, his responsibilities on the bench—as he saw them at least—would never permit "writing [his] private notions of policy into the Constitution."

If in his work as a justice Frankfurter proved to be surprisingly restrained, off the bench there has probably never been a more ebullient member of the Supreme Court. Described by one observer as "electricity made human," he had a wit that rarely failed to entertain, and it was once said that "Wherever Frankfurter is, there is no boredom. As soon as he bounces in . . . the talk and the laughter begin."

When Gardner Cox painted Frankfurter's likeness at the behest of one of the latter's former Harvard law students in 1960, the artist found the encounter with his subject an unalloyed pleasure from start to finish. In conceiving the portrait, Cox was intent on investing it with some of the same effervescence that Frankfurter exuded to him. The result was an unusually informal composition, where the sketchlike randomness of line found in the background was meant to echo the subject's own pyrotechnic energy and charm.

HARLAN FISKE STONE
1872–1946

ALFRED JONNIAUX

1882–1974

Oil on canvas

127 x 91.5 cm. (50 x 36 in.)

Circa 1946

Department of Justice

By the second decade of the twentieth century, America's legal community was well into the throes of a hot debate focusing on the proper judicial approach to the host of new federal and state laws seeking to monitor the workings of this country's burgeoning and increasingly complex industrial economy. In essence, the question boiled down to whether judges were obliged to tolerate legislative attempts to alleviate such problems as harsh working conditions and unfair competitive practices, or whether, in the name of time-honored legal precedents demanding non-interference in these matters, they ought to declare these legislative innovations unconstitutional. For the more liberal minded, the first alternative seemed to be the only way to ensure social justice in the face of increasingly palpable evidence that the mechanisms of an unrestrained marketplace were all too often working to the advantage of a managerial elite and in the process denying the promise of American life to large segments of the population. Unless the courts began to recognize with greater frequency the constitutional validity of legislative efforts to correct this imbalance, many warned, the stability of America's free institutions would soon be at risk.

For the dean of Columbia University's law school, Harlan Fiske Stone, however, such reasoning under the rubric of sociological jurisprudence amounted for the most part to specious nonsense. Proper interpretation of the law, he claimed, rested on precedent and fixed principles, and in his writings he looked approvingly on those judicial traditionalists who, for example, invoked the sanctity of property and contract rights against legislative attempts to protect the less economically advantaged with workmen's compensation laws or minimum wage regulations.

To a large extent Dean Stone owed his views in this matter to a fundamental conservatism that never substantially altered. Nevertheless certain aspects of his thinking did. By the 1920s Stone was coming to recognize that the problems arising from the rapidly changing social and economic conditions of modern industrial America frequently demanded new legislative solutions. As his adherence to this outlook increased, he became convinced—like Oliver Wendell Holmes and a good many others—that no principle of law was so hallowed or immutably inflexible that it should automatically be invoked in the courts to prevent implementation of these solutions.

In short, by the mid-1920s Stone had become an advocate of judicial restraint when it came to questioning the constitutionality of many types of legislation. As a result, when President Calvin Coolidge appointed him to the Supreme Court in 1925, he gradually found himself aligned with Justices Holmes and Brandeis against a conservative majority that was often inclined to invalidate legislative innovations seeking to expand governmental control over the workings of the nation's private economic sector.

Speaking of his place as a frequent member of a dissenting minority on the Court, Stone once observed: "One never knows how far he should go in setting up his own views as against those of the majority, but I have learned from experience that I lead a happier life when I have voiced my convictions." This did not mean, however, that he always regarded his disagreements with the Court's majority with resigned equanimity. Among his most famous minority dissents was the opinion he wrote in the 1936 case of *United States v. Butler*, where he vehemently objected to the Court's overturning of the New Deal's Agricultural Adjustment Act, a law designed to ease the plight of the nation's depression-ridden farmers. In response to the Court majority's assertion that the Constitution prohibited any federal interference in agriculture, Stone was unmincing, and even somewhat sarcastic, in his criticism of his fellow justices. Accusing them on the one hand of resorting to a "tortured construction of the Constitution" to justify themselves on this occasion, he reminded them that judges were not the "only agency of government that must be assumed to have the capacity to govern."

Some historians have minimized the significance of Stone's cries for judicial self-restraint by suggesting that he was simply following a path charted by Holmes and Brandeis. To a large extent that may be true. Yet, as a Stone biographer has pointed out, it was he who remained on the Court long enough to carry "the Holmes-Brandeis tradition to fulfillment" in the late 1930s and early 1940s. By the end of his career on the bench, Stone could claim the distinction of having lived to see more of his dissenting opinions accepted by Court majorities than any other justice in history.

Elevated to the chief justiceship by Franklin Roosevelt in 1941, Stone also played a pivotal part in pushing the Court toward a more activist role in ensuring political rights and civil liberties. Thus, while claiming that the Court's power to nullify legislative policy related to the nation's economic life was limited, he took a decidedly broader view on judicial negation of measures that seemed to curtail an individual's freedom of thought or his right to participate in the democratic process. As a result, during his years as Chief Justice, Stone guided the Supreme Court toward several landmark decisions in this area—among them *West Virginia State Board of Education v. Barnette*, which overturned a law requiring public school students, regardless of personal conviction, to recite the pledge of allegiance, and *Smith v. Allwright*, which put an end to the South's systematic disenfranchisement of blacks in primary elections.

Stone's portrait, by the Belgian-born artist Alfred Jonniaux, was

completed shortly before Stone died in 1946. Painted in a studio at Washington, D.C.'s Corcoran Gallery of Art, the likeness recalls a journalist's description of Stone on the bench, which claimed that his most striking physical traits were "his breadth of black-gowned shoulder, breadth of forehead, [and] breadth of jaw."

Also suggested in Jonniaux's rendering is the amiable openness that became one of the hallmarks of Stone's style as Chief Justice, and that proved both a strength and a weakness. As one of his Court brethren noted at the beginning of his chief justiceship, Stone's easy manner in guiding the justices' discussions of cases produced a "relaxed atmosphere" that was a welcome contrast to the iron hand with which his predecessor, Charles Evans Hughes, had presided over the Court's daily workings. At the same time, however, Stone's reluctance to use his authority to close off debate before it became too strident often damaged the Court's sense of collegiality and led to rumors of more than usual rancor among the justices. Yet in the long term, the benefits of Stone's approach perhaps outweighed the divisiveness it encouraged. At least that was the judgment of one of his fellow justices, who observed that "those who stand at closer range know that the Court . . . grew in stature under the influence of Harlan Fiske Stone."

CHARLES H. HOUSTON
1895–1950

BETSY GRAVES REYNEAU

1888–1964

Oil on canvas

91.4 x 71.1 cm. (36 x 28 in.)

1943–1944

National Portrait Gallery,

Smithsonian Institution;

gift of the Harmon Foundation

In the spring of 1915, Charles Houston graduated from Amherst College, where he had distinguished himself as one of the school's most capable scholars, and with America's entry into World War I two years later, he pursued the same course that so many other well-educated young men were following: In the hope of playing a useful role in America's effort to subdue Germany, he enlisted in the army's officer-training program. Houston's venture into soldiering, however, fell well short of that patriotic expectation. For, as a black, he soon found that the impulse to demean and discriminate against members of his race was every bit as pervasive in America's rigidly segregated armed forces as it was in its civilian society, and when he returned home from Europe in 1919, the memories he brought with him consisted mainly of incident upon incident where he and his fellow black officers had been the victims of racially motivated harassment.

Not surprisingly, Houston came away from this wartime experience deeply embittered, and many years later, recalling the tenor of his thoughts during his final days as a lieutenant, he noted, "I felt damned glad I had not lost my life fighting for this country." Nevertheless, army service had yielded a positive fruit. On his return to civilian life, Houston knew that he had a special mission. In the fall of 1919 he enrolled in Harvard Law School, armed with the conviction that the best way to fight the iniquities suffered by American blacks in virtually every phase of their lives was through the legal system.

Following his graduation from Harvard in 1922 and an academic fellowship for further study of the law in Spain, Houston did not immediately rush into any courtroom crusades seeking redress of black grievances. Instead, joining his father's law firm in Washington, D.C., he settled into a fairly quiet and routine practice. By the early 1930s, however, Houston was emerging as a central figure in the legal battle to gain greater justice for blacks in America, and in 1935 he became special counsel for the National Association for the Advancement of Colored People, charged with orchestrating that organization's courtroom efforts to halt racial discrimination.

In shouldering this responsibility, Houston knew that the long-standing inequalities imposed on blacks by America's white establishment were many, ranging everywhere from discrimination in employment, housing, and public facilities to denial in many states of the

right to vote. But he also believed that, given the NAACP's relatively modest resources, it would be a grave mistake to attack all the manifestations of blacks' second-class status at once. Rather, in his estimation, the wisest strategy lay in singling out that dimension of the black civil-rights plight where the inequalities were most palpable and most readily provable in a court of law. For Houston that dimension was public education, where for decades blacks had been relegated to schools vastly inferior to those provided for whites.

Houston's first major victory on this front came in 1936, when a Maryland court ruled that the University of Maryland's all-white law school was obliged to admit qualified black applicants to its curriculum. Two years later, that ruling became a national norm when Houston and another NAACP lawyer successfully appealed a similar case involving the University of Missouri to the United States Supreme Court. Meanwhile, Houston was also instituting legal procedures challenging the practice of paying black teachers in segregated school systems substantially less than their white counterparts. By 1940, when he resigned as the NAACP's special counsel, that effort had gone a considerable way in eliminating such unjust differentials.

But although Houston initially gave priority to promoting equal education, his skills as a civil-rights lawyer inevitably drew him into other aspects of his cause. By the early 1940s he was playing a pivotal role in a pair of landmark court cases that ultimately forced white labor unions to cease their discrimination against black workers. Several years later, he was involving himself in a series of litigations that ended in two Supreme Court decisions negating neighborhood covenants prohibiting blacks from owning property.

When measured against the much broader strides made in black civil rights in the 1950s and 1960s, these and other Houston triumphs appear at first glance to represent comparatively small gains. Yet in light of the deeply rooted nature of the institutionalized racism that Houston was combating, their immediate significance was substantial. More important, they were a wedge that—by penetrating the thick armor of custom and legal precedent that had long shielded white America's discriminatory treatment of blacks—opened the way for still larger alterations in this country's interracial relationships. In short, when an admirer described Houston in 1950 as the civil-rights movement's "Moses," the sobriquet was well deserved.

During Houston's early years as a lawyer, he had combined the pursuit of private practice and deepening involvement in civil-rights cases with teaching at Howard University's black law school, and during his tenure as vice-dean there, he had done much to upgrade the quality of its curriculum and student body. Among his most oft-repeated bits of wisdom to students in those days was the saying, "No tea for the feeble, no crepe for the dead." No one adhered to this stoical sentiment more closely than Houston himself, and in mounting his attacks on racial discrimination, he brought a drive that was uncompromising and that doubtless led to his premature death at fifty-five. "In any fight," he noted in a letter written in anticipation of his dying, "some fall." But in Houston's lexicon, that was no reason to shrink from the struggle.

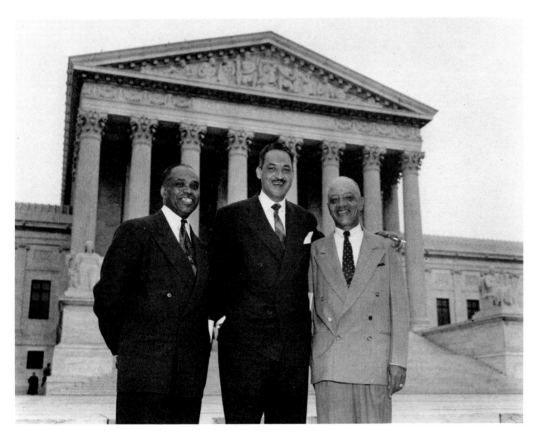

By 1954, when the Supreme Court unanimously ordered an end to racial segregation in American public schools in the case of *Brown v. Board of Education*, Houston had been dead for four years. Had he lived, doubtless this ultimate fruit of his many courtroom battles for equality in education would have tasted all the sweeter, knowing that the individual most responsible for it was his one-time protégé, Thurgood Marshall. Marshall is seen here on the Supreme Court steps at the time of *Brown* flanked by two other civil-rights lawyers. UPI/Bettmann Newsphotos

In 1939 a Michigan-born artist by the name of Betsy Graves Reyneau returned to this country from Europe, where she had been living for the past eleven years. Shortly after her arrival, she became appalled at the many forms of discrimination that continued to plague American blacks and that, in her view, made this country's white establishment little better than the racist-minded regimes that now prevailed in Hitler's Germany and Mussolini's Italy. Like Houston, whose encounter with discrimination in the army during World War I had galvanized his determination to become a champion of the black cause, Reyneau was moved to action. By 1942 she was embarked on a series of portraits depicting American blacks who had made significant contributions to this country's cultural, social, and scientific progress. In creating this pantheon of black notables, Reyneau's motive was obvious: to give lie to the widely held notion, so often invoked to justify black discrimination, that blacks were an inherently inferior race.

Among the twenty-three likenesses Reyneau ultimately completed for this group was one of Houston, which she painted during an extended stay in Washington, D.C., in 1943 and 1944. In its overall impact, the picture gave credence to the observation of many who knew Houston that he was a quiet and remote individual. But this tranquility was largely a mask, and beneath it lay an impassioned bitterness that never left him and that remained the central driving force throughout his career as a civil-rights lawyer.

WILLIAM HENRY HASTIE
1904–1976

GARDNER COX

1906–1988

Oil and charcoal on canvas

111.7 x 104.1 cm. (44 x 41 in.)

1972

Harvard Law Art Collection

In accepting an award recognizing him for his accomplishments in the struggle for black civil rights, William Hastie confessed to the group honoring him that the thing he always feared most in life was the loss of his capacity for "indignation against injustice." Coming from a man whom someone once described as "very modest, very unassuming [and] very calm," the remark seemed somewhat incongruous, and it was difficult to believe that the main force shaping much of Hastie's career had been an unrelenting sense of outrage over the denial to American blacks of their full complement of privileges and opportunity.

But that was indeed the case, and in the years between 1930, when he received his Harvard law degree, and 1949, when he became the first black appointed to a judgeship in the federal circuit courts, Hastie had stood in the vanguard in his people's struggle for equality. As a solicitor for the Department of Interior during the early years of the New Deal, for example, Hastie played a key role in drawing up the federal government's first affirmative action program designed to halt racial discrimination in hiring for public works projects. Several years later, with America at war with Germany and Japan, he was serving as an aide to Secretary of War Henry Stimson, designated with the responsibility for devising policies regarding the mobilization of blacks in the armed forces.

In this capacity, Hastie soon found himself sharply at odds with a military establishment that had much greater tolerance for racial bigotry, discrimination, and harassment than he. As a result, during his three-year tenure at the War Department, his many recommendations urging equal opportunity for blacks in uniform seemed as often as not to go unheeded, and eventually, tired of being circumvented and ignored, Hastie resigned. Nevertheless, the battle had not proven as futile as it appeared on the surface. In the wake of Hastie's resignation and largely because of the publicity it created, the army and navy began adopting his point of view, mandating policies of racial integration where it had never before existed and opening new opportunities for black advancement. The significance of this turn of events is hard to overstate, and it has been suggested that Hastie's pressuring against discrimination within the military became a main factor in quickening the pace of racial integration in American civilian life following World War II.

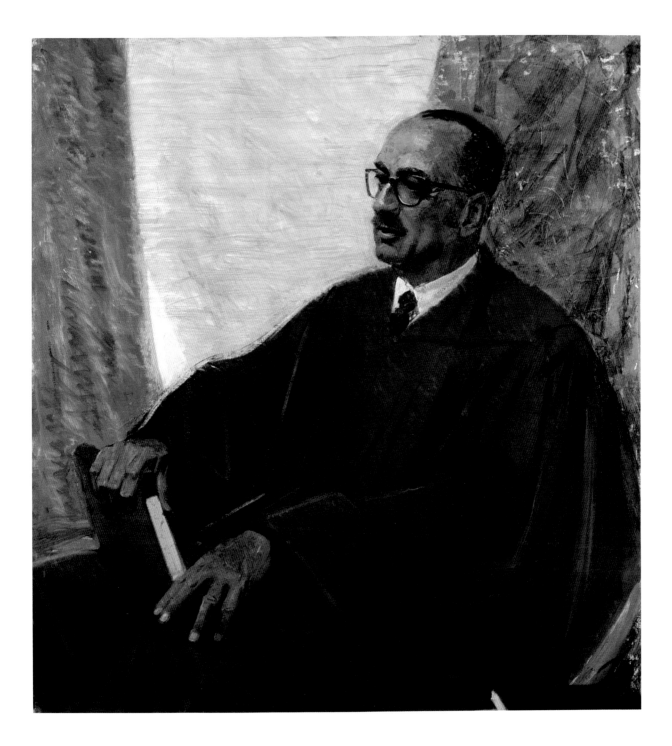

But Hastie's contributions to the advancement of black civil rights were not confined to his services as a governmental policymaker. He also served his cause well as a practicing lawyer, and like his cousin Charles Houston, he became in the 1930s and 1940s an indispensable figure in mounting the black community's courtroom battles against various forms of segregation. In fact, it was Hastie who in 1933 orchestrated, for the National Association for the Advancement of Colored People, its first serious litigation attempting to break down the barriers of segregation in education.

The case involved a black applicant to the University of North Carolina's all-white pharmacy school, and in it the NAACP took the premise that, since North Carolina funded no comparable facility for blacks, the school was obliged to admit any qualified black resident of the state seeking entrance to it. In the end Hastie lost the suit. Nevertheless, his cool, well-reasoned arguments mightily impressed even his opposition, and following the court's decision, the presiding judge described Hastie's performance as the "most brilliantly argued" presentation he had ever witnessed in his twenty-two years on the bench. Though unsuccessful, it was clear that Hastie had proven that the possibility of winning equal educational opportunity for his people was not merely a dim quixotic dream, but a distinct probability.

In the process Hastie also demonstrated his own considerable value as a civil-rights lawyer. In the next sixteen years he played an often-crucial role in litigations that, among other things, won blacks the right to picket businesses denying them jobs and largely negated state laws calling for passenger segregation in public transportation. But the courtroom success with perhaps the most noteworthy implications came in 1944, when in the Supreme Court case of *Smith v. Allwright*, he and co-counsel Thurgood Marshall challenged the constitutionality of whites-only primary elections in Texas. In its decision in favor of Hastie and Marshall's contentions, the Court put an end to a polling practice that in effect disenfranchised blacks in many southern states, and for the first time since Reconstruction it seemed possible that blacks would finally have a political voice in that region.

In an article about Hastie published in the late 1940s, the writer noted that his subject "has never been known to get excited or lose his temper." That imperturbability never left Hastie, and when he sat for his portrait by Gardner Cox in 1972, the artist found him an unusually subdued subject. Then in his twenty-third year as a federal judge, Hastie betrayed emotion only once in the course of posing, Cox later recalled, over a joke told by the artist. As a result the finished likeness's most striking characteristic was its sense of self-contained serenity.

Whether Cox realized it or not, he had thus documented in oil one of the less tangible, but significant, assets that Hastie had brought to the civil-rights movement. For, although he could not have accomplished what he did without possessing considerable legal acumen, there was also little doubt that much of his success as an advocate of black rights had rested on a quiet poise that even the emotionally charged issue of racism could not shake.

HUGO BLACK
1886–1971

When the arch-conservative Supreme Court Justice Willis Van Devanter announced his retirement from the bench in 1937, and President Franklin Roosevelt declared his intention of replacing him with Alabama Senator Hugo Black, journalist William Allen White called it a "veritable three-bagger" for FDR. And indeed it was. First, few in Congress were more solidly committed than Black to the recent myriad of ground-breaking legislation spawned by Roosevelt's administration to control the nation's economic life, and unlike Van Devanter, who had recently joined other conservative justices in declaring many of these innovations unconstitutional, he was certain to take a decidedly tolerant view of Roosevelt's New Deal measures. Secondly, in choosing a senator to succeed Van Devanter, Roosevelt had also assured that, given the Senate's club-like predilection for viewing its own members less critically than it would an outsider, the confirmation of Black's appointment posed few problems. Finally, the fact that Black came from the South eliminated one of the main sources of potential trouble in that regard—namely the Senate's conservative southern Democrats, who might otherwise be reluctant to approve someone as liberal as Black.

Although most observers had to agree with White's analysis of the situation, a good many thought that Roosevelt's three-base hit was hardly worthy of cheers. Granted, Black had been a capable lawyer back in the days of his private practice in Birmingham, Alabama, and had done a creditable job during his stints as a police court judge and public prosecutor. None of these credentials, however, seemed to mark him as particularly well qualified for a seat on the nation's most important tribunal. Instead it appeared to many that his appointment was nothing less than an uncommonly egregious exercise in political expedience. While one commentator wailed that Black's nomination had "carried the spoils system to the Supreme Bench, openly and cynically," another lamented: "There have been worse appointments to high judicial offices; but . . . I can't remember where or when."

But the indignation over Black's elevation to the Supreme Court did not reach flood tide until several weeks after the Senate confirmed him, when a journalist dredged up the story that Black had once been a member of the Ku Klux Klan and that he owed his senatorial election in 1926 largely to Klan support. Naturally, this alliance with an organization dedicated to preserving America's white Protestant purity, often

Hugo Black

ROBERT VICKREY

Born 1926

Tempera and ink on board

52.7 x 40 cm. (20³/₄ x 15³/₄ in.)

1964

National Portrait Gallery,

Smithsonian Institution;

gift of Time Inc.

through violence and intimidation of blacks, Catholics, and Jews, among others, raised yet graver questions about Black's fitness for the Court. Moreover, Black's explanation that he had been a Klan member for only a short time and had never subscribed to its tenets did little to satisfy many of his detractors.

Yet Black not only survived this new burst of outrage; he also soon proved that the rights and privileges of Americans, regardless of race, color, or creed, were entirely secure in his judicial hands. In fact, no justice has ever exhibited a stronger commitment to safeguarding those rights and privileges than Black did during his thirty-four years on the Court. Thus, although he did indeed fulfill Roosevelt's expectation that he would help lead the Court away from its tendency to declare New Deal legislation unconstitutional, Black's significance as a justice rests primarily on his many opinions calling for full and complete protection under the Bill of Rights in cases where American law and custom seemed to deny that protection. By the final years of his tenure on the Court, the criticisms directed at him focused not on racial or ethnic intolerance. Instead, they revolved around the charge that in moving the Court toward its ever more activist role in the quest toward ensuring racial equality, the rights of political or religious dissent, and the alleged criminal's protection against self-incrimination and trial without counsel, Black had exerted altogether too much influence. As the *New York Times* put it in 1961, this country had "no more zealous, no more single minded advocate of individual liberty than Justice Black."

When *TIME* magazine asked Black to sit for a cover portrait by Robert Vickrey in 1964, he agreed only reluctantly. At the moment he was seventy-eight, and there were those who said that he was too old to continue on the Court. As a result, Black and his wife were fearful that Vickrey's likeness might call too much attention to the justice's age. The first sitting, therefore, proved something of a trial for the artist, as Black's wife looked suspiciously over his shoulder, expressing disapproval whenever he injected a sign of age into the likeness. "Each dewlap brought forth a groan," Vickrey noted, recalling this awkward situation years later. "Crow's feet caused incoherent mumblings. When I began to depict his handsome bald dome, I could see her cringe."

But Black's lifelong passion for tennis, or more particularly his pride in the strength of his game, finally saved the day for artistic veracity. After winning a match against the *TIME* reporter who had been interviewing him as Vickrey painted, Black was considerably more mellow at his second sitting, and although his wife continued to chastise Vickrey when she thought he was going too far in revealing her husband's age, the expressions of disapproval seemed a bit more amiable.

Had pressure for Black's retirement not made the justice and his wife so preoccupied with the age question, they might have realized that there was a quality in the justice's bearing that was bound to make an interpretation of his features flattering. Under Black's picture in the 1905 University of Alabama yearbook were printed the words:

Robert Vickrey

"I am one of those gentle souls that will use the devil himself with courtesy." Black maintained the good-natured affability that inspired the juxtaposition of those words with his student photograph throughout his life, and it was that trait, rather than the signs of advancing age, that Vickrey's likeness seems to highlight.

EARL WARREN

1891–1974

The phrase "a revolution made by judges" appears at first glance to be a contradiction in terms, and in most times and places it would seem nonsensical in light of the bench's traditional role as a force for social and political continuity. Yet that is precisely how one legal scholar has characterized the work of the Supreme Court during the years of Earl Warren's chief justiceship, and to a large extent the description is apt.

From 1953, when the Senate confirmed Warren's appointment, to his retirement sixteen years later, the Court did indeed become the catalyst for far-reaching change in many phases of American society. In their decision of *Brown v. Board of Education*, bringing an end to the segregation of blacks in public schools, for example, Warren and his fellow justices had helped to usher in a new era in race relations. In such decisions as *Gideon v. Wainwright* and *Miranda v. Arizona*—upholding on the one hand the accused criminal's right to counsel and on the other his right to remain silent in post-arrest questioning—they had precipitated drastic reforms in this nation's law-enforcement procedures. In their ruling in *Baker v. Carr*, premised on the principle of "one-man-one-vote," they had stripped states of their time-honored prerogative to determine district representation in their legislatures on factors other than population. And in a series of other cases that included *Yates v. United States*, they had sharply curtailed the government's right to penalize individuals for their extremist and allegedly dangerous political beliefs.

Simply put, under Warren's guidance the Court assumed an activism in ensuring the constitutional rights of individuals that was unprecedented in its history and in the process prompted departures from the status quo that a good many found jolting. For the more conservative, many of these changes were also decidedly unwelcome. While Dwight Eisenhower, who had appointed Warren Chief Justice, once referred to that act as the "biggest damned-fool mistake I ever made," others went so far as to launch a movement calling for Warren's impeachment by Congress.

Rulings in Supreme Court cases, of course, are never dependent solely on one member of that tribunal, and the "impeach Earl Warren" advocates were wrong in their apparent assumption that without Warren many of the liberal decisions regarding human rights during his chief justiceship might have been avoided. Nevertheless, there is

no doubt that he exercised substantial influence on his brethren. By the time he resigned in 1969, it was generally conceded that not since the days of John Marshall had one man had so much impact on the Court's direction.

Such an exalted ranking in American judicial history, however, hardly seemed to be in the offing when news of Warren's appointment first became public in 1953. Having begun his rise to public prominence as an assistant city attorney in Oakland, California, Warren had by the late 1930s become attorney general of California and in 1943 was beginning his first of three terms as that state's immensely popular governor. But, though indisputably successful, he had never exhibited signs of an intellectual originality that might mark him as a potential shaper of modern American law. As one journalist rather harshly put it in 1947, to the world at large Warren appeared to be simply an "honest, likable, and clean" man who had "probably never bothered with abstract thought twice in his life." Thus, on the eve of his chief justiceship, the speculation among seasoned observers was that he would most likely be remembered as a capable and congenial administrator of the Court's business and little more.

In reaching that conclusion, however, the commentators had failed to perceive one significant fact: Warren cared deeply for people, and although he was only indifferently grounded in legal theory and

Earl Warren

GARDNER COX

1906–1988

Oil on canvas

104.1 x 89.5 cm. (41 x 35¹/₄ in.)

1963

National Gallery of Art;

on loan to the National

Portrait Gallery,

Smithsonian Institution

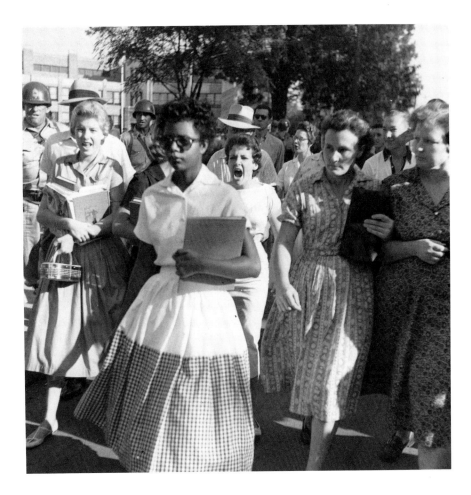

Ultimately the Warren Court's desegregation mandate in *Brown v. Board of Education* did force public school integration on a large scale, but not without protest. The best-remembered confrontation came in 1957, when several black youths, among them the girl pictured here, weathered for days the racist jeers of anti-integration mobs as they tried to attend the previously all-white Central High School in Little Rock, Arkansas. UPI/Bettmann Newsphotos

often unconcerned about precedent, he brought to the Court a singularly acute ethical sense when it came to issues involving the rights and well-being of individuals. After listening to a lawyer as he bolstered his argument with citations of one legal authority after another, he frequently responded with the question, "Yes, but is it fair?" It was this preoccupation with fairness that compelled him to direct the Court toward a body of landmark decisions that sometimes seemed to stretch the rights and freedoms of individuals to their constitutional limits.

Of all the decisions handed down by the Warren Court, many would say that the most significant was *Brown v. Board of Education*, where Warren had declared that "in the field of education the doctrine of 'separate but equal' has no place. Separate educational facilities are inherently unequal." So saying, the Chief Justice had issued a mandate whose implementation would become for years the source of bitter racial confrontation but would ultimately bring America substantially closer to realizing its ideal of equal opportunity for all.

Warren himself, however, took greatest pride in knowing that it had been during his tenure that the Court had put an end to legislative districting based on considerations other than population. For him, the decisions forcing this change in the political process represented the realization of democracy's most fundamental principle—that all voters should carry equal weight in the elective process.

Warren had a gregarious dimension to his personality that expressed itself frequently in a crushingly hearty handshake and booming laugh. But there was a more remote side as well, and when Gardner Cox—himself an extremely sociable creature—painted Warren's portrait in 1963, he encountered his subject in one of his more diffident modes. Efforts to engage Warren in conversation during the sittings, Cox noted later, generally met with polite but discouraging responses, and it was soon clear that Warren viewed his posing sessions more as a task than as an opportunity for verbal interchange. Cox, however, did succeed in drawing out the Chief Justice when he posed the question he asked of many of his sitters—"What would you endow a child with if you could endow him with just one quality?" Warren did not answer for several minutes. Then, finally he said, "the ability to tolerate opinions at variance with his own."

The "Impeach Earl Warren" campaign never came close to its objective. It did, however, create at least one trying moment for Warren, when in 1963 he found himself confronted in San Francisco with picketers intent on removing him from the chief justiceship. The San Francisco Examiner

Notes on Sources

Introduction:
"Amass more wealth," Anton-Hermann Chroust, *The Rise of the Legal Profession in America*, vol. 2 (Norman, Okla., 1965), p. 17. "Among the multiplicity," *ibid.*, p. 18. "Not only USELESS," *ibid.*, p. 20. "In America there are neither nobles," Alexis de Tocqueville, *Democracy in America*, ed. J. P. Mayer and Max Lerner (New York, 1966), p. 247. "The great English common law," Chroust, *Rise of the Legal Profession*, vol. 2, p. 105. "T'is warrant otherizes," *ibid.*, p. 95. "If a lawyer confines himself," *ibid.*, p. 285.

John Jay:
"Le Washington de la Negotiation," in John Adams, *Diary and Autobiography of John Adams*, ed. L. H. Butterfield, vol. 3 (Cambridge, Mass., 1962), p. 85. "A man and his office," Margaret Christman, *Fifty American Faces from the Collection of the National Portrait Gallery* (Washington, D.C., 1978), p. 29. "In nominating you," Irving Dilliard, "John Jay," in Leon Friedman and Fred L. Israel, eds., *The Justices of the United States Supreme Court, 1789–1969* (New York, 1969), vol. 1, p. 10. "Just as I had laid aside," George C. Mason, *The Life and Works of Gilbert Stuart* (New York, 1879), p. 206. "We are lately so fond," *Boston Argus*, September 11, 1792. "Party-colored" robes, Charles Warren, *The Supreme Court in United States History* (Boston, 1926), vol. 1, p. 48.

William Pinkney:
"I have heard," Alfred Niles, "William Pinkney," in William Draper Lewis, ed., *Great American Lawyers* (Philadelphia, 1907–1909), vol. 2, p. 177. "A man of consummate talents," Charles Warren, *History of the American Bar* (New York, 1966), p. 260. "He rises higher," Niles, "William Pinkney," p. 177. "As little for his colleagues," Albert Beveridge, *The Life of John Marshall*, vol. 4 (Boston, 1916), pp. 132–33. "The prosopopoeia," Niles, "William Pinkney," p. 199. "The most thoroughly equipped lawyer," Warren, *History of the Bar*, p. 260. "So exquisite was," Niles, "William Pinkney," p. 200. "Never . . . lost sight," Joseph Story, *Life and Letters of Joseph Story*, ed. William W. Story, vol. 2 (Boston, 1851), p. 493. "His place has not yet been occupied," *ibid.*, p. 495.

Thomas Addis Emmet:
"The mind," Thomas Addis Emmet, *Memoir of Thomas Addis and Robert Emmet*, vol. 1 (New York, 1915), p. 228. "The favorite counsellor," Charles Warren, *The History of the Harvard Law School* (New York, 1970), vol. 1, p. 243. "To attempt the dangerous paths," Horace Hagan, *Eight Great American Lawyers* (Oklahoma City, Okla., 1923), p. 139. "There is an appearance," Hagan, *ibid.*, p. 140.

William Wirt:
On Wirt's resemblance to Goethe see John Pendleton Kennedy, *Memoirs of the Life of William Wirt* (Philadelphia, 1849), vol. 1, p. 15. "Raise by my pen," *ibid.*, p. 265. *Tom Jones* as "bread and butter" is in Joseph Robert, "William Wirt, Virginian," *Virginia Magazine of History and Biography* 80 (October 1972): 392. "'The blood more stirs,'" John Hand Hall, "William Wirt," in Lewis, *Great American Lawyers*, vol. 2, p. 288. "All that anybody," Robert, "William Wirt, Virginian," p. 424. "A culprit par-

doned," Kennedy, *Memoirs of Wirt*, vol. 2, p. 362.

Henry Wheaton:
"I doubt," James Scott, "Henry Wheaton," in Lewis, *Great American Lawyers*, vol. 3, p. 248. "Too deep," *ibid.* "H. Wheaton . . . has commenced," Elizabeth F. Baker, *Henry Wheaton, 1785–1848* (Philadelphia, 1937), p. 15. "Golden book of American law," Scott, "Henry Wheaton," p. 254. "Too high for criticism," Frederick Hicks, *Men and Books Famous in the Law* (Rochester, N.Y., 1921), p. 234.

John Marshall:
"There is not a better natured," Kennedy, *Memoirs of Wirt*, vol. 2, p. 241. "I have had the gratification," Chester Harding, *A Sketch of Chester Harding, Artist*, ed. Margaret White (Boston, 1929), pp. 136–37. "Lax lounging manner," Christman, *Fifty American Faces*, p. 89

James Gould:
"The fertile source," Warren, *History of Harvard Law School*, vol. 1, p. 183. "Every word was pure English," Simeon Baldwin, "James Gould," in Lewis, *Great American Lawyers*, vol. 2, p. 472. "A non sequitur," Warren, *History of Harvard Law School*, vol. 1, p. 183. "My house is your home," William Dunlap, *A History of the Rise and Progress of the Arts of Design in the United States*, vol. 2, pt. 1, ed. Rita Weiss (New York, 1969), p. 206.

Jeremiah Mason:
"Anak of the Boston bar," in "Clevenger," *The United States Magazine and Democratic Review* 14 (February 1844): 204. "But if you took me by the throat," Claude Fuess, *Daniel Webster* (Hamden, Conn.,

1963), vol. 1, p. 108. "I cannot gyrate to ye," John Chipman Gray, "Jeremiah Mason," in Lewis, *Great American Lawyers*, vol. 3, p. 25. "He'll have twice as much," in C. H. Hill, "Jeremiah Mason and the Bar," *American Law Review* 12 (1877–1878): 247. "Thank God for that!" Gray, "Jeremiah Mason," p. 26.

Daniel Webster:
"He broke upon me like a thunder storm," Fuess, *Daniel Webster*, vol. 1, p. 91. "A schoolmaster among," *ibid.*, vol. 2, p. 314. "A great three-decker," *ibid.*, p. 315. "It is, Sir, as I have said," *ibid.*, p. 231. "Many were sinking," in *ibid.*, p. 232. "A small Cathedral," James Barber and Frederick Voss, *The Godlike Black Dan: A Selection of Portraits from Life in Commemoration of the Two Hundredth Anniversary of the Birth of Daniel Webster* (Washington, D.C., 1982), p. 36. "Caricatures," in John Frazee, "The Autobiography of Frazee, the Sculptor," pt. 2, *North American Quarterly Magazine* 6 (July 1835): 20.

Horace Binney:
"To have every link," in Warren, *Supreme Court*, vol. 2, p. 127. "That was a *bad* case," *ibid.*, p. 128. "Undisguised dismay," *ibid.* "Double-and-twisted," *ibid.*, p. 129. "Apollo in manly beauty," in Warren, *History of the Bar*, p. 433. "Dignity, ease, suavity," *ibid.*, p. 433.

James Kent:
"The law, I must frankly confess," Hicks, *Men and Books*, p. 137. "Always extremely hated," James Brown Scott, "James Kent," in Lewis, *Great American Lawyers*, vol. 2, p. 495. "Narrow dirty street," in Hicks, *Men and Books*, p. 139. "One of the loveliest," in Philip Hone, *The Diary of Philip Hone*, ed. Alan Nevins (New York, 1927), p. 380. The discussion of Kent's royalties is in Hone, *Diary*, p. 645. "He is not a good sitter," in Samuel F. B. Morse, *Samuel F. B. Morse: His*

Letters and Journals, ed. Edward Lind Morse, vol. 1 (New York, 1914), p. 250.

Joseph Story:
"It is vain to attempt," William Schofield, "Joseph Story," in Lewis, *Great American Lawyers*, vol. 3, p. 134. "Brother Story," Gerald Dunne, *Justice Joseph Story and the Rise of the Supreme Court* (New York, 1970), p. 91. "Those who . . . recite to him," in Arthur Sutherland, *The Law at Harvard: A History of Ideas and Men, 1817–1867* (Cambridge, Mass., 1967), p. 103. "We must go to you," Warren, *History of Harvard Law School*, vol. 2, p. 66. "It was a very large folio," in Schofield, "Joseph Story," p. 130. "His talk would gush out for hours," Warren, *History of Harvard Law School*, vol. 2, p. 68.

Simon Greenleaf:
"Story prepared the soil," *Centennial History of the Harvard Law School, 1817–1917* (Cambridge, Mass., 1918), p. 216. "Not a cloud has ever passed," Warren, *History of Harvard Law School*, vol. 2, pp. 18–19. "A vein of humor," *Centennial History*, p. 217. "I can conceive of no surer plan," Gerald T. Dunne, "Joseph Story," in Friedman and Israel, *Justices of the Supreme Court*, vol. 1, p. 446. "A grosser injustice," Warren, *Supreme Court*, vol. 2, p. 25. "I am sick at heart," Carl Swisher, *History of the Supreme Court of the United States*, vol. 5: *The Taney Period, 1836–64* (New York, 1974), p. 93. "It is impossible for one who has not studied," *Centennial History*, p. 217. "I have neither the heart," Warren, *History of Harvard Law School*, p. 121.

Lemuel Shaw:
"Do you suppose," Leonard W. Levy, *The Law of the Commonwealth and Chief Justice Shaw* (Cambridge, Mass., 1957), p. 19. "Labors of the Bar," Frederic Hathaway Chase, *Lemuel Shaw: Chief Justice of the Supreme Judicial Court of Massachusetts, 1830–1860* (Boston, 1918), p. 139.

"Gentlemen, this may seem to you," *ibid.*, p. 281. "Spit in the face," in Levy, *Law of the Commonwealth*, p. 102. "I confess I regard him," Chase, *Lemuel Shaw*, p. 277. "Well, Judge Merrick," *ibid.*, p. 290.

Thomas Ruffin:
"As a principle of moral right," Julius Yanuck, "Thomas Ruffin and North Carolina Slave Law," *Journal of Southern History* 21 (November 1955): 462. "It always seemed to me," *ibid.*, p. 464. "With pleasure," Joseph K. L. Reckford, "The Dialectic and Philanthropic Societies Portraits" (unpublished honors essay in American Studies, University of North Carolina, 1981), p. 106.

Rufus Choate:
"What's the use," Claude M. Fuess, *Rufus Choate: The Wizard of the Law* (New York, 1928), p. 135. "She went down the harbor," George P. Hoar, *Autobiography of Seventy Years*, vol. 2 (New York, 1903), p. 353. "Some of our technical brethren," Fuess, *Rufus Choate*, p. 151. "Of whose health thieves," *ibid.*, p. 141. "Well, what did he say?" *ibid.*, p. 184. "No gambler," Fuess, *Rufus Choate*, p. 171. "The most beautiful young man," Edwin P. Whipple, "Some Recollections of Rufus Choate," *Harper's Monthly* 57 (November 1878): 876. "Fresh, personal beauty," Jean Matthews, *Rufus Choate: The Law and Civic Virtue* (Philadelphia, 1980), p. 11. "It is as ugly," Whipple, "Some Recollections," p. 876. "Remembrancer of one," *Boston Transcript*, April 7, 1862.

Richard Henry Dana, Jr.:
"Tight frock coat," in Richard Henry Dana, Jr., *Two Years Before the Mast* (New York, 1964), pp. 9–10. "Weapon to convict him," Richard Henry Dana, Jr., *The Journal of Richard Henry Dana, Jr.*, ed. Robert F. Lucid (Cambridge, Mass., 1968), p.

145. "The change in public sentiment," *ibid.*, p. 636. "My life has been a failure," *ibid.*, p. xxxii.

Charles O'Conor:
Quotations about *Forrest v. Forrest* are found in the *New York Evening Post*, January 23, 1852. "I feel better already," John Bigelow, "Some Recollections of Charles O'Conor," *Century Magazine* 29 (March 1885): 735.

Roger B. Taney:
"The pure ermine," Warren, *Supreme Court*, vol. 2, p. 16. "Gave all the light of day," Carl B. Swisher, *Roger B. Taney* (Hamden, Conn., 1961), p. 109. "The loss of Judge Taney," Walker Lewis, *Without Fear or Favor: A Biography of Chief Justice Roger Brooke Taney* (Boston, 1965), p. 423. "Cannot be Obeyed," Warren, *Supreme Court*, vol. 2, p. 307. "Cunning chief," Lewis, *Without Fear*, p. 421. "He was, next to Pontius Pilate," *ibid.*, p. 471. "I have no ambition to be," Swisher, *Taney*, pp. 473–74.

William M. Evarts:
"Immortal," Brainerd Dyer, *The Public Career of William M. Evarts* (Berkeley, Calif., 1933), p. 92. "Very uncommon talents," Chester L. Barrows, *William M. Evarts: Lawyer, Diplomat, Statesman* (Chapel Hill, N.C., 1941), p. 17. "Traitor, Renegade," *ibid.*, p. 138. "Set the whole superstructure," *ibid.*, p. 158. "The sentences fall," Dyer, *Public Career*, p. 91. "Had stolen the livery," Barrows, *Evarts*, p. 160. "Moses and Solon combined," Marion Adams to William Evarts, March 20, [1884], Evarts Papers, Library of Congress. "I cannot say that Eastman Johnson's," *Boston Transcript*, April 6, 1885.

Belva Ann Lockwood:
"Woman is without legal capacity," Julia Hull Winner, *Belva A. Lockwood* (Lockport, N.Y., 1969), pp. 121–22. "No pen can portray," *ibid.*, p. 122. "Plain,

black velvet," *ibid.*, p. 36. "Bustle about girls," *ibid.*, p. 57. "The original impetus," Washington *Evening Star*, February 11, 1913. "National Portia," Washington *Evening Star*, February 11, 1913.

Thomas M. Cooley:
"In every respect models," *American Law Review* 32 (1898): 917. "A mere doubt," Jerome Knowlton, "Thomas McIntyre Cooley," *Michigan Law Review* 5 (March 1907): 318. "There is ground," Alan Jones, "Thomas M. Cooley and the Michigan Supreme Court: 1865–1885," *American Journal of Legal History* 10 (April 1966): 112–13. "In a field," Bernard Schwartz, *The Law in America* (New York, 1974), p. 182.

Christopher C. Langdell:
"A mere boy," Henry James, *Charles W. Eliot*, vol. 1 (Boston, 1930), p. 43. "Old crank," Joel Seligman, *The High Citadel: The Influence of Harvard Law School* (Boston, 1978), p. 35. "Virtues of a slow mind," Samuel Batchelder, *Bits of Harvard History* (Cambridge, Mass., 1924), p. 307. "Medieval," Joseph H. Beale, Jr., "Professor Langdell—His Later Teaching Days," *Harvard Law Review* 20 (November 1906): 10. "As intransigeant as a French Socialist," Sutherland, *Law at Harvard* (Cambridge, Mass., 1967), p. 188. "Knocking at its classic doors," Seligman, *High Citadel*, p. 41. "When the end of the chapter," Alpheus T. Mason, *Brandeis: A Free Man's Life* (New York, 1946), p. 35.

Joseph H. Choate:
"Extraordinary promise," in Joseph H. Choate, *Arguments and Addresses of Joseph Hodges Choate*, ed. Frederick C. Hicks (St. Paul, Minn., 1926), p. 9. "The great lawyers," Edward Sanford Martin, *The Life of Joseph Hodges Choate* (New York, 1920–1921), vol. 1, p. 445. "Treasonable activity," Choate,

Arguments, p. 198. "And when he sat down," Martin, *Life of Choate*, vol. 2, p. 15. "Now, if Your Honor please," Choate, *Arguments*, p. 165. "I have said it once," Theron Strong, *Joseph H. Choate* (New York, 1917), p. 141. "He it is who," in "Memorial of Joseph H. Choate," *Association of the Bar of the City of New York Year Book* (New York, 1918), pp. 98–99. "Dashing manner," Patricia Hills, *John Singer Sargent* (New York, 1986), p. 155. "Sargentolatry," *ibid.*, p. 162.

James C. Carter:
"Really believe," George Alfred Miller, "James Coolidge Carter," in Lewis, *Great American Lawyers*, vol. 8, p. 37. "Systems of despotic nations," *ibid.*, p. 18. "Nothing is ever decided," *ibid.*, p. 35.

John Marshall Harlan:
"In a tone and language," Louis Filler, "John M. Harlan," in Friedman and Israel, *Justices of the Supreme Court*, vol. 2, p. 1287. "We don't have much trouble," Alpheus T. Mason, *The Supreme Court from Taft to Warren* (Baton Rouge, La., 1968), p. vii. "Upon reflection," Filler, "John M. Harlan," p. 1285. "Spirit and substance," *ibid.*, p. 1288. "With a badge of inferiority," *ibid.*, p. 1289. "As if the whole world," G. Edward White, "John Marshall Harlan I: The Precursor," *American Journal of Legal History* 19 (January 1975): 8. "With one hand on the Constitution," Filler, "John M. Harlan," p. 1293.

Clarence Darrow:
"Clarence Darrow is now," Kevin Tierney, *Darrow: A Biography* (New York, 1979), p. 77. "A hypocrite and a slave," *ibid.*, p. 77. "Great, monstrous, greedy," *ibid.*, p. 184. "Attorney for the damned," Thomas J. Fleming, "Take the Hatred Away, and You Have Nothing Left," *American Heritage* 20 (December 1968): 75. "Not a state's attorney," Tierney, *Darrow*, p. 337. "Everyone acclaimed it," telegram, Jo Davidson to Clarence Darrow, March 29,

1929, Jo Davidson Papers, Manuscript Division, Library of Congress. "About the bust Mrs. D," Clarence Darrow to Jo Davidson, June 7, [1929], Jo Davidson Papers.

Oliver Wendell Holmes:
"More interesting than momentous," John Garraty, "Holmes's Appointment to the U.S. Supreme Court," *New England Quarterly* 22 (September 1949): 300. "About seventy-five years ago," Schwartz, *Law in America*, p. 191. "Fool to drool," Louis Auchincloss, "The Long Life and Broad Mind of Mr. Justice Holmes," *American Heritage* 29 (June/July 1978): 74. "When men have realized," Paul A. Freund, "Oliver Wendell Holmes," in Friedman and Israel, *Justices of the Supreme Court*, vol. 3, p. 1766. "Bitter disappointment," Garraty, "Holmes's Appointment," p. 301. "A sage with the bearing," in Felix Frankfurter, ed., *Mr. Justice Holmes* (New York, 1931), p. 166. "He is one of us," Catherine Drinker Bowen, *Yankee from Olympus: Justice Holmes and His Family* (Boston 1943), p. 408. "While in Boston," Mark deWolfe Howe, ed., *Holmes-Pollock Letters* (Cambridge, Mass., 1944), p. 268.

Louis D. Brandeis:
"Leaders of the bar," Mason, *Brandeis*, p. 101. "It has been one of the rules," *ibid.*, p. 69. "One of the deepest wounds," *ibid.*, p. 470. "In his own time," *ibid.*, p. 633.

Joseph Henry Beale:
"A fencing match," Zechariah Chafee, Jr., "Joseph Henry Beale," *Harvard Law Review* 56 (March 1943): 699. "Teaching by combat," Felix Frankfurter, "Joseph Henry Beale," *Harvard Law Review* 56 (March 1943): 702. "Show me one case," Sutherland, *Law at Harvard*, p. 216. "But Mr. Beale," Felix Frankfurter, *Felix Frankfurter Reminisces*, recorded by Dr. Harlan B. Phillips (New York, 1960), p. 22. "Epoch-making," Arthur Leon Harding, "Joseph Henry Beale: Pioneer," *Mis-*

souri Law Review 2 (April 1937): 131. "Almost grotesque," in Charles Hopkinson, "The Portrait Painter and His Subject," *Atlantic Monthly* 186 (October 1955): 74. "No portrait which," is in a typescript of Charles Hopkinson's 1947 lecture "An Artist at Work," p. 3, Hopkinson Papers, Archives of American Art, Smithsonian Institution.

John W. Davis:
"Something to do with alcohol," William H. Harbaugh, *Lawyer's Lawyer: The Life of John W. Davis* (New York, 1973), p. 26. "I'm going to quit," *ibid.*, p. 27. "I should like to get," *ibid.*, p. 89. "No one has due process," *ibid.*, p. 127. "More elegant," *ibid.*, p. 128. "I do not like to have," *ibid.*, p. 405. "And every time," *ibid.*, p. 503. "Type-cast," *ibid.*, p. 514.

Roscoe Pound:
"Schoolmaster of the American Bar," Schwartz, *Law in America*, p. 230. "Law must be stable," Arthur Goodhart, "Roscoe Pound," *Harvard Law Review* 78 (November 1964): 29. "Drives me silly," Schwartz, *Law in America*, p. 231. "Homey illustrations," Paul Sayre, *The Life of Roscoe Pound* (Iowa City, Iowa, 1948), p. 142. "Court painter," *Boston Globe*, October 21, 1962.

Charles Evans Hughes:
"Clearer case," in Merlo J. Pusey, *Charles Evans Hughes* (New York, 1963), vol. 2, p. 654. "I guess we better take it," *ibid.*, p. 114. "Among the most important," *ibid.*, p. 314. "Most compelling figure," *ibid.*, p. 614. "Horse-and-buggy," Frank Friedel, "The Sick Chicken Case," in John A. Garraty, ed., *Quarrels That Have Shaped the Constitution* (New York, 1987), p. 251. "Old man," in Drew Pearson and Robert S. Allen, *The Nine Old Men* (New York, 1936), p. 96. "Like wit-

nessing Toscanini," Samuel Hendel, "Charles Evans Hughes," in Friedman and Israel, *Justices of the Supreme Court*, vol. 3, p. 1913. "Their own ideals," in "Real and Unreal Portraiture," *Literary Digest* 47 (August 19, 1913): 210.

Benjamin N. Cardozo:
"I am told," Benjamin N. Cardozo, *The Law and Literature and Other Essays and Addresses* (New York, 1931), p. 3. "To read his opinions," Schwartz, *Law in America*, p. 201. "Still possesses," G. Edward White, *The American Judicial Tradition* (New York, 1976), p. 259. "Only possible successor," George Hellman, *Benjamin N. Cardozo: American Judge* (New York, 1940), p. 206. "Up he goes," *ibid.*, p. 218. "Chief recreation," letter, Andrew Kaufman to Frederick Voss, May 1, 1987. "You've made me look," Hellman, *Cardozo*, pp. 137–38.

Zechariah Chafee, Jr.:
"To cause direct," Jerold S. Auerbach, "The Patrician As Libertarian: Zechariah Chafee, Jr., and Freedom of Speech," *New England Quarterly* 42 (December 1969): 515. "An acquired taste," *ibid.*, p. 513. "Should be out mountain climbing," Melvin Urofsky, "Zechariah Chafee, Jr." *Dictionary of American Biography*, supplement 6 (New York, 1980), p. 105. "To define the nature," Jonathan Prude, "Portrait of a Civil Libertarian: The Faith and Fear of Zechariah Chafee, Jr.," *Journal of American History* 60 (December 1973): 655. "High minded fellow," notes of author's conversations with Gardner Cox, August 19, 1987, National Portrait Gallery, Smithsonian Institution. "Scheherazade of the law school," in "Goodbye, Messrs. Chips," *TIME* (July 16, 1956): 62. "I don't want justice," notes of author's conversations with Gardner Cox, August 19, 1987.

Learned Hand:

"Bucketshop," transcript of conversation with Gardner Cox, artist files, National Portrait Gallery. "There are two possible ways," *The Spirit of Liberty: The Learned Hand Centennial Exhibition at the Harvard Law School* (Cambridge, Mass., 1972), p. 9. "Tenth Justice," *New York Times*, August 19, 1961. "Rubbish!" in "A Matter of Spirit," *TIME* (August 25, 1961): 16. "No constitution, no law," Schwartz, *Law in America*, p. 263. "What then is the spirit of liberty," *ibid.*, p. 263. *"He is a magnificent subject!"* Eleanor Platt to Charles C. Burlingham, June 4, 1944, Charles Burlingham Papers, Harvard Law Library Special Collections. "One of the good ones," transcript of conversation with Gardner Cox, artist files, National Portrait Gallery.

Augustus Noble Hand:

"Abundantly without ambition," Marvin Schick, *Learned Hand's Court* (Baltimore, Md., 1970), p. 25. "Always quote Learned," Charles E. Clark, "Augustus Noble Hand," *Harvard Law Review* 68 (May 1955): 1114. "A swill-pail tragedy," Charles Wyzanski, Jr., "Augustus Noble Hand," *Dictionary of American Biography*, supplement 5 (New York, 1977), p. 270. "A judge who could have upheld," Schick, *Hand's Court*, p. 24.

Arthur T. Vanderbilt:

"See that fellow," Arthur T. Vanderbilt II, *Changing Law: A Biography of Arthur T. Vanderbilt* (New Brunswick, N.J., 1976), p. 23. "Justice delayed," *ibid.*, p. 167. "One man in this set-up," *ibid.*, p. 218. "Why didn't you persuade them," *ibid.*, p. 219.

Felix Frankfurter:

"Never commit vealth," Leonard Baker, *Brandeis and Frankfurter: A Dual Biography* (New York, 1984), p.
237. "Farrago of misquotations," *ibid.*, p. 260. "Searing pain," *ibid.*, p. 270. "The most influential," Helen Shirley Thomas, *Felix Frankfurter: Scholar on the Bench* (Baltimore, Md., 1960), p. 22. "Writing [his] private notions," in "The Passionate Restrainer," *TIME* (March 5, 1965): 68. "Electricity made human," in "The Passionate Restrainer," *TIME* (March 5, 1965): 68. "Wherever Frankfurter is," Baker, *Brandeis and Frankfurter*, pp. 381–82.

Harlan Fiske Stone:

"One never knows," Alpheus T. Mason, *Harlan Fiske Stone: Pillar of the Law* (New York, 1956), p. 313. "Tortured construction," *ibid.*, p. 410. "Holmes-Brandeis tradition," Alpheus T. Mason, "Harlan Fiske Stone," in Friedman and Israel, *Justices of the Supreme Court*, vol. 3, p. 2227. "His breadth of black-gowned shoulder," Mason, *Stone*, p. 261. "Relaxed atmosphere," *ibid.*, p. 791. "Those who stand at closer range," *ibid.*, p. 795.

Charles H. Houston:

"I felt damned glad," Genna Rae McNeil, "Charles Hamilton Houston (1895–1950) and the Struggle for Civil Rights" (Ph.D. diss., University of Chicago, 1975), p. 66. "Moses," in William H. Hastie, "Charles Hamilton Houston, 1895–1950," *Journal of Negro History* 35 (July 1950): 356. "No tea for the feeble," Hastie, "Charles Hamilton Houston," p. 358. "In any fight," McNeil, "Charles Hamilton Houston," p. 446.

William Henry Hastie:

"Indignation against injustice," Gilbert Ware, *William Hastie: Grace Under Pressure* (New York, 1984), p. 122. "Very modest," *ibid.*, p. 84. "Most brilliantly argued," *ibid.*, p. 52. "Has never been known," Beverly Smith, "The First Negro Governor," *Saturday Evening Post* (April 17, 1948): 16.

Hugo Black:

"A veritable three-bagger," Virginia Van der Veer Hamilton, *Hugo Black: The Alabama Years* (Baton Rouge, La., 1972), p. 277. "Carried the spoils system," *ibid.*, p. 277. "There have been worse appointments," *ibid.*, p. 281. "No more zealous," *New York Times Magazine*, February 26, 1961, p. 13. "Each dewlap brought forth," Robert Vickrey, *The Affable Curmudgeon* (Orleans, Mass., 1987), p. 150. "I am one of those gentle souls," Hamilton, *Hugo Black*, p. 27.

Earl Warren:

"A revolution made by judges," Anthony Lewis, "Earl Warren," in Friedman and Israel, *Justices of the Supreme Court*, vol. 4, p. 2791. "Biggest damned-fool mistake," *New York Times*, July 10, 1974. "Honest, likable, and clean," John D. Weaver, *Warren: The Man, the Court, the Era* (Boston, 1967), p. 16. "Yes, but is it fair?" in "Earl Warren's Way: 'Is it Fair?'" *TIME* (July 22, 1974): 66. "In the field of education," *New York Times*, July 10, 1974. "The ability to tolerate opinions," typescript of interview with Gardner Cox, undated, p. 18.8, artist files, National Portrait Gallery.

Bibliography

Adams, Charles Francis. *Richard Henry Dana, a Biography.* 2 vols. Boston: Houghton Mifflin Company, 1890.

Auchincloss, Louis. "The Long Life and Broad Mind of Mr. Justice Holmes." *American Heritage* 29, no. 4 (June/July 1978).

Auerbach, Jerold S. "The Patrician as Libertarian: Zechariah Chafee, Jr., and Freedom of Speech." *New England Quarterly* 42, no. 4 (December 1969).

Baker, Elizabeth. *Henry Wheaton, 1785–1848.* Philadelphia: University of Pennsylvania Press, 1937.

Baker, Leonard. *John Marshall: A Life in Law.* New York: Macmillan Publishing Co., Inc., 1974.

—. *Brandeis and Frankfurter: A Dual Biography.* New York: Harper & Row, 1984.

Barrows, Chester Leonard. *William M. Evarts: Lawyer, Diplomat, Statesman.* Chapel Hill, N.C.: University of North Carolina Press, 1941.

Bartlett, Irving H. *Daniel Webster.* New York: W. W. Norton & Company, Inc., 1978.

Batchelder, Samuel Francis. *Bits of Harvard History.* Cambridge, Mass.: Harvard University Press, 1924.

Beveridge, Albert Jeremiah. *The Life of John Marshall.* 4 vols. Boston: Houghton Mifflin Company, 1916.

Bigelow, John. "Some Recollections of Charles O'Conor." *Century Magazine* 29, no. 5 (March 1885).

Binney, Charles Chauncey. *The Life of Horace Binney.* Philadelphia: J. B. Lippincott Company, 1903.

Bowen, Catherine Drinker. *Yankee from Olympus: Justice Holmes and His Family.* Boston: Little, Brown and Company, 1943.

Brady, Patrick. "Slavery, Race, and the Criminal Law in Antebellum North Carolina: A Reconsideration of the Thomas Ruffin Court." *North Carolina Central Law Journal* 10, no. 2 (Spring 1979).

Centennial History of the Harvard Law School, 1817–1917. Cambridge, Mass.: The Harvard Law School Association, 1918.

Chafee, Zechariah. "Joseph Henry Beale." *Harvard Law Review* 56, no. 5 (March 1943).

Chase, Frederic Hathaway. *Lemuel Shaw: Chief Justice of the Supreme Judicial Court of Massachusetts, 1830–1860.* Boston: Houghton Mifflin Company, 1918.

Choate, Joseph Hodges. *Arguments and Addresses of Joseph Hodges Choate.* Edited by Frederick C. Hicks. St. Paul, Minn.: West Publishing Company, 1926.

Chroust, Anton-Hermann. *The Rise of the Legal Profession in America.* Vol. 2. Norman, Okla.: University of Oklahoma Press, 1965.

Clark, Charles E. "Augustus Noble Hand." *Harvard Law Review* 68, no. 7 (May 1955).

Clark, Thomas C. "Roscoe Pound: The Man Who Struck the Spark." *Journal of American Judicature* 48, no. 3 (August 1964).

Commager, Henry Steele. *The American Mind: An Interpretation of American Thought and Character Since the 1880s.* New Haven, Conn.: Yale University Press, 1950.

Cox, Gardner. Transcripts of conversations with Gardner Cox. Curatorial files, National Portrait Gallery, Smithsonian Institution.

Dana, Richard Henry, Jr. *The Journal of Richard Henry Dana, Jr.* Edited by Robert F. Lucid. Cambridge, Mass: The Belknap Press of Harvard University Press, 1968.

Dunlap, William. *A History of the Rise and Progress of the Arts of Design in the United States.* Edited by Rita Weiss. 3 vols. New York: Dover Publications, 1969.

Dunne, Gerald T. *Justice Joseph Story and the Rise of the Supreme Court.* New York: Simon and Schuster, 1970.

—. *Hugo Black and the Judicial Revolution.* New York: Simon and Schuster, 1977.

Dyer, Brainerd. *The Public Career of William M. Evarts.* Berkeley, Calif.: University of California Press, 1933.

Emmet, Thomas Addis. *Memoir of Thomas Addis and Robert Emmet.* 2 vols. New York: The Emmet Press, 1915.

Fisher, Samuel Herbert. *Litchfield Law School, 1774–1833.* New Haven, Conn.: Yale University Press, 1946.

Frankfurter, Felix. *Felix Frankfurter Reminisces.* Recorded by Dr. Harlan B. Phillips. New York: Reynal & Company, 1960.

—, ed. *Mr. Justice Holmes.* New York: Coward-McCann, Inc., 1931.

Friedman, Leon, and Fred L. Israel, eds. *The Justices of the United States Supreme Court, 1789–1969.* 4 vols. New York: R. R. Bowker Company, 1969.

Fuess, Claude Moore. *Rufus Choate: The Wizard of the Law.* New York: Minton, Balch & Company, 1928.

—. *Daniel Webster.* 2 vols. Hamden, Conn.: Archon Books, 1963.

Garraty, John A. "Holmes's Appointment to the U.S. Supreme Court." *New England Quarterly* 22, no. 4 (September 1949).

—, ed. *Quarrels That Have Shaped the Constitution.* New York: Harper & Row, 1987.

Griswold, Erwin N. "Joseph Henry Beale: A Biographical Sketch." *Harvard Law Review* 56, no. 5 (March 1943).

Hagan, Horace H. *Eight Great American Lawyers.* Oklahoma City, Okla.: Harlow Publishing Company, 1923.

Hamilton, Virginia Van der Veer. *Hugo Black: The Alabama Years.* Baton Rouge, La.: Louisiana State University Press, 1972.

Harbaugh, William H. *Lawyer's Lawyer: The Life of John W. Davis.* New York: Oxford University Press, 1973.

Harding, Arthur Leon. "Joseph Henry Beale: Pioneer." *Missouri Law Review* 2, no. 2 (April 1937).

Harding, Chester. *A Sketch of Chester Harding, Artist.* Edited by Margaret Eliot White. Boston: Houghton Mifflin Company, 1929.

Hellman, George. *Benjamin N. Cardozo: American Judge.* New York, McGraw-Hill Book Company, Inc., 1940.

Hicks, Frederick C. *Men and Books Famous in the Law.* Rochester, N.Y.: The Lawyers Co-operative Publishing Co., 1921.

Hill, C. H. "Jeremiah Mason and the Bar." *American Law Review* 12 (1877–1878).

Hopkinson, Charles Sydney. Papers. Archives of American Art, Smithsonian Institution.

Horton, John Theodore. *James Kent: A Study in Conservatism, 1763–1847.* New York: Da Capo Press, 1969.

Ireland, Robert M. "William Pinkney: A Revision and Reemphasis." *American Journal of Legal History* 14, no. 3 (July 1970).

Jones, Alan. "Thomas M. Cooley and the Michigan Supreme Court: 1865–1885." *American Journal of Legal History* 10, no. 2 (April 1966).

—. "Thomas M. Cooley and 'Laissez-Faire Constitutionalism': A Reconsideration." *Journal of American History* 53, no. 4 (March 1967).

Kennedy, John Pendleton. *Memoirs of the Life of William Wirt.* 2 vols. Philadelphia: Lea and Blanchard, 1849.

Knowlton, Jerome. "Thomas McIntyre Cooley." *Michigan Law Review* 5, no. 5 (March 1907).

Levy, Leonard. *The Law of the Commonwealth and Chief Justice Shaw.* Cambridge, Mass.: Harvard University Press, 1957.

Lewis, Walker. *Without Fear or Favor: A Biography of Chief Justice Roger Brooke Taney.* Boston: Houghton Mifflin Company, 1965.

Lewis, William Draper, ed. *Great American Lawyers.* 8 vols. Philadelphia: The John C. Winston Company, 1907–1909.

McNeil, Genna Rae. "Charles Hamilton Houston (1895–1950) and the Struggle for Civil Rights." Ph.D. diss., University of Chicago, 1975.

Marsh, D. M. "The Four Ages of Joseph Choate." *American Heritage* 26, no. 3 (April 1975).

Martin, Edward Sandford. *The Life of Joseph Hodges Choate.* 2 vols. New York: Charles Scribner's Sons, 1920–1921.

Mason, Alpheus Thomas. *Brandeis: A Free Man's Life.* New York: Viking Press, 1946.

—. *Harlan Fiske Stone: Pillar of the Law.* New York: Viking Press, 1956.

—. *The Supreme Court from Taft to Warren.* Baton Rouge, La.: Louisiana State University Press, 1968.

Mason, Jeremiah. *Memoir, Autobiography and Correspondence of Jeremiah Mason.* Kansas City, Mo.: Lawyers' International Publishing Co., 1917.

Matthews, Jean V. *Rufus Choate: The Law and Civic Virtue*. Philadelphia: Temple University Press, 1980.

Monaghan, Frank. *John Jay*. New York: Bobbs-Merrill Company, 1935.

Morris, Richard B. *John Jay, the Nation, and the Court*. Boston: Boston University Press, 1967.
 New York Times obituaries.

Oliver, Andrew. *The Portraits of John Marshall*. Charlottesville, Va.: University Press of Virginia, 1977.

Prude, Jonathan. "Portrait of a Civil Libertarian: The Faith and Fear of Zechariah Chafee, Jr." *Journal of American History* 60, no. 3 (December 1973).

Pusey, Merlo John. *Charles Evans Hughes*. 2 vols. New York: Columbia University Press, 1963.

Robert, Joseph C. "William Wirt, Virginian." *Virginia Magazine of History and Biography* 80, no. 4 (October 1972).

Samuels, Warren J. "Joseph Henry Beale's Lectures on Jurisprudence, 1909." *University of Miami Law Review* 29 (Winter 1975).

Sayre, Paul. *The Life of Roscoe Pound*. Iowa City, Iowa: College of Law Committee, 1948.

Schick, Marvin. *Learned Hand's Court*. Baltimore, Md.: Johns Hopkins Press, 1970.

Schwartz, Bernard. *The Law in America*. New York: American Heritage Publishing Co., Inc., 1974.

Seligman, Joel. *The High Citadel: The Influence of Harvard Law School*. Boston: Houghton Mifflin Company, 1978.

Shapiro, Samuel. *Richard Henry Dana, Jr., 1815–1882*. Lansing, Mich.: Michigan State University Press, 1961.

Story, Joseph. *Life and Letters of Joseph Story*. Edited by William Wetmore Story. 2 vols. Boston: Charles C. Little and James Brown, 1851.

Strong, Theron. *Joseph H. Choate*. New York: Dodd, Mead and Company, 1917.

Strum, Philippa. *Louis D. Brandeis: Justice for the People*. Cambridge, Mass.: Harvard University Press, ·1984.

Sutherland, Arthur E. *The Law at Harvard: A History of Ideas and Men, 1817–1967*. Cambridge, Mass.: The Belknap Press of Harvard University Press, 1967.

Swisher, Carl Brent. *Roger B. Taney*. Hamden, Conn.: Archon Books, 1961.

—. *History of the Supreme Court of the United States*. Vol. 5: *The Taney Period, 1836–64*. New York: Macmillan Publishing Co., Inc., 1974.

Thomas, Helen Shirley. *Felix Frankfurter: Scholar on the Bench*. Baltimore, Md.: Johns Hopkins Press, 1960.

Tierney, Kevin. *Darrow: A Biography*. New York: Thomas Y. Crowell, Publishers, 1979.

Vanderbilt, Arthur T., II. *Changing Law: A Biography of Arthur T. Vanderbilt*. New Brunswick, N.J.: Rutgers University Press, 1976.

Van Santvoord, George. *Sketches of the Lives and Services of the Chief-Justices of the Supreme Court of the United States*. New York: Charles Scribner, 1854.

Ware, Gilbert. *William Hastie: Grace Under Pressure*. New York: Oxford University Press, 1984.

Warren, Charles. *The Supreme Court in United States History*. 2 vols. Boston: Little, Brown and Company, 1926.

—. *A History of the American Bar*. New York: Howard Fertig, Inc., 1966.

—. *The History of the Harvard Law School*. 2 vols. New York: Da Capo Press, 1970.

Weaver, John Downing. *Warren: The Man, the Court, the Era*. Boston: Little, Brown and Company, 1967.

Wheaton, Henry. "William Pinkney." *The Library of American Biography*. Edited by Jared Sparks. Vol. 6. Boston: Hilliard, Gray, and Co., 1836.

White, G. Edward. "John Marshall Harlan I: The Precursor." *American Journal of Legal History* 19, no. 1 (January 1975).

—. *The American Judicial Tradition: Profiles of Leading American Judges*. New York: Oxford University Press, 1976.

Wigdor, David. *Roscoe Pound: Philosopher of Law*. Westport, Conn.: Greenwood Press, 1974.

Winner, Julia Hull. *Belva A. Lockwood*. Lockport, N.Y.: The Niagara County Historical Society, 1969.

Wyzanski, Charles, Jr. "Augustus Noble Hand." *Harvard Law Review* 61, no. 4 (April 1948).

Yanuck, Julius. "Thomas Ruffin and North Carolina Slave Law." *Journal of Southern History* 21, no. 4 (November 1955).

Index

Italicized page numbers refer to illustrations.

Photography Credits

Will Brown: p. 61
Sheldan Collins: p. 35
Wayne Geist: pp. 16, 92, 99, 159, 160
Helga Photo Studio, Inc.: pp. 2
(courtesy of Hirschl & Adler
Galleries), 6
Pollitzer, Strong & Meyer: pp. 115,
118
H. C. Scherr-Thoss: p. 50 (Litchfield
Law School)
Mark Sexton: p. 77
M. Stewart: p. 131 (lunch pail)
Katherine Wetzel: pp. 46, 47
Rolland White: pp. 36, 83, 87, 121,
177

Edited by Frances Kellogg Stevenson
and Dru Dowdy

Designed by Polly Sexton,
Washington, D.C.

Set in Adobe Trump Medieval
Printed by Collins Lithographing and
Printing, Inc., Baltimore, Maryland